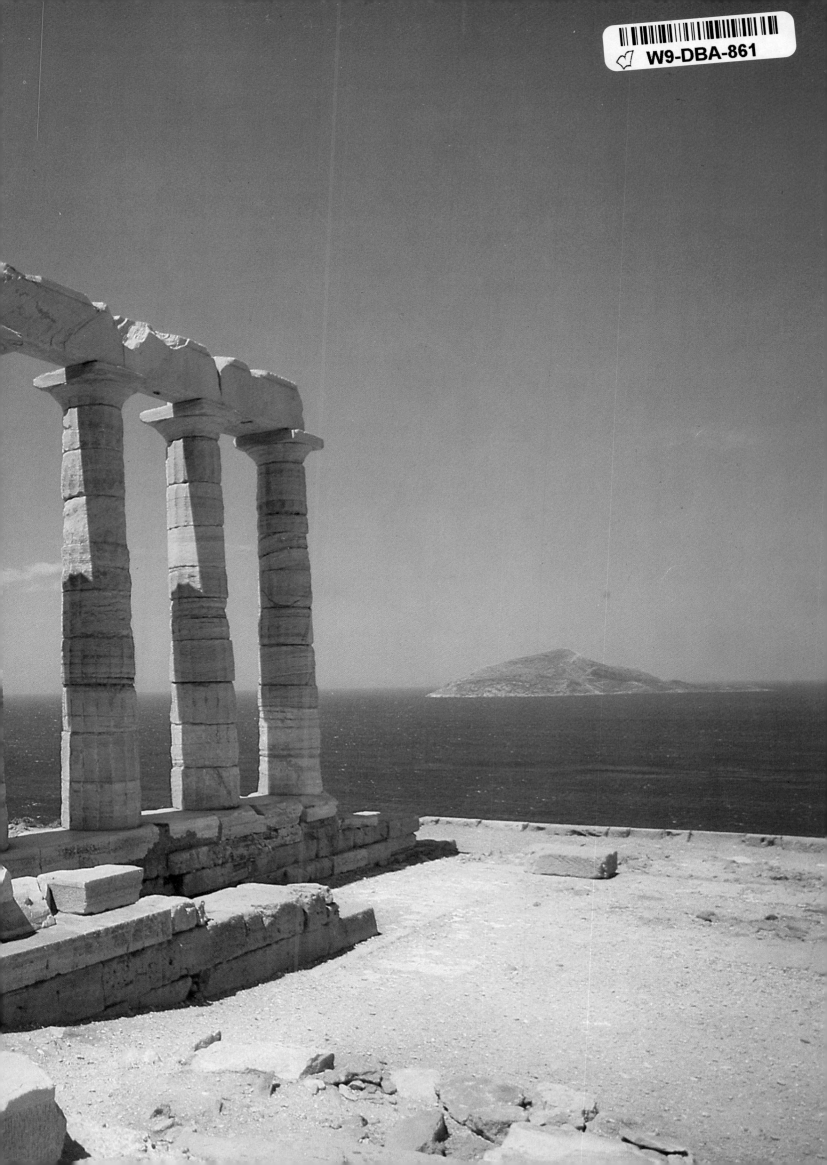

THE CULTURAL HISTORY OF
GREECE

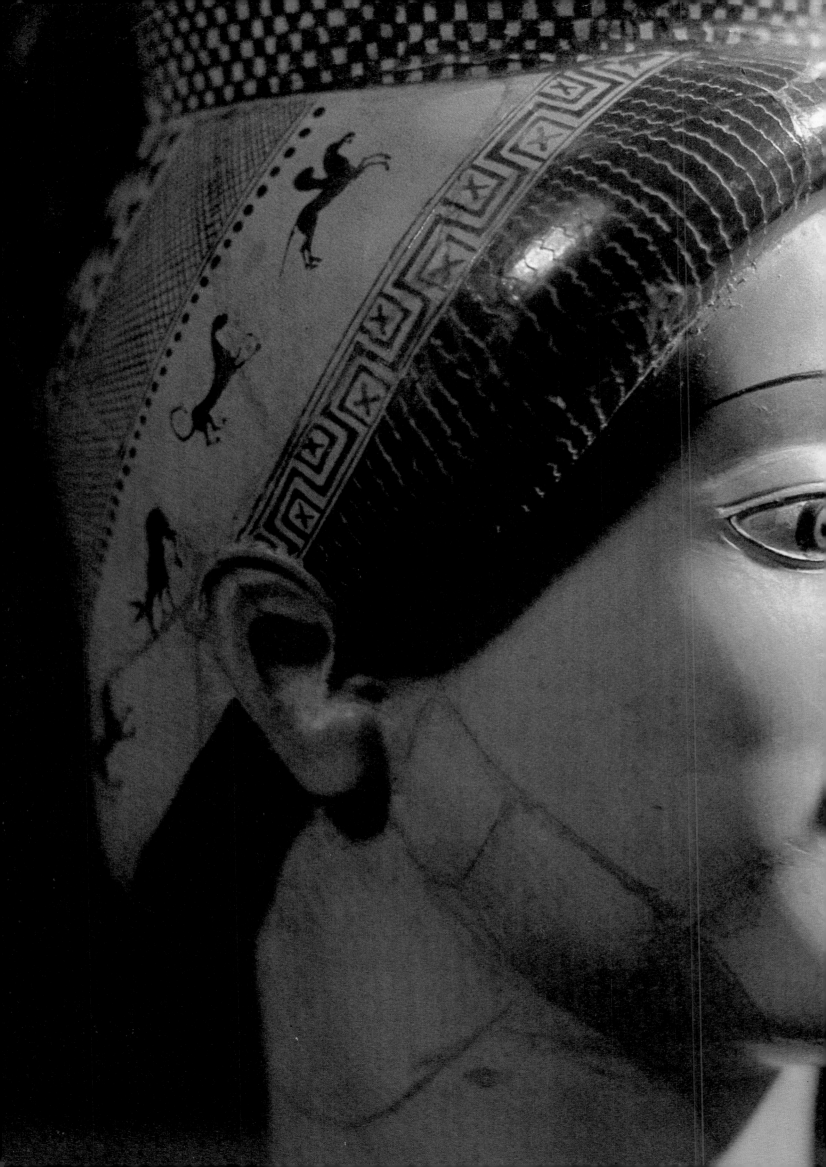

THE CULTURAL HISTORY OF
GREECE

TEXT AND PHOTOGRAPHS
BY HENRI STIERLIN

Cover

Detail of a bronze statue of the sea god Poseidon, dating from 490 B.C. One should notice the copper leaf coating the lips, as well as the originally inlaid eyes.

Endpapers

Colonnade at the Doric temple of Poseidon on Cape Sunion, at the tip of the Attic peninsula overlooking the Aegean. This temple sacred to the sea god was built by order of Pericles shortly after the Persian Wars. Finished in 449 B.C., it was a classical peripteral hexastyle in antis with thirteen columns at the sides. This view shows the southern colonnade, the only one which has survived to our times.

Title page

Detail of a drinking vessel, or "rhyton", in the shape of a woman's head. Signed Xarinos, it dates from about 490 B.C. and is one of the finest examples of Attic red-figured black ware. Such works prove beyond all question that the Greek potters of the preclassical period were no lesser masters than the better known sculptors. This one was found in an Etruscan tomb at Tarquinia in Italy. (Archaeological Museum, Tarquinia)

Photo credits

The 180 colour photographs that illustrate this work were all provided by Henri Stierlin, Geneva, except for the following documents:
André Held, Ecublens, p. 34 right and 86.
Agence Internationale d'Edition, p. 36-37 top.
Yvan Butler, Geneva, p. 78 bottom left and 93 bottom.
Tournage film TV, p. 81 bottom, 82, 83 bottom and 85 left.
Spyros Tsavdaroglu, Athens, p. 81 top and 83 top.
The author and photographer is most grateful to all those who made this book possible: the Directorate of Greek Museums, the National Museum at Athens, the museums at Delphi, Salonika and Iraklion, and especially Professor Nicholas Yalouris, Inspector General of Greek Antiquities, and Professor Manolis Andronikos of the University of Salonika.

ISBN 2-8302-0602-9
13 089 002

Printed in Italy

ISBN 0-906053-64-1

Contents

Forever Living Greece 6

The Island of Minos Restored
to Life 10

Santorin : an Aegean Pompeii 20

The Achaean Warriors of Mycenae 26

The Archaic Dawn
and the Preclassical Period 34

From the Persian Wars to Pericles 55

A Tragic Age 70

The Discovery of Philip II's Tomb 80

Alexander's Epic 86

Forever Living Greece

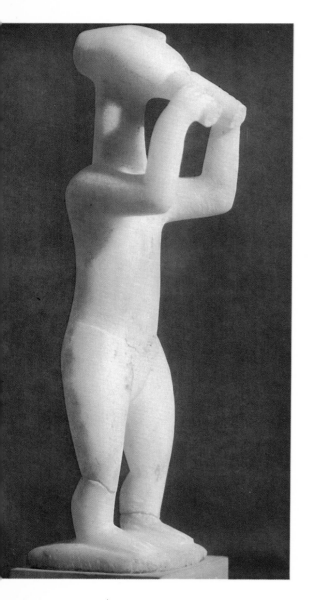

Marble Cycladic idol representing a flute player. This extremely simplified statue was found on the island of Ceos and dates from about 2800-2200 B.C. (National Museum, Athens)

Ancient Greece is the mother of the whole of our Western civilization, of all our ways of thinking and intellectual categories. But she it is too who gave birth to our aesthetic ideals. Ancient Greece is a universe of discourse, a reference system we cannot help appealing to unconsciously, so hardy and undying are the ties which bind us to this "great ancestor".

Nonetheless the wide-spread influence of Greek civilization seems quite out of proportion with the country's relatively small dimensions. What is Greece after all on the geographical scale? Nothing more than an indented coast line at the southeastern end of the European continent, a meagre archipelago made up of arid islands scattered through the Aegean Sea and bordered on the south by Crete. Such is Hellas, the name traditionally given to the formation made up of mainland Greece, including the Peloponnesus and Macedon (all too often termed "barbaric"), along with a straggling string of small islands stretching on towards another Greece carried over into Asia which, though it did indeed make an essential contribution to the art and culture of the Hellenic world, was never regarded as belonging to Greece proper. This definition, accepted by writers and scholars as far back as ancient times, is in any case the one we deem most suited to our purpose. As for the fringe of cities founded at the foot of the Anatolian plateaux, bordering on Asia Minor, we shall put them aside for the while, with the intention of recalling their treasures in greater detail within the framework of the vast survey which we propose to devote to "The World of Asia Minor".

Greece, a divided land with few roads, is cut up into deep bays by the omnipresent sea. It is an island country where the traveller can easily get lost among the multitude of coves, gulfs, isthmuses and capes, but its inhabitants succeeded from the very outset in coming to terms with this maritime environment which was destined to carry them towards new, vaster and more fertile lands. For this reason, our "World of Greece" will also quite rightly include what is generally called Magna Graecia, i.e. the colonies settled by Achaeans from the Peloponnesus or from central Greece at the very dawn of Hellenic civilization, in Homer's times, in Southern Italy and Sicily, with the glorious cities of Cumae, Syracuse, Agrigentum, Segesta, Paestum, etc.

Making a dive into the past, the "World of Greece" is also the dazzling Western dawn which archaeologists ascribe to Minoan civilization, destined later on, when the rulers of the mainland finally undermined Cretan maritime supremacy, to give birth, through a process of continuous evolution, to the fabulous culture discovered by Schliemann at Mycenae. Since the English architect Michael Ventris succeeded in proving, in 1953, that the so-called "linear B" Creto-Mycenaean script is merely a primitive method of transcribing an early Greek dialect, there is no longer any valid reason for refusing to include these remote beginnings in the Greek world. His discovery simultaneously proved that the Mycenaeans worshipped the same gods as did the Greeks, both in Homer's times and during the classic period.

This book is thus a very ambitious venture. Our purpose is indeed to give a concise yet complete account of the artistic and architectural masterpieces created over a period of two thousand years extending from the Cycladic "idols", which date back to the second millenium B.C., and the first Cretan palaces, up through and including the last centuries of the pre-Christian era, when Rome began asserting its dominion over what had hitherto been known

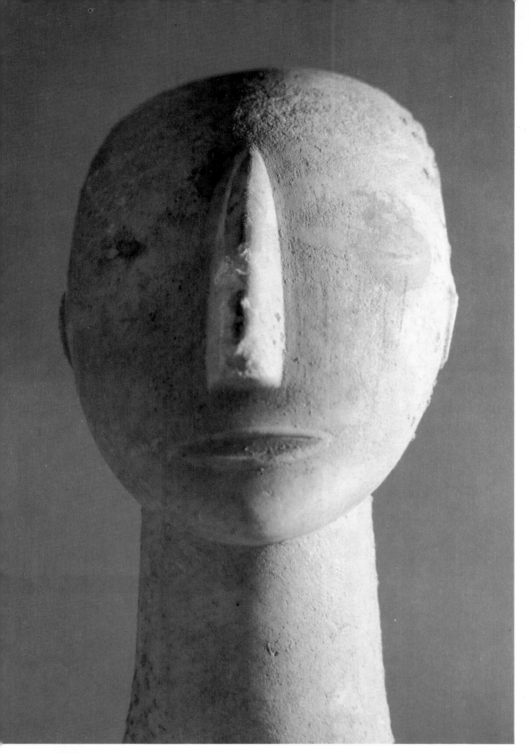

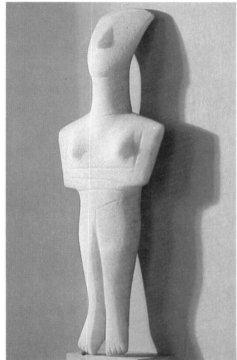

Head of a marble Cycladic idol. Judging by its height (29 cm — 15.6 in), it probably crowned a sculpture much larger than most of those found in the Cyclades group. The simplified features were touched up with polychrome decoration, some traces of which can still be seen at eye level. The work dates from the middle of the third millenium B.C. (National Museum, Athens)

Small marble Cycladic idol showing a female figure with crossed arms. The pose calls to mind Anatolian statues of the Great Mother. (National Museum, Athens)

as the world of Greece. The historic adventure of Ancient Greece came to an end only when the whole of the Hellenistic world was drawn into the orbit of the Roman Empire, but this political downfall by no means restrained the still vigorous influence of Greek civilization. Even after the fall of Rome, the Greek language gave the early Christian Church its philosophical vocabulary which has remained instrumental in modelling our thought up to the present day. Many words we currently use have Greek roots. Our whole way of looking at the world can be summed up as a sometimes complementary, sometimes contradictory intertwining of ancient Hellenic ideals and Judeo-Christian ethics, cemented together during the Byzantine period so as to form a more or less coherent doctrine. Needless to say, Greek civilization also lives on in a language which even now enables us to bridge a gap of thirty centuries.

Ever-Present History

Though Greek civilization still makes itself felt, Greece as such remains an enigma. It is indeed difficult to understand how this tiny land can continue to nourish our classical heritage more than twenty centuries after the collapse of the political and military supremacy of the Hellenistic "Koine", a thousand years after the great schism which resulted in the rise of the distinction between

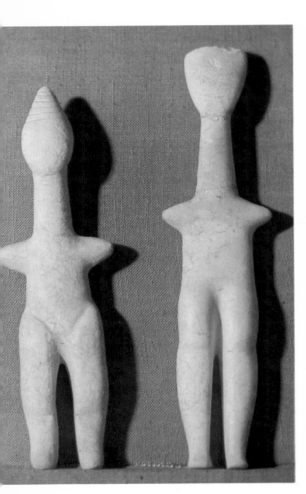

Two small Cycladic idols dating from about 2200–2000 B.C. The shape of the head is simpler than in earlier works, while the neck has grown longer and the arm stumps give a cruciform impression. (National Museum, Athens)

The famous harper found on the island of Ceos. This Parian marble Cycladic carving based on contrasting curves and counter-curves proves that the inhabitants of the Greek Archipelago had invented musical instruments as far back as the third millenium B.C. (National Museum, Athens)

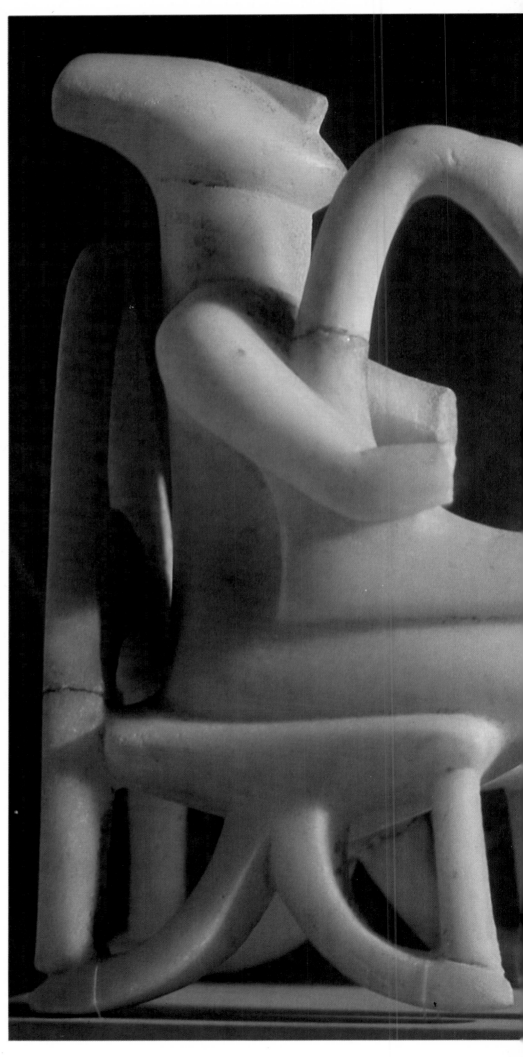

8

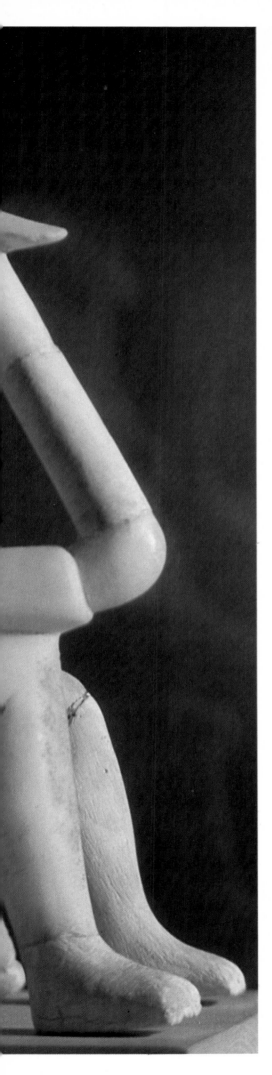

the Greek Orthodox Church and the Roman Catholic Church, and five hundred years after the taking of Constantinople by the Ottoman Turks.

Nonetheless, Ancient Greece, revived not only by learned men of the Renaissance and nineteenth century travellers and poets, but also by twentieth century archaeologists, has not yet finished bequeathing her cultural and artistic riches to us. The past few decades have been marked by outstanding and essential discoveries which have revolutionized our knowledge of the Greek world.

On the one hand, we have the island of Santorin, where an entire cross-section of Minoan civilization has risen from the dead in a discovery worthy to be compared with a thirty-five-century-old Pompeii, complete with its streets, dwellings, store-rooms and marvellously well-preserved mural paintings; and on the other hand, in the middle of Macedonia, towards the northern border of what is traditionally known as Greece, the opulent tomb of Philip II, father of Alexander the Great, has recently been unearthed, revealing a whole series of masterpieces dating back to the turning-point between the classical period and the dawn of the Hellenistic era.

These two major discoveries, both made by native Greek archaeologists, will be related in two separate chapters of our "World of Greece". They prove that history is still with us, forever alive. It is our duty to report on these latest finds, the importance of which can be compared with the discovery of Tutankhamen's hypogeum in Egypt in 1922.

Such is the heritage bequeathed to us by the great Greek civilization which will never cease to astound and dazzle us with the splendour of the ideal its artists succeeded in bringing to life.

Mysterious Beginnings

The Cycladic "idols" are the first great works of art which bear witness to Greek genius. The artefacts in question are extremely simplified marble sculptures, reduced to purest geometric lines, which can be situated half-way between symbols and abstraction. They reach a maximum height of 1.5 m (5 ft), though most of those found vary in height from 20 to 40 cm (8-16 in). The very fine-grained marble used probably came from quarries on the island of Paros. The various statuettes, generally characterized by symmetric structure, are remarkable for their rigorous frontality.

The most typical "idols", found on the islands of Syra and Ceos in the Cyclades group, remain quite mysterious. So mysterious indeed that art historians and archaeologists are hard put to date them with any approximate accuracy. Reckonings vary within a range of several centuries, from 2800 to 2000 B.C. To all appearances, these "idols" seem to be mere "petrified" copies of terracotta statuettes dating back to the fourth millenium B.C., similar to those brought to light at Lerna in Argolis. They most often portray the Great Mother of the Gods, theme which can be traced to Near Eastern and Anatolian sources.

One should not forget that the whole of the third millenium B.C. was a time of stress and turmoil in the Aegean world, shaken by migratory movements as well as by the passage of various trends of influences originating in the east. Some regions were just emerging from the Neolithic Age, others had entered upon the Chalcolithic period, while yet others were witnessing the dawning of the Bronze Age. The Cycladic "idols", which have also been found outside the Greek Archipelago, in Sardinia and even on the shore of the Black Sea, apparently followed migration paths. In addition, the burial customs which have been discovered in the same archaeological context, with round "beehive" tombs characterized by corbelled stone vaults, call to mind similar structures erected in Syria and Palestine and herald the monumental Mycenaean "tholos" tombs.

Be that as it may, the fact remains that the earliest works of art found within the borders of what was to become the world of Greece bear witness to an undeniable sense of sculptural form and a remarkable will to simplicity and technical perfection. The Parian marble chosen by Cycladic artists as means of expression was well adapted to extol and intensify the vigorous pureness of line which is the most striking feature of these works. The same material was moreover destined to be favoured as well by Greek sculptors during both the archaic and classic periods.

One question remains unanswered: were the Cycladic artists Greeks? Specialists are rather unwilling to admit that possibility, since the first Hellenic peoples are estimated to have settled in Greece no earlier than 2000–1900 B.C. ...

The Island of Minos Restored to Life

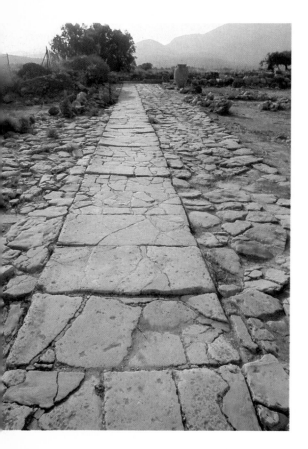

Paved Minoan roadway leading to the palace at Mallia, in Crete. The palace was originally erected about 2000 B.C. and considerably enlarged some four hundred years later.

The Cretan palace at Mallia, excavated by the French School at Athens, displays architectural vestiges which have enabled specialists to reconstruct the over-all lay-out of a complex originally covering an area 100 m (330 ft) wide and 130 m (430 ft) long.

The first archaeological discoveries made on the island of Crete date back to only a century ago and are thus far more recent than excavations undertaken in Egypt and Mesopotamia. Earlier explorations are overshadowed by the importance of the excavations begun at Cnossus under the direction of Sir Arthur J. Evans in 1900, immediately after the island won independence. One should not forget however that the great Heinrich Schliemann himself planned to complete the discoveries he had made at Troy (Hissarlik) and Mycenae between 1870 and 1890 by means of investigations in Crete. Unluckily both for him and for us, he was unable to obtain permission from the Turks. The first vestiges of Minoan civilization were actually unearthed by native Greek archaeologists like J. Chatzidakis who excavated several sites in 1883. The site of the palace of Minos at Cnossus had already been pin-pointed in 1878 by M. Kalokairinos, an art collector.

The excavations undertaken by Lord Evans nonetheless aroused world-wide interest from the very outset, not only on account of their considerable extent and the expenditure accordingly involved but also owing to the extraordinary originality of the civilization which he succeeded in bringing out of oblivion, breaking a silence which had lasted over three thousand years. To be sure, one can find fault with the large-scale restorations carried out by the English archaeologist. The results are in some cases frankly appalling. On the other hand however, if it had not been for these hypothetical and debatable restorations, the Minoan world might well have remained the exclusive property of a tiny group of scholars and specialists. Crete and in particular Cnossus would never have had the enormous vogue among tourists which can be observed nowadays.

Sight-seers do indeed need some material basis to help them to imagine the past. And though the digging at Mallia, directed by the French School at Athens, is undeniably remarkable from a technical viewpoint, it is not the kind

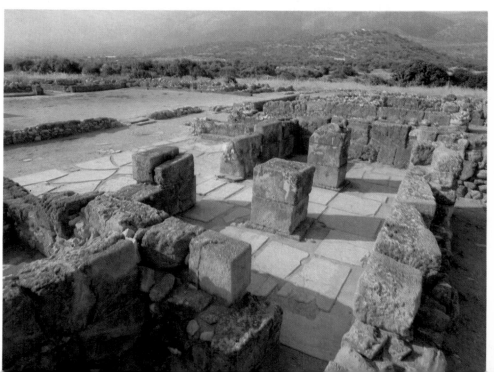

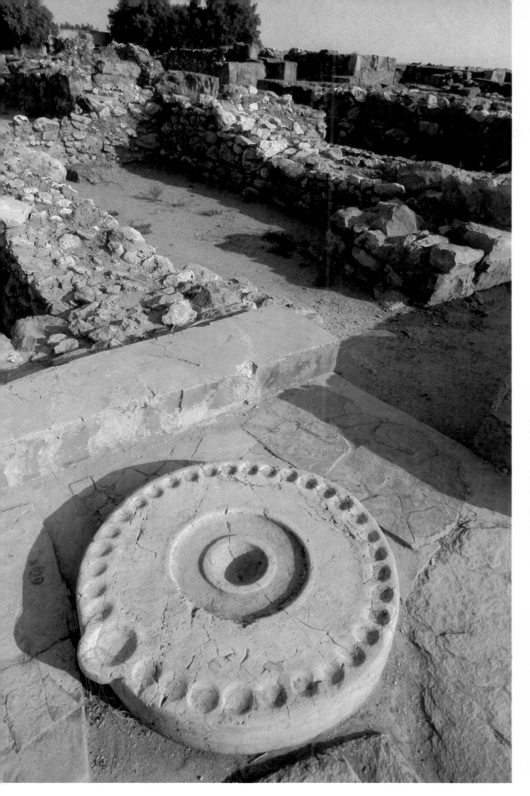

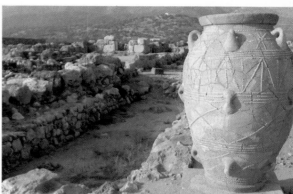

Altar, or "kernos", in the palace at Mallia. To all appearances, ancient Cretans deposited the first fruits of the harvest in the thirty-four outer cavities, while drink-offerings were poured into the central basin.

Enormous jars, or "pithoi", contained supplies for the household of the lords of Mallia.

The ruins at Mallia include sunken circular store pits.

of site that would be capable of drawing crowds. Lovers of pure archaeology should not too hardly blame the enormous efforts made by Evans: they help us to dream of a still living Minoan Crete. Though they are the result of times gone by, though they reflect an archaeological doctrine now regarded as obsolete, they nonetheless help give us a concrete idea of the pomp and splendour of a civilization which made its influence felt in the whole eastern half of the Mediterranean basin in the second millenium B.C.

Crete, an Ancient Cross-Roads

Crete is a large island, 260 km (156 mi) long, which resembles a bar closing up the southern end of the Aegean Sea. The island is simultaneously a relay and a rampart. On the one hand, it is a relay between Greece and Asia Minor, a stopping-place on the sea route from the Aegean archipelago to Africa, Egypt and the Phoenician coast. On the other hand, it is a mighty rampart guarding the entrance to the Aegean at the far end of the scattered island chain made up of the Cyclades and Sporades groups. Its wooded mountain ranges rise up to an altitude of 2,500 m (8,250 ft), while the southern coast is lined by an unbroken stretch of steep cliffs with no natural harbour except in the Mesara

This small steatite vase with carved ornamentation is called the "Prince's Goblet". It was unearthed in the Hagia Triada and dates from 1500 B.C. On the left, an officer wearing a helmet and bearing a sabre seems to be reporting to a prince dressed in a typical Cretan loincloth. (Iraklion Museum)

Rhyton, or drinking vessel used for libations. This Minoan work, representing a black steatite bull's head, was discovered in the ruins of the Little Palace at Cnossus and probably dates from 1550 B.C. The horns were originally of gold. (Iraklion Museum)

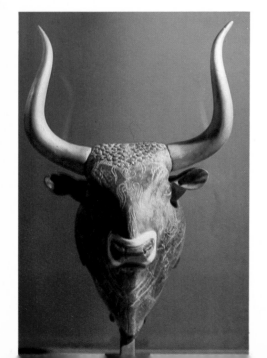

region, where ships weighed sail in ancient times, bound for Cyrenaica, 280 km (168 mi) away across the open sea. Communication with the mainland was less difficult towards the east: eastward-bound ships remained constantly in sight of land, progressing from one island to another until they finally reached the Asia Minor coast. Navigators who chose this route could put into harbour for shelter at night on the island of Carpathus or Rhodes and, once they came in view of Anatolia, continue safely on hugging the coast towards Cyprus or Phoenicia. The nearest island on the north, facing Cnossus, is Thera, or Santorin, the southernmost island of the Cyclades groups. In the following chapter of this work, we shall retrace the fundamental part played by Santorin within the framework of Minoan civilization. Pursuing their northward course, Cretan merchants sailed on without hindrance, despite the violence of the meltem, or north wind, along a string of close set islands which led them to mainland Greece, either to Argolis or to Attica.

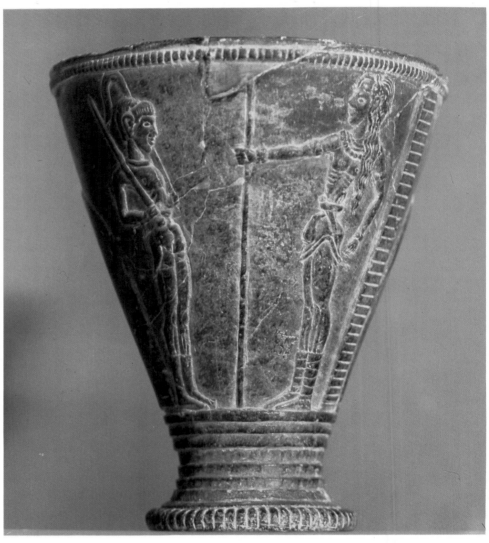

Crete is therefore a cross-roads in the full meaning of the word, half-way between Eastern Europe and Africa, between Greece and Anatolia or Phoenicia. Though lacking the mineral wealth of Cyprus, renowned throughout ancient times for its copper mines, Crete is nonetheless richly endowed with natural resources. The island is covered with corn and linen fields, vineyards, olive groves, date palms and plum trees. Herds of sheep and pigs, as well as once wild bulls and goats go to make up a quite diversified livestock population, while the first horses were brought to the island about 1600 B.C. Fishermen's catches add to the variety of Cretan menus.

Taken all round, the Minoans thus disposed of important natural resources which enabled them to export wine, olive oil and cypress wood, to say nothing of the beautiful artefacts produced by their remarkable artists and craftsmen. The island country was moreover destined to experience an extraordinary maritime boom, leading to Cretan thalassocracy which asserted itself in the latter half of the second millenium B.C.

The "urban revolution" began quite early on the island of Crete. A neolithic aggregation dating back to about 2700 B.C. has been unearthed near the Katsaba river. It would seem to have been founded prior to the great Anatolian

invasion which sowed the seeds of Minoan civilization. These immigrants from Asia Minor were the first to acquaint the island's inhabitants with the use of bronze. They were followed, about 2200 B.C., by Egyptians put to flight by the disturbances and revolutions which marked the end of the Old Kingdom on the banks of the Nile. They too brought with them new techniques which were later turned to account by the Cretans. Relations between Crete and the Nile Delta had been established as far back as the Neolithic Age. Imported Egyptian artefacts dating from the Third and Sixth Dynasties (i.e. 2800-2000 B.C.) have been unearthed at several sites on the island of Crete.

The Birth of Civilization

Homer christened Crete "the island of a hundred cities". Even before the founding of towns worthy of the name, an agricultural aggregation which may

The famous terracotta "Disc of Phaestus". The signs were printed on wet clay by means of stamps—an ancient version of movable type. The hieroglyphic inscription, probably an Anatolian dialect, dates from 1600 B.C. It has not yet been deciphered, though it includes only 45 different characters. It probably has no connection with Cretan civilization. (Iraklion Museum)

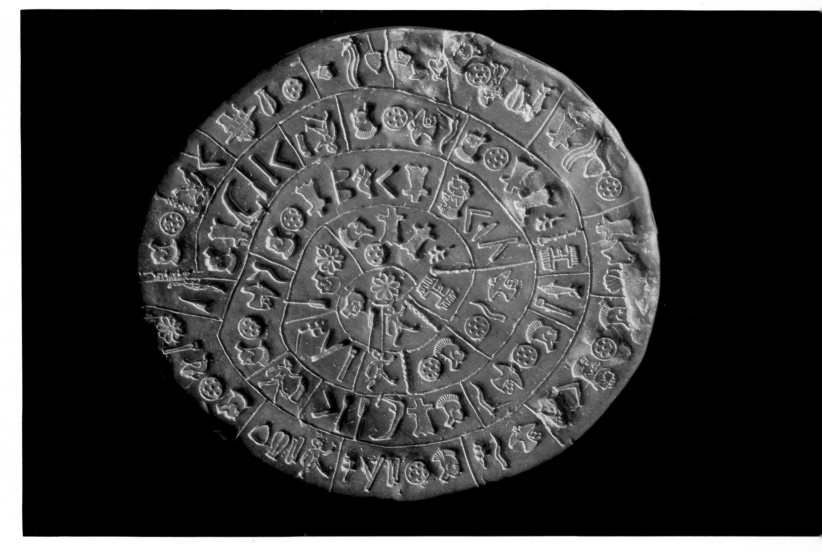

have had a fairly dense population existed about 2200 B.C., at a time when relations with Egypt and Asia Minor were already well established. Under the combined influence of these Near Eastern peoples, the leaders of the different clans of Cretan farmers soon began erecting more sumptuous residences. About 2000-1900 B.C., at least in the wealthier parts of the island, these dwelling-places were gradually transformed into genuine palaces. They marked the incipiency of an extremely original Bronze Age civilization. The island was at that time divided into numerous independent regions, each one of which gave birth to sophisticated arts and crafts including pottery, jewellery, glyptics, or carvings on precious stones, painting and the first traces of a distinctive written language: the so-called "linear A" script which, up to the present day, has resisted all our attempts at its deciphering.

These great palaces, characteristic of Minoan architecture, are most often situated in the middle of fertile plains. One encounters them at Cnossus, on the island's northern coast, as well as at Mallia in the east and at Phaestus on the southern coast.

The Cretans were both farmers and seafarers. The island's prosperity was due not only to its natural wealth but also to the commercial talents of its

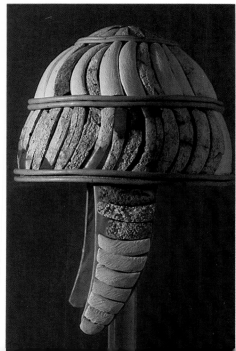

inhabitants. Crete soon became a genuine maritime power, possessing one of the most important fleets in the Mediterranean alongside Egypt and especially Phoenicia.

Minos and His Legends

Long before the first excavations were undertaken in Crete, the existence of a highly developed civilization on the island was reported by a series of legends and ancient texts. Among the most important authors who furnish information about it, we should mention Homer and Hesiod in the eighth century B.C., as well as the philosopher Plato in the fourth century... Homer and Hesiod, the earliest Greek authors, portray King Minos, who governed Crete, as a wise ruler. The Odyssey mentions "Cnossus where Minos ruled, holding converse with great Zeus every ninth year". As a matter of fact, the king of Cnossus was himself the son of Zeus, king of the gods, and Europa the beautiful. Minos was the very embodiment of kingship: never was there a more majestic ruler than he. He lived in his palace at Cnossus, built by the architect Daedalus.

Later traditions give however a very different account. Forgetting the king's solemn majesty and unerring equity, they describe the master of Crete as a cruel despot who levied sanguinary tribute. Seven young Greeks were sent to Crete every nine years and fed to the Minotaur, monstrous offspring of Queen Pasiphae and a sacred bull, kept in the Labyrinth at Cnossus... We all know the legend: Theseus, son of Aegeus, king of Athens, wishing to put an end to the humiliation of his countrymen, volunteers to go to Crete; once there, Ariadne, Minos' daughter, helps him through the Labyrinth by tying a string at the entrance and carrying it through the maze, thus enabling the hero to kill the monster. Theseus leaves Crete, taking Ariadne with him, but he deserts her in Naxos and sails on towards Athens. His father, catching sight of the black sail, sign of mourning, raised by Theseus instead on the torn white one, drowns himself in the Aegean Sea, believing his son has been devoured by the Minotaur...

Both Minos' supporters and his disparagers agree however on at least one point: the undeniable importance of the Cretan ruler. He was a powerful king

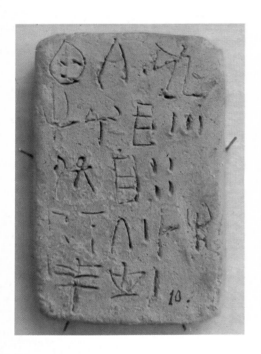

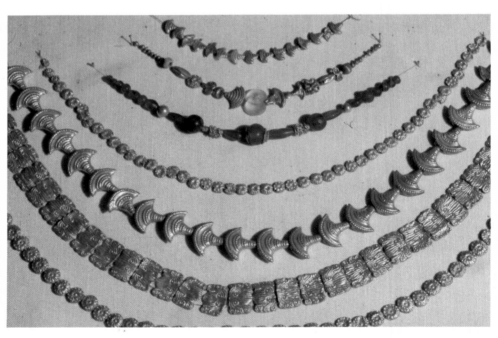

who brought the whole of Greece into subjection. According to Plato's version of the story, Minos was the first king of a city governed by a system of codified laws which he received directly from Zeus, his father. Wisdom, power, justice and majesty — such are the terms used over and over again to qualify Minos, whose name has become synonymous with the kings of Cnossus, just as the Roman emperors would later call themselves Caesar.

Minoan Art and the Earliest Palaces

From the very outset, the first Cretan palaces which sprang up at the dawn of the second millenium B.C. at Cnossus and Mallia were enormous edifices with rectangular ground-plans. The centre of the complex was taken up by a vast

rectangular courtyard where festivities and royal ceremonies were customarily staged. The courtyard was surrounded by buildings serving miscellaneous purposes: the domestic apartments of the ruler and his suite, the throne room, spacious state rooms and assembly halls, the treasury with its fabulous collection of jewellery, textiles and glyptics, to say nothing of the countless storerooms where supplies for the royal household were hoarded. Provisions were generally stored in enormous jars, or "pithoi", containing corn, olives, oil and wine intended for the nobles and their large staff of servants. Metalliferous ore and ingots were piled up in underground chambers.

A network of pipes brought water to the palace wash rooms. Waste water was drained by a sewer system. This system of stone-built conduits and clay water pipes used both for drainage and sanitation is one of the most interesting features of Cretan palatial architecture.

At Cnossus, this palatial architecture made greater use of stone than of wood. The various buildings comprised within the palace complex were faced with stone. Beams imbedded in the masonry braced the walls as a precaution against earthquakes. The columns were cylindrical in shape and tapered, with a rather narrow base which grew gradually wider towards the top. However paradoxical it may seem, this formula was actually quite rational, since it enabled Cretan architects to shorten the span of the architraves. It gave birth to a distinctive style which was perpetuated by later mural paintings and finally furnished Evans with the models he needed for his restorations at Cnossus.

The palace's stone foundations were crowned with several storeys; walls were of sun-dried bricks so as to ease the over-all strain on the edifice. Some buildings had as many as three storeys, resulting from several successive extensions. In the end, these manifold annexes gave the palaces a complicated or even baffling appearance, in spite of the over-all uniformity of the lay-out. In all probability, the legend of the labyrinth originated in this confusing accumulation of halls, corridors, store-rooms and staircases which numbered several hundred and were all clustered round the central courtyard. The myth of the Minotaur, a man-eating monster wandering through the mazes of Minos' gigantic palace with its inextricable entrances and concealed exits, probably reflected the rigorously centralized system of government introduced

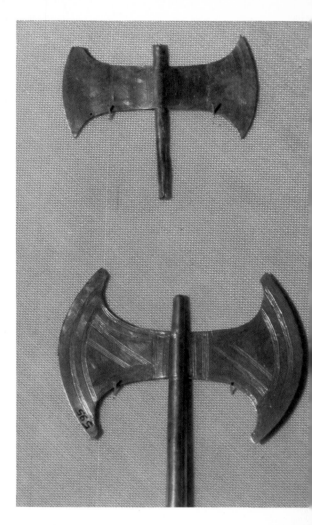

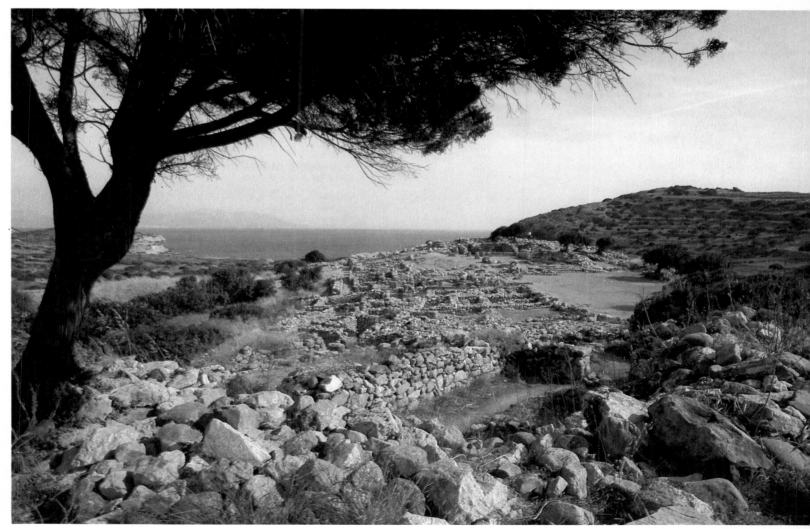

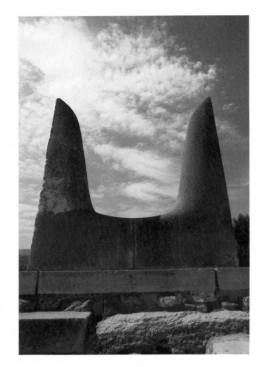

by the first king of Cnossus who ruled his maritime empire by central administration, with the help of a highly developed bureaucracy.

The sumptuous palatial houses of the nobles and priests made up the central core of the city round which clustered craftsmen's workshops as well as the shops of the enterprising Cretan merchants who traded with distant lands. Near Cnossus, about 4 km (2.5 mi) north of Minos' palace, was the port of Amnissus, where merchant ships weighed sail, bound for the colonies established by the Cretans at the four corners of the Mediterranean in order to sell off their manufactured products and luxury articles: jewellery, murex-dyed purple robes, glyptics, choice wines and olive oil.

Painting and the Late Palaces

All of a sudden, this expanding world which appeared to be experiencing a period of extraordinary prosperity, was struck by an unexpected and mysterious catastrophe. About 1700 B.C., the early palaces were destroyed, razed to the ground, burned down. What had happened? What was the cause of this upset? Scholars and specialists are lost in conjecture. Some favour the hypothesis of a pirate raid or the first assaulting wave of the mainland warriors christened the Achaeans in the Homeric poems. Others incline to the belief that the cause of the disaster was a tremendous earthquake. It is indeed a well-known fact that earthquakes are often extremely dangerous in the Aegean basin. (In 1856, an almost unbelievably strong seism left only eighteen houses standing out of a total of over 3,600 in the town of Iraklion!)

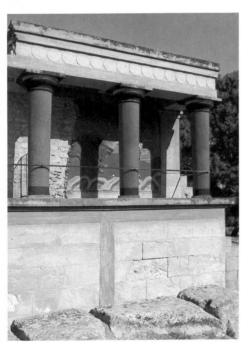

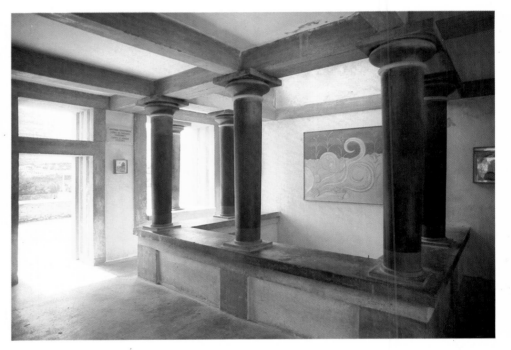

Northern entrance to the palace at Cnossus, with the restored colonnade.

Top:
Stylized horns, symbolizing Minos' sacred bull, at Cnossus.

Right:
Spacious state room in the palace at Cnossus, restored by Lord Evans. The Minoan columns line a light well.

Facing page:
Staircase in the lustral bath at Cnossus. One should notice the typically tapered Minoan columns with their narrow base and flattened capital. Restored polychrome decoration invites us to take a trip back through time to the fifteenth century B.C., when this setting was created by Cretan kings.

Be that as it may, the Cretans, though sorely tried, refused to be disheartened by the disaster. They set to work without delay and rebuilt their cities on a larger and even richer scale than before, inaugurating the era of the new palaces. About 1600 B.C., Minoan civilization entered upon its most fastuous period, restored to life by the excavations undertaken by Lord Evans at Cnossus. The Cretan world was then at the height of its power and glory. To all appearances, the palaces were not fortified. Cretan palatial architecture had no military counterpart. The Cretan rulers relied entirely on the protection granted by their country's insularity and on the deterrent power of their mighty fleet.

Needless to say, architecture continued to flourish, often set off with extremely original wall paintings which can be compared neither to the frescoes ornamenting contemporaneous Egyptian tombs nor to the interior decoration of Syrian and Phoenician palaces.

Minoan art depicts the love of life, joy and cheerfulness of an almost carefree people. The mural paintings found in Cretan palaces bring back to life pleasure derived from nature and the simple things of daily life. They are remarkable for their bright and vivid colours. Cretan painters' favourite subjects were flowers and birds fluttering round beautiful, young and happy beings with graceful gestures, clothed in garments emphasizing the sophisticated elegance of timeless fashion. In addition, there is a leitmotif we meet with very often: the national sport, or bull game. The players had to be both daring and

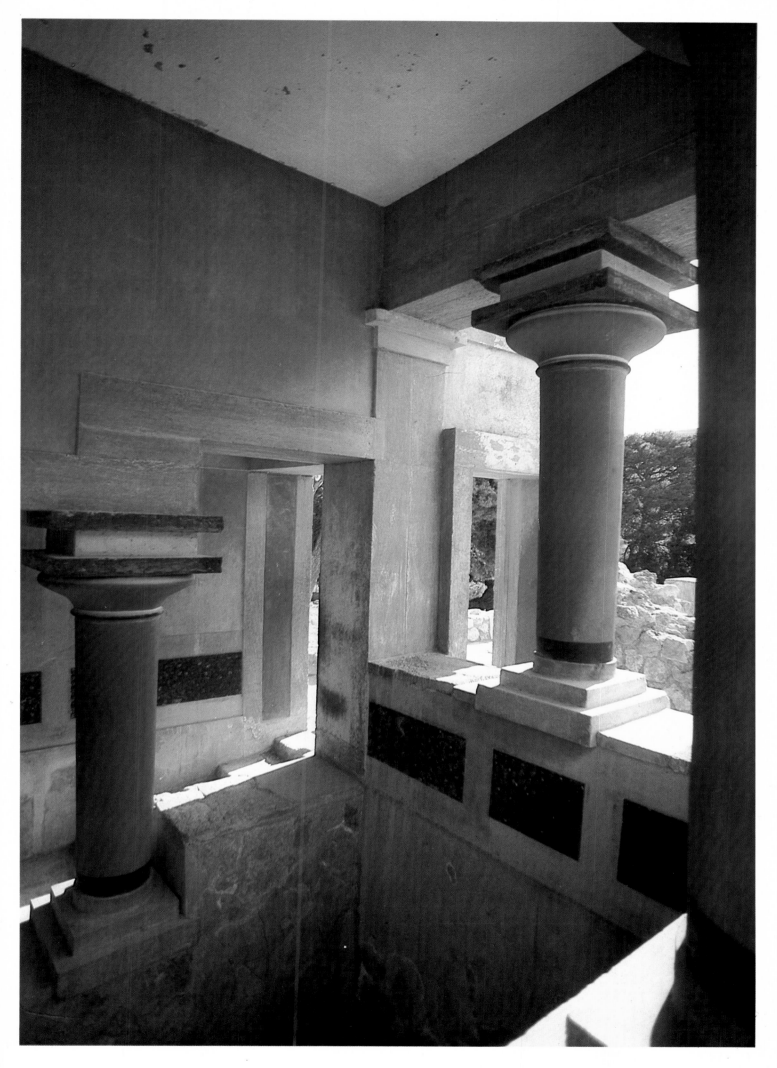

The famous "Snake Goddess", an earthenware statuette found in the central sanctuary, or treasury, at Cnossus. This miniature work of art is 30 cm (12 in) high and dates from 1600 B.C. It shows a young woman wearing a flounced skirt, a tight belt and a scanty bodice. (Iraklion Museum)

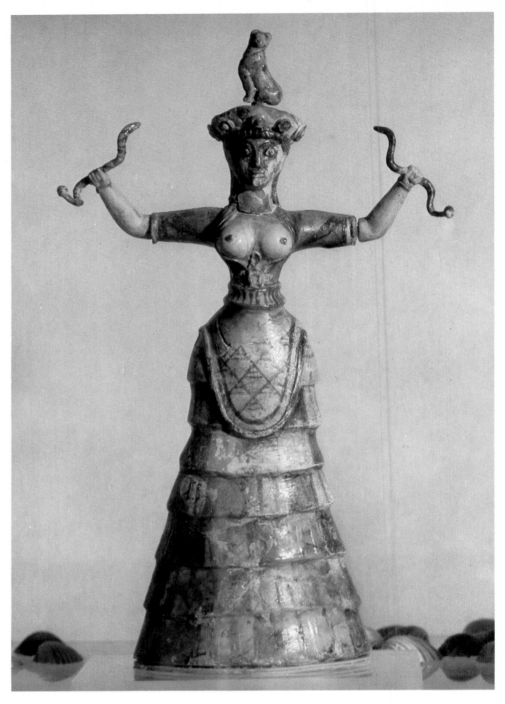

"Pithos", or food jar, unearthed at Cnossus. This ceramic vessel is decorated with stylized double-edged axes and bucranes symbolizing the sacred Cretan bull. (Iraklion Museum)

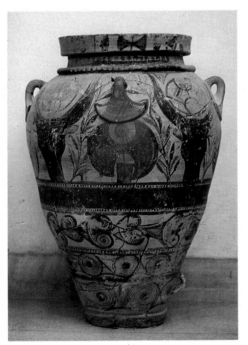

determined. The game was actually a kind of athletic discipline. Paintings portray young boys performing pirouettes and making somersaults over raging bulls. The Cretan bull game was not a bull fight, since the aim was not to kill the animal. The origin of this face to face combat, which is probably at the root of the legend about the Minotaur, was perhaps connected with an initiatory rite... The sacred bull furnished in any case a subject portrayed not only by fresco painters but also by jewellers and goldsmiths, to say nothing of the supremely skilful artists who decorated the precious drinking vessels known as "rhytons".

Undue Restoring

The mural paintings at Cnossus have been restored—along with the palace architecture—on the basis of a theory which gave free rein to conjecture and hypothesis. For this reason, we have deemed preferable not to reproduce these works largely due to Lord Evans' associate, the Swiss painter and archaeologist Emile Gilliéron. The frescoes brought to light on the island of Santorin are indeed better suited to illustrate Cretan painting. They will be dealt with in the next chapter. Recently discovered and restored according to a more sensible, serious and scientific conception of archaeological work, they give us a much better idea of what Minoan art was actually like. Though they are not as imposing as the paintings ornamenting the walls of the palace at Cnossus, their felicitous style and artistic quality are by no means lessened by their "provin-

cialism". The fact is that Gilliéron's "inventions", with their gaudy colours and explicitly "modern" style, have more in common with early twentieth century painting than with the authentic art of the Minoan world...

Minoan art is an art full of fancy, gardens, exuberant decorative rhythms which give free play to imagination and naive delight. Subject matter is unfettered, entirely free from constraint. Nothing recalls formalism, nothing is conventionalized in accordance with religious tradition. There are no battle scenes, no military parades, no depressing esoteric themes, no obsession by anguish and the idea of death.

Nonetheless, art is present even in the Cretan burial places. The vast "tholos", or "beehive", tombs which can be seen in the southern Mesara plain, at Platanus, give us a good example. The maximum interior diametre is 13 m (43 ft), while the walls are often 2.5 m (8 ft) thick. These corbelled stone vaults (now caved in) which crowned the royal sepulchres of the Cretans several thou-

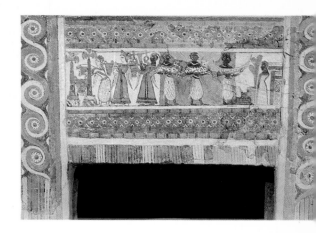

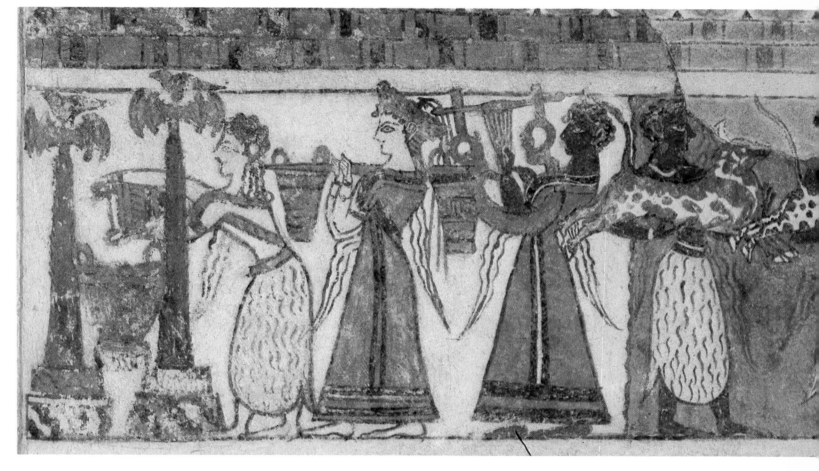

sand years ago herald the great "tholos" tombs of Mycenae with their cupola roofs and long entrance passages.

Gods and Religion

The members of the ancient Cretan aristocracy led a life remarkable for its extraordinary luxury and comfort. One of the specific features of Minoan civilization is indeed that it seems to have taken better care of man than of the gods, whose temples remained small and unpretentious throughout this period. To be sure, the palace complexes also include sites reserved for domestic worship. Nonetheless, these places of worship seem to scorn the slightest show of solemnity. They are but small chapels dedicated to the domestic gods. Only one altar was intended for ritual purposes. The Cretans made libations and offered up animals as a sacrifice to their rustic gods, but nothing bears witness to the existence of a form of public worship worthy to be compared to the awe-inspiring celebrations which were an integral part of Egyptian and Mesopotamian religion.

As a matter of fact, archaeologists have not discovered a single Minoan temple. On the other hand, there are caves where offerings are known to have been made to the gods. Open-air holy places were perhaps surrounded by low dry stone walls (temenos). Nature was actually the Minoans' main temple. There they worshipped the Great Mother of the Gods, embodying the fertility of nature, food plants, herds and the human family.

Detail of the sarcophagus found in the Hagia Triada. A crater placed between two masts surmounted by axes is being filled by young women bearing amphorae, followed by a harper playing sacred songs. On the right, two slaves carrying animals intended to be offered up as a sacrifice.

Top:
The famous carved limestone sarcophagus found in the Hagia Triada dates from 1450 B.C. Polychrome decoration depicts a sacrifice offered up to the gods. On the far right, we can see the deceased attending the ceremonies performed in his honour. (Iraklion Museum)

Santorin: an Aegean Pompeii

One of the most remarkable Minoan archaeological sites has only recently been discovered in a place where just about no one had any suspicion of its existence: outside Crete, on the tiny island of Santorin, or Thera, belonging to the Cyclades group. Santorin is the nearest land on the northern sea route leading from the kingdom of Minos to mainland Greece. Native Greek archaeologists have brought to light, on the island's southern coast, the remains of a town erected three thousand five hundred years ago. The importance of this discovery has thrown historians into confusion and overturned all the knowledge about the Cretan world which had been so patiently gathered until that time.

Santorin is an island in the shape of a jagged crescent. The view one gets of it when approaching by air bears evidence of the catastrophe which took place there in long by-gone days. The natural roadstead formed by the island is in actual fact the sunken crater of a volcano which exploded in the fifteenth century B.C. The eruption reduced to nothing the achievements of a highly developed civilization which flourished about the same time as the kingdom of Cnossus in Crete. As a matter of fact, Santorin was probably originally an important Cretan colony and stopping-place on the sea route to the Greek mainland. The geological vestiges of this disrupted site give the visitor a good idea of the tremendous cataclysm which took place here in ancient times, in the very heart of the Aegean world: a ring of rocks is all that remains of what was once a round island dominated by the towering cone of a volcano rising up to an altitude of 1,000 m (3,300 ft).

Let's try to imagine the unfolding of this vision out of hell which has been reconstructed by modern vulcanologists: the pressure of gasses accumulated in the lava cone of the volcano suddenly expanded, causing the whole island to blow up. The explosion of Santorin was an even greater calamity than the eruption of Krakatoa in Indonesia in 1883 which caused some 36,000 casualties. The event was actually one of the most terrifying natural catastrophes mankind has ever witnessed. Its effects were felt as far away as Egypt: the shower of ashes and the tidal wave caused by the collapse of this island in the Aegean are described by Moses in Exodus.

Entrance to the West House at the northern end of the Triangular Plaza at Akrotiri on the island of Santorin. In the fifteenth century B.C., the whole city was buried under several metres of volcanic ash. Thanks to this protective covering, the Minoan buildings have survived to the present day.

The sheltered roadstead in the middle of the island of Santorin is actually the enormous crater of a volcano which exploded and sank into the sea thirty-five centuries ago. The small island in the middle emerged several hundred years after the catastrophe.

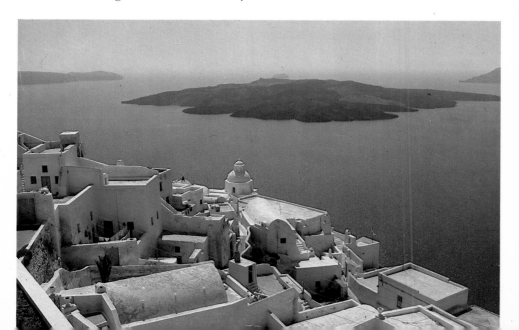

The event had of course much more appalling sequels in Crete itself. When the island of Santorin was swallowed up by the sea amidst shattering explosions and incandescent ash-clouds, it gave rise to a gigantic tidal wave. All the ports on the northern coast of Crete were swept away by the murderous roller. The fleets of Minoan coastal towns such as Mallia and Gournia were reduced to nothing, while the harbours were completely destroyed. Fallen in ruin, they were never destined to rise again. The disaster gave the death blow to Cretan civilization. It marked the beginning of the irremediable decline of the wealthy Minoan cities and their merchant fleets which up to then had been the uncontested masters of the Mediterranean. Even the proud city of Cnossus, King Minos' capital, disappeared soon after being deprived of its port at Amnissus, destroyed by the tidal wave.

Marinatos' Work

The terrifying tragedy of Santorin remained graven on the memory of mankind. One thousand years later, Plato was to conjure up the legend of Atlantis. This paradise lost, located by a whimsical and unfounded tradition in the middle of the Atlantic Ocean, inspired ancient Greek philosophy and has

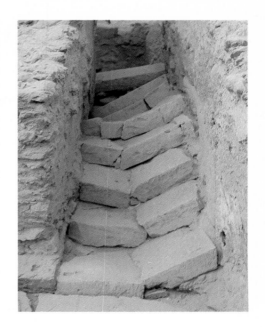

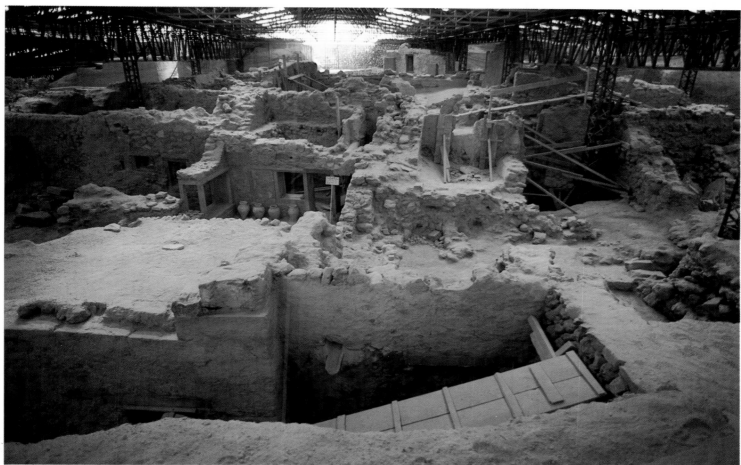

continued to fascinate modern European novelists. At the present time, it has also arrested the attention of scientists: geophysicists and vulcanologists as well as historians have attempted to pin-point this legendary land.

For the Greek archaeologist Spiridon Marinatos, the enigma's solution was beyond doubt. Convinced as early as 1932 that Atlantis was none other than the island of Santorin, he attempted to prove that the catastrophe which destroyed the island also caused the decline of Minoan Crete. Using every effort to obtain permission to undertake excavations on the island, he had to wait until 1967 before he could make his dream come true. He then began digging on the southern coast of Santorin, at a site called Akrotiri. Choosing to investigate a zone where two French archaeologists had unearthed about a hundred vases one hundred years earlier, he had a stroke of luck at the first attempt. Marinatos understood that only the southern coast, sheltered from the strong north winds which blow over the Cyclades group during the summer, could have provided a mooring ground for the sailing boats of ancient times. Akrotiri was the site he deemed most likely to prove his hypothesis.

Over-all view of the excavations at Akrotiri in Santorin. This city built about 1500 B.C. was brought to light by Spiridon Marinatos in 1967. The whole site is now protected by an enormous roof.

Top:
This broken stairway bears evidence of the well nigh unbelievable violence of the volcanic eruption which shook the island of Santorin in ancient times.

And he was not mistaken. Marinatos rapidly brought to light a city buried under several metres of volcanic ash. It was an Aegean Pompeii, destroyed fifteen centuries before the famous eruption of Vesuvius. Today the archaeological site at Akrotiri, covered over by an enormous roof protecting the excavations, enables us to discover the alignment of Minoan roads, the layout of public squares, the appearance of houses some of which are still three storeys high. The visitor can examine the doors and windows, rooms, staircases and stone-built conduits of this ancient city. All these vestiges which had slept for thousands of years under the ashes have been brought back to life.

A Forerunner of Greek Democracy

Marinatos has awoken treasures which turn the history of the Minoan world upside down. The city of Akrotiri, theatre of an unprecedented disaster, is now reappearing as if by magic, enabling us to take a trip back through time. The excavations begun by Marinatos are being continued by his former assistant, Christos Doumas. According to the estimations of this Greek archaeologist, faithfully following in the footsteps of his predecessor, only a twentieth part of the ancient city has been excavated up to now. Most of the dwellings which have been unearthed seem to have belonged to patricians: they exhibit sumptuous decorations recalling the mural paintings of Cretan palaces. This fact would seem to tell that the political organization of the colonies founded by the Minoans in foreign lands probably differed from the system of government in the mother country. It indeed seems likely that no Minoan-style palaces will be discovered in Santorin. Thera apparently had no king. The island was governed by an oligarchy of wealthy merchants specialized in the import-export business. This vitally important Cretan "colony", which largely contributed to the wealth of Cnossus, was perhaps a remote ancestor of Plato's Republic.

The store-rooms which have been brought to light are similar to those discovered by archaeologists at Cnossus, Mallia and Phaestus. They contain the same enormous oil and wine jars in which provisions were stored for the population. Everything is in such good order that the visitor can well imagine how unexpected the disaster must have been. Nonetheless, up to the present time, searchers have not discovered a single skeleton. Metallic treasures, jewels and seals also seem to have disappeared. The only logical conclusion is that premonitory signs of the impending explosion enabled the inhabitants to leave the island in time to escape death and salvage their wealth. Be that as it may, the fugitives were unable to take with them the beautiful mural paintings which adorn the palatial dwellings of the Minoan ship-owners of Thera.

Marvellous Frescoes

At the site of Akrotiri, paintings remarkable for their exceptional charm and very high quality are gradually emerging from the mists of time. Strangely enough, the most striking feature of this several-thousand-year-old art is its pure and refreshing spontaneity.

Needless to say, the restoring of these works of art has entailed slow and patient work. When Marinatos began his excavations, he found them lying broken on the ground, buried under collapsed walls and several metres of volcanic ash. The pieces of this enormous puzzle were carefully conveyed to the Placa district, at the foot of the Acropolis in Athens, where teams of Greek experts have done their utmost to put them back together again. Modern techniques have nothing in common with the hasty methods used at the beginning of the century by Lord Evans and his fellow-workers at Cnossus: at that time, three or four fragments no larger than a hand's width were regarded as sufficient for recreating entire panels... The restoring of the Santorin frescoes, though much slower, is also considerably more reliable, since archaeologists no longer give free play to their imagination.

While awaiting the final results, other art treasures on view in the National Museum at Athens give us just as good an opportunity of admiring the talents of Minoan painters. The most striking feature of these works is the candid straightforwardness of the subjects portrayed in an easy, extremely simplified style, with bright and glowing colours bounded by well defined outlines delineating clear-cut, graceful silhouettes showing great economy of line. Some paintings show swallows fluttering above lily beds and blue monkeys climbing trees. Others portray young girls bearing offerings, decked out in their finest attire. Yet others give us a look at attractive Cretan women with naked breasts, dressed only in wide pleated skirts and tight belts, going to pick flowers in the fields. Fishermen hawl in their catch. Gazelles quickly sketched with unerring accuracy make a pair with a mischievous picture of boxing

Rounded pitcher with heads of barley. The supremely graceful shape of this artefact is typical of Cycladic art. It is one of the finest ceramic vessels unearthed at Akrotiri. (National Museum, Athens)

Facing page:
Detail of "The Child Boxers", a mural painting brought to light in Santorin by Spiridon Marinatos. This art dating from the fifteenth or sixteenth century B.C. still displays the characteristic bloom and spontaneity of youth. (National Museum, Athens)

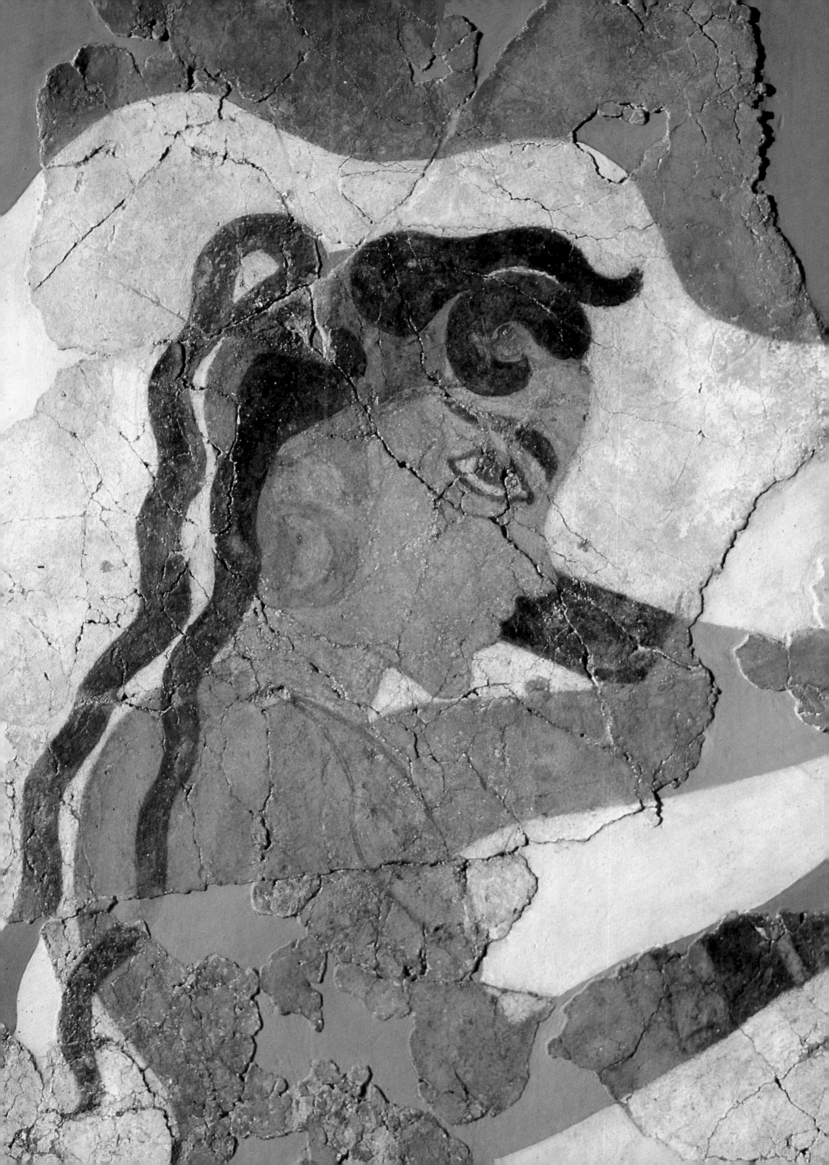

children. This is an art full of artless liveliness which always sticks close to daily life in spite of its very high aesthetic standards. Nothing in these paintings reminds us of royal pomp or the mysteries of religion.

But we also find landscapes. Quite a few of the frescoes brought to light in Santorin depict scenes from the African coast where Cretan merchants sailed off in order to trade with the inhabitants of Cyrenaica and the Nile Delta. In front of the city, we discover the fleet manned by these undaunted navigators, the square-sailed ships, the oarsmen drawn up in line, the forecastles, the light and airy baldachins. Such paintings surely portray historic events: departures or returns from naval expeditions to distant lands...

Such is the stirring message conveyed by the "middle-class" art of Santorin, similar in many ways to the heritage left us by the Venetian Republic where the countless patrons of the arts vied with one another, each one wanting to possess and live amidst the most beautiful setting, created by the ablest and most famous artists.

Besides these remarkable mural paintings, the site of Akrotiri also gives us a possible explanation of the end of the Minoan world. The explosion of the island of Thera may have been only one of the causes which played a part in the decline of the Cretan cities. It was nonetheless decisive. About 1400 or, at the very latest, 1380 B.C., the great Minoan palaces were destroyed and deserted.

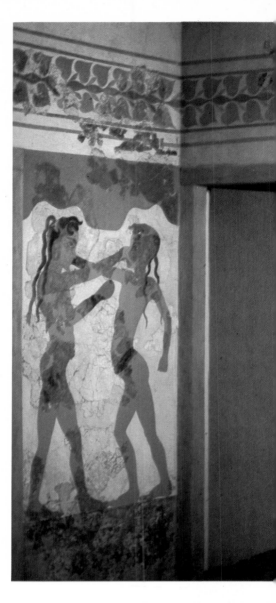

The Achaeans at Cnossus: Linear B

What was going on in Crete in the meantime? In the last chapter, we recounted events through the building of the new palaces, in the sixteenth century B.C., when Minoan civilization was in the heyday of its glory. The Achaeans, new-comers who had developed a warlike civilization in the Peloponnesus, began by trading with Cnossus. These conquerors, who were the first to introduce horses and chariots in Eastern Europe, were a Hellenic people of Indo-European extraction. They quickly adapted themselves to the maritime conditions prevailing in Greece. Following the Cretans' example, they built a fleet which soon entered into competition with that of the Minoans. In a short space of time, the Mycenaeans outshined their Cretan teachers. About 1450 B.C., they succeeded in gaining a foothold in Crete, bringing the king into subjection and imposing the Greek tongue at the court at Cnossus. The clay tablets inscribed in "linear B" script, found not only at Pylos and Mycenae on the mainland but also in the heart of Crete, at Cnossus, date back to this period.

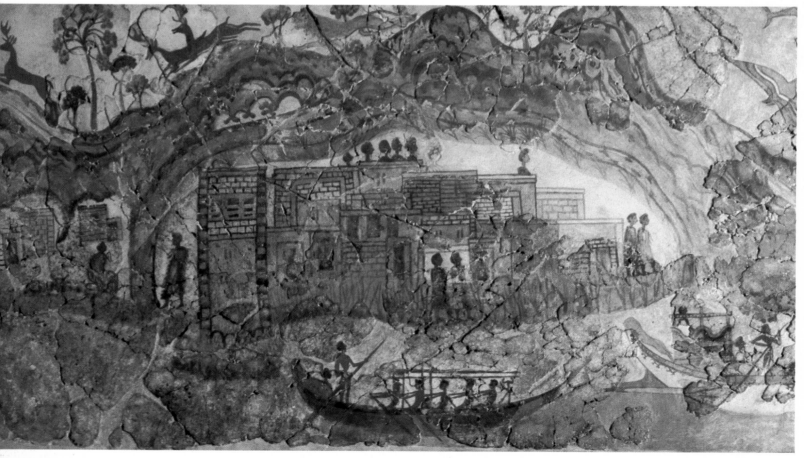

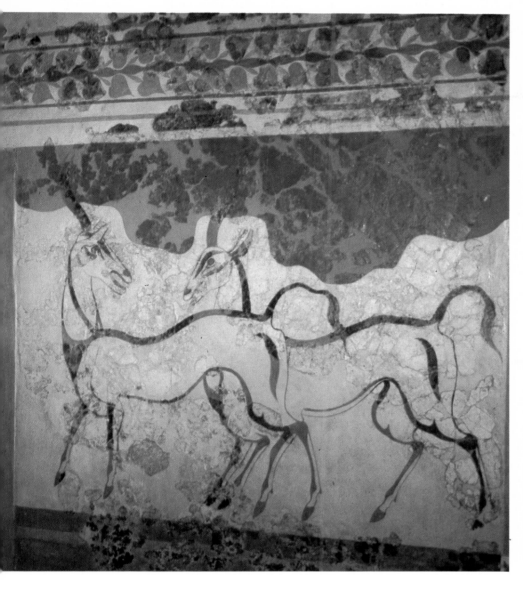

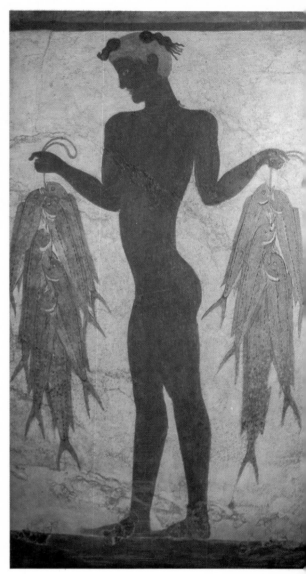

As we have already stated, the deciphering of the so-called linear B script was the doing of an amateur: the English architect Michael Ventris, assisted by John Chadwick, a linguist. This capital discovery, made in 1953, thoroughly transformed our knowledge and hypotheses regarding the genesis of Greek civilization. Nonetheless, the evolution of writing in the Creto-Mycenaean world is a question which remains to be clarified. What was the basis for the still undeciphered linear A script from which linear B was derived?

If we want to apprehend the principles of the creation of an original script in Crete, we can only suppose that the Minoans adopted a Near Eastern system combining picture symbols and syllabic characters written in a distinctive way. Linear B comprises no more than a hundred signs which can be divided into about twenty ideograms and seventy syllabic characters. Numbers are indicated by means of a clever decimal system.

Most of the characters used in linear B script are directly borrowed from linear A. However when we attempt to transcribe linear A on the basis of the known value of identical syllabic characters used in linear B, the result is a wholly unknown language. Specialists can thus be sure that the earliest Cretan inscriptions were not written in Greek. The language spoken by the Minoans may perhaps have been an Anatolian dialect.

As for the tablets inscribed in linear B script, their contents are generally limited and deceiving. The inscriptions discovered up to now include no religious texts, no codified laws, no literary or historic works. One most often finds lists of merchandise, inventories of herds, catalogues of various treasures — in short, elements of what was probably an annual accountancy connected with the management of palace property. These texts inscribed on sun-dried brick tablets were not meant to be handed down to posterity. They owe their survival to the burning of the archives which fired the clay. Their sole importance from a historical standpoint is to help establish the approximate date of the incipiency of a truly Hellenic civilization.

The "fisherman's mural" found in the West House at Akrotiri in Santorin. This painting shows a naked human figure holding a string of mackrels in each hand. The bold colours and graceful outlines bear witness to the aesthetic mastery of the artist who executed this work thirty-five centuries ago. (National Museum, Athens)

Top left:
A corner of the West House at Akrotiri. On the left, we see the fresco entitled "The Child Boxers". On the right, the antilope fresco, remarkable for restraint and purity of line, is one of the most perfect masterpieces of Minoan pictorial art. (National Museum, Athens)

Facing page:
The extraordinary wall painting entitled "The Naval Expedition" is the latest discovery made in the West House in Santorin. This detail shows a landscape and a seaport with passing ships. In the background, a panther is running after gazelles or deer. The city itself, with its flat-roofed houses, is strikingly picturesque. (National Museum, Athens)

The Achaean Warriors of Mycenae

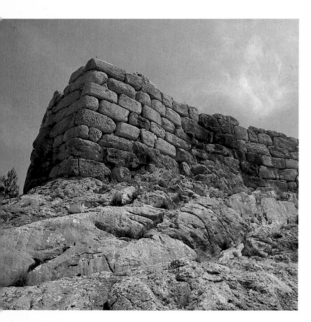

When Heinrich Schliemann discovered the fabulous treasures of Mycenae in 1876, this city built in the second millenium B.C. immediately became the symbol of an entire civilization. Guided by Homer's poem which had already enabled him, six years before, to unearth the ruins of Troy at the site known as Hissarlik, on the shore of the Hellespont, right at the mouth of the Straits, Schliemann could no longer have any doubts about the veracity of the facts related in the Iliad: the Trojan War did really and truly take place. The famous German archaeologist did not know however that the magnificent riches he had unearthed in the Grave Circles at Mycenae dated back to three or four centuries before the coalition formed by the Achaeans against Troy. Agamemnon's feats of arms were performed in the thirteenth century B.C., whereas the treasures brought to light at Mycenae date from about 1600 B.C. What is even more surprising is the extremely long space of time which elapsed between the events narrated by Homer and the period at which his poem itself was born. At the present time, most experts agree that the great Greek poet lived during the eighth century B.C., i.e. nearly five hundred years after the adventures he described.

Minoan civilization was not actually anterior to the development of Mycenae. The first Hellenic tribes entered Greece about 1900 B.C., when the earliest palaces were being built by the kings of Cnossus in Crete.

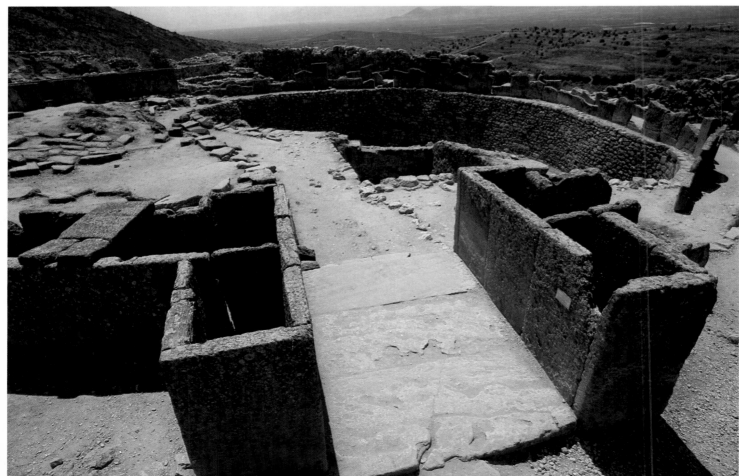

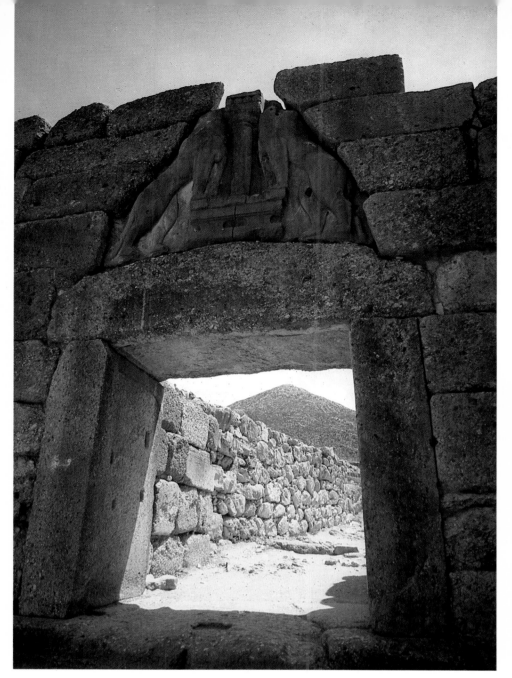

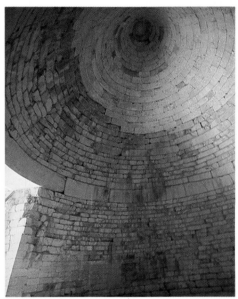

Facing page, top:
Western bastion of the "Cyclopean" ramparts at Mycenae, built by the Achaeans in the fourteenth century B.C.

Facing page, bottom:
Royal Grave Circle at Mycenae. This circular enclosure 26 m (86 ft) in diametre contains the famous shaft graves in which Schliemann discovered in 1876 the treasures now on exhibit in the National Museum at Athens.

Inside view of the stone vaulted chamber tomb attributed to Clytemnestra. Along with the near-by structure known as the "Treasury of Atreus", it is one of the most remarkable Bronze Age monuments still in existence.

Top left:
The Lion's Gate at Mycenae gives access to the citadel. The colossal tympanum surmounting a monolithic lintel weighing some 20 tons is decorated with a relief carving showing two lions front to front, separated by a pillar similar in shape to Minoan columns. The lions' heads, probably carved on separate blocks, have not survived.

Long, unroofed entrance passage, or "dromos", leading to the "Tomb of Clytemnestra". The doorway, with its triangular relieving arch, was originally flanked by columns. This type of funerary structure is more recent than the shaft graves discovered within the precincts of the citadel.

Lords and Charioteers

The first Greeks were a warlike people governed by princes. Their troops possessed bronze weapons. The lords, driving chariots drawn by two horses, often fought each other in single combat. The Achaeans—as they were christened by Homer—were organized into several independent principalities.

These martial lords and charioteers lived on the heights of fortified acropolises where they developed a feudal-type society. The dwellings they built were extremely distinctive. Mycenaean houses were characterized by the so-called "megaron", a structure of Indo-European origin, as was also the language spoken by these unpolished and valorous men. The megaron was originally a long, rather narrow hall with a flat roof sustained by four columns and an entry porch. The centre was taken up by a large hearth. This is where the Achaean lords assembled before their king, seated on a throne. As opposed to Minoan palace complexes, made up of a baffling maze of miscellaneous structures clustered round a central courtyard, the Mycenaean roofed megaron was simultaneously the hearth, the assembly hall and the council chamber, the very heart of the king's residence. Similar structures have also been found in Anatolia where the Hittites, a people of Indo-European descent, settled towards the end of the third millenium B.C. Specimens of megarons dating back to the dawn of the Bronze Age can be seen both at Kültepe and at Troy (Hissarlik).

Mycenae, the "City Rich in Gold"

In actual fact, military architecture was a more typical feature of Mycenaean cities than the dwelling-places properly speaking. Nothing can be more striking than the mighty Mycenaean fortresses, most often built on rising ground so as to be more easily protected from enemies. Each and every lord lived in a castle or citadel surrounded by "Cyclopean" walls, massive and irregular structures of enormous polygonal stone blocks. Mainland Greece contains countless examples, more or less well preserved, of such fortified acropolises dating back to the late Bronze Age (1600–1200 B.C.). The most spectacular one is undeniably the fortress of Mycenae.

Silver rhyton with gold horns and muzzle found in one of the shaft graves at Mycenae. This beautiful piece of metal-work is 15.5 cm (6.2 in) high and dates from the sixteenth century B.C. It is probably the work of a Minoan goldsmith. (National Museum, Athens)

One of the few surviving specimens of Mycenaean sculpture. This woman's head, which may have belonged to a female sphinx, was unearthed south of the Grave Circle. It dates from the thirteenth century B.C. and is in a remarkable state of preservation, still showing traces of red and blue polychrome decoration. (National Museum, Athens)

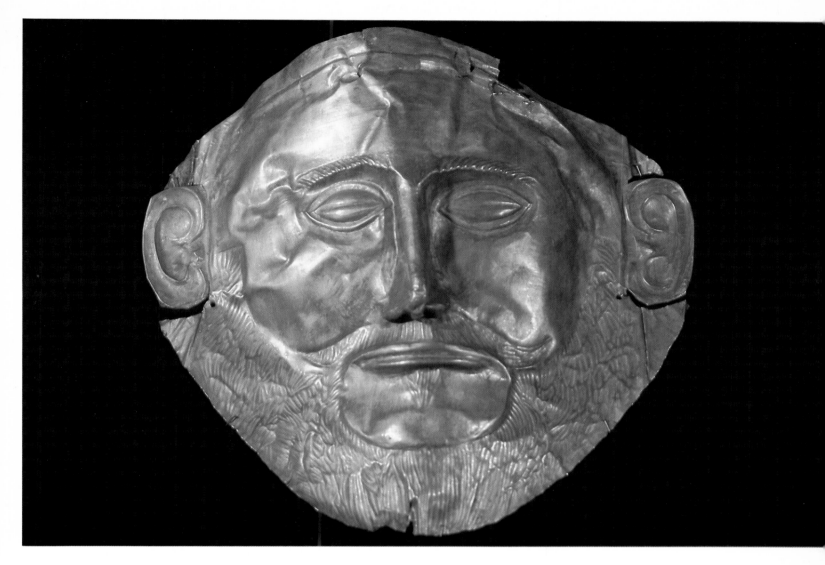

The ruins of Mycenae, called by Homer the "city rich in gold", rise up in Argolis, about forty kilometres (25 mi) south of the Isthmus of Corinth. The city's high defensive walls encompass the crest of an escarpment overlooking the plain of Argos. The area enclosed within the precincts of this imposing and majestic "Burg" is close to three hectares (7.5 acres), while the surrounding walls are some 900 m (3,000 ft) round. The builders took advantage of the site, bordered on two sides by steeply sloping ravines. The main entrance—the only one which could be used by the lords' chariots—opens to the west. A ramp built along the six-metre (20 ft) thick wall enabled the city's defenders to attack their besiegers from above. The gate itself, surmounted by an enormous monolithic tympanum decorated with a relief carving representing affrontee lions, is protected on the right-hand side by a tremendous advanced bastion which gave the defenders yet another advantage, enabling them to strike besetting forces from behind where their shields were of no use. The "Lion's Gate", probably built during the fifteenth century B.C., gives access to a rectilinear ramp running along the edge of the famous "Grave Circle" where Schliemann discovered the shaft graves with their fabulous treasures dating back to 1600 B.C. These graves were not originally within the precincts of the fortifications. They were enclosed several hundred years later, when the city of Mycenae reached the height of its power and expansion.

Staircases lead from the Cyclopean walls to the palace, now almost entirely destroyed. The foundations alone are still standing, but they enable us to identify the typically symmetrical lay-out of the megaron. The entry porch leading to the megaron opened on an inner courtyard. Above the central hearth which heated and lighted this banquet hall where the ruler and his "vassals" assembled, a sky-light served as a chimney. The floor was tiled, the walls decorated with frescoes recalling the style of Cnossus palace paintings, though the subjects portrayed were quite different—most often hunting or battle scenes. The semi-darkness prevailing in this long hall supported by wooden columns and uprights made the megaron the stage of the tragic dramas and conflicts which marked the life and death of Atreus and his two sons, Agamemnon and Menelaus, whose fate was destined to inspire not only Homer but also the great Athenian tragedians of the classic period.

Schliemann believed this death mask found in one of the shaft graves at Mycenae to be a portrait of Agamemnon. In actual fact, it dates from the sixteenth century B.C., i.e. three hundred years before the Trojan War. A marvellous example of repoussé work, it is 32 cm (12.8 in) high. (National Museum, Athens)

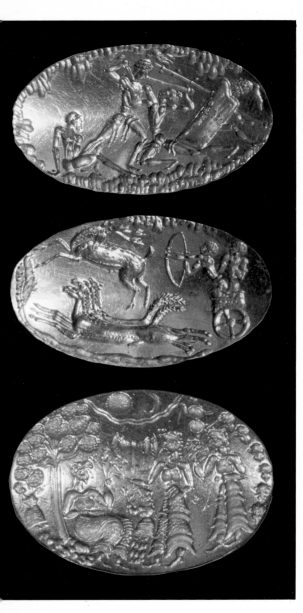

At Mycenae, there seems to have been a separate throne room opening on the central courtyard. The lay-out of the Achaean palace discovered by archaeologists at Pylos is somewhat different. It is an edifice 55 m (182 ft) long and 30 m (99 ft) wide, where the megaron served two purposes simultaneously. The walls of this roofed courtyard where the king held audience were ornamented with frescoes. The protecting gryphons of Cnossus bear evidence of Cretan influence.

Minoans and Mycenaeans

In actual fact, the Mycenaeans, often called Achaeans, inherited their arts and techniques from the Minoans. Not only did they draw inspiration from Cretan art forms, but they also took over from their teachers in the field of trade and maritime supremacy. There was nonetheless a fundamental difference between the two civilizations, in as much as Cretan culture was gay, joyful and carefree, whereas the civilization developed by the Greek warriors on the mainland was harsher and gloomier. In spite of these contrasting keys, the fact remains that in many cases it is well nigh impossible to discriminate between pieces of jewellery and metal ware originating at Cnossus and those produced in mainland Greece.

We have just cause for supposing that the most beautiful objects found in the Mycenaean tombs are the work of Minoans, but it remains difficult to ascertain how they came to Mycenae. Were they spoils of war? Articles made by craftsmen recruited in Crete and employed at the court of the Achaean kings? Works sold to the Greeks by enterprising Cretan merchants? The two marvellous embossed gold cups found in the Vaphio tomb in Laconia are an excellent example. The workmanship proves beyond all question that they were made by an artist from Cnossus. In addition, the subject portrayed—the capture and taming of wild bulls—recalls a purely and typically Cretan tradition. It is the same with the gold and silver "damascened" daggers and swords unearthed in Mycenaean shaft graves. Though the objects themselves betray the Mycenaean lords' inherent liking for war and military pomp, the techniques used are undeniably derived from Cretan sources. These and similar works of art found at Mycenae may be proof of a genuine luxury industry developed by Crete, comparable with the business founded by the Greeks themselves during the classic period on the shores of the Black Sea for the leaders of the Scythian tribes: artists and craftsmen worked to order, so as to please their clients...

Further proof of Minoan influence is furnished by the mode of burial adopted on the mainland in the fourteenth century B.C. As opposed to earlier

Three gold bezels of Cretan workmanship found in shaft graves at Mycenae. These miniature low relief carvings 3 cm (1.2 in) in diametre were perhaps used as seals. From top to bottom, they show a battle scene, deer hunting and three women in a flower garden. (National Museum, Athens)

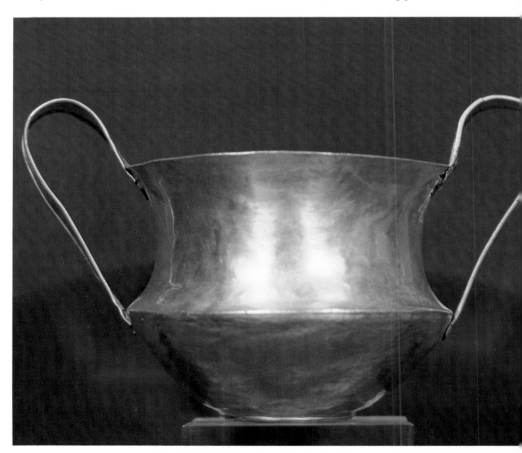

This solid gold cantharus found in a shaft grave at Mycenae dates from the sixteenth century B.C. The shape recalls that of contemporaneous ceramic vessels. (National Museum, Athens)

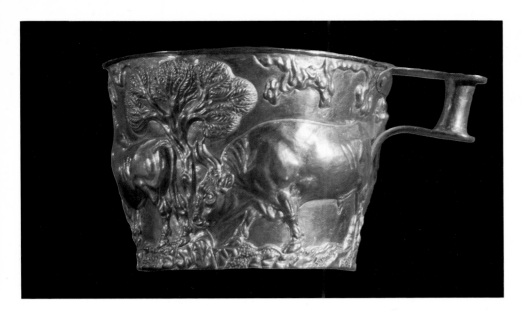

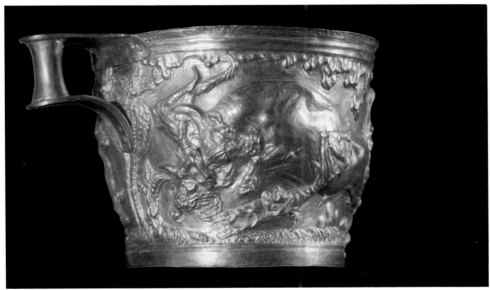

Pair of embossed gold cups found in the Vaphio tomb in Laconia. Both the fine workmanship and the decoration, showing the bull sacred to Minoan civilization, enable us to attribute these works to Cretan craftsmen. They probably date from about 1500 B.C. (National Museum, Athens)

Detail of a mural painting discovered in 1970 near the ramparts at Mycenae. This skilful and graceful art dating from the thirteenth century B.C. draws its inspiration from Minoan frescoes. (National Museum, Athens)

shaft graves, fourteenth century Mycenaean burial places patently draw their inspiration from the "tholos" or stone vaulted chamber tombs which can also be seen in Crete, at Platanus for example, in the Mesara plain. As a matter of fact, marvellous funerary structures can be found in Mycenae proper as well as at other contemporaneous sites such as Orchomenus and Dendra. Some of these "tholos", or beehive tombs, with their corbelled vaulting and cupola roofs, are remarkable for their well nigh unbelievable proportions. The hall known as the "Treasury of Atreus", probably the best known Mycenaean "tholos" tomb, is no less than 14.5 m (48 ft) in diametre and 13 m (43 ft) high. A long, straight, trench-like passage, or "dromos", leads to the entrance: a monumental stone gate flanked by columns and crowned by an enormous monolithic lintel weighing some 120 tons.

"Tholos" tombs also comprise a sunken, underground chamber. The circular cupola with its pointed arches rises above ground level but is covered over with earth so as to form a mound-like structure surrounded by a low dry stone wall. The "Treasury of Atreus" and the "Tomb of Clytemnestra" which date back to about 1340–1320 B.C., are two of the most perfect examples of this remarkable Cyclopean funerary architecture.

Gold, Death, Violence

Mycenaean civilization did indeed make a quite barbaric show of its magnificent treasures. The awe-inspiring and flamboyant wealth of the Achaean warriors' tombs was however counterbalanced by the stern severity of their military power. This splendour, combining gold, death and violence, was not incompatible with sophisticated tastes inherited from Minoan Crete.

Just as in Crete, man played a more important part than the gods in the Mycenaean world. Religion remained a marginal preoccupation and, as far as

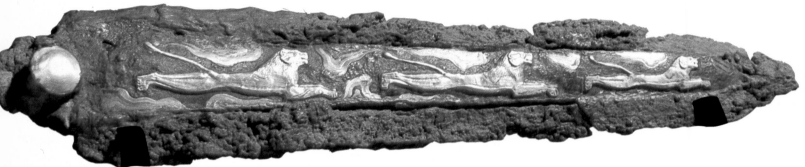

Dagger blade inlaid with pictorial designs showing three running lions, found in a shaft grave at Mycenae. It is an excellent example of native Mycenaean art, remarkable for both precision and vitality. (National Museum, Athens)

Top:
Detail of a dagger blade inlaid with gold, silver and enamel-work dating from the sixteenth century B.C., also found in a shaft grave at Mycenae. The pictorial inlays represent a lion hunt. The fragment shown here is actually only 7 cm (2.8 in) long. (National Museum, Athens)

architecture is concerned, temples were of minor importance as compared to the kings' tremendous citadels and palatial dwellings. Nonetheless, it is interesting to remark that the Mycenaean deities mentioned in linear B inscriptions relating to religious sacrifices were identical with those worshipped by the Greeks during the classic period: Zeus, Poseidon, Hera, Athena, Artemis, Hermes and Dionysus... That is moreover no wonder, at least for those of us who are acquainted with the part played by these gods and goddesses in Homer's epic poems.

Towards the close of the Mycenaean period, religious edifices may have taken on more individual characteristics. On the acropolis at Mycenae, the place of worship, similar to domestic altars in Crete, was a mere annexe within the palace precincts. The temple as such won its independence for the first time at Eleusis, an ancient city of Attica, where archaeologists have unearthed the ruins of a Mycenaean sanctuary with a ground-plan centred round a megaron-type structure.

Mycenaean Expansion

The Achaean lords inherited not only their arts and crafts but also their political sphere of influence from the Minoans. On the mainland, they governed Thessaly, Boeotia and Attica as well as the Peloponnesus, and their influence soon spread overseas to the islands. Their merchant fleet, protected by formidable warships, ploughed the Mediterranean from east to west. Following the example set by their Cretan predecessors and teachers, they soon founded warehouses and colonies abroad. After gaining a foothold in Crete in the fifteenth century B.C., they also took possession of Rhodes and Cyprus. In the thirteenth and fourteenth centuries, Mycenaean settlements were established on the Anatolian coast. Between Caria and Cilicia, the Achaeans became so strong that they actually cut off the Hittites' supply of copper, formerly imported from the island of Cyprus. Mycenaean influence subsequently spread to Syria, where the Achaeans founded a colony at Ras Shamra (Ugarit) and perhaps also at Byblos, before going on to Jericho and Egypt. As a

matter of fact, there is evidence attesting that a team of skilful Mycenaean craftsmen worked at Tell el-Amarna, the new capital city built by the heretical pharaoh Akhenaten.

The influence of Mycenae spread not only southwards but also towards the west. Courageous Greek merchants made their way to Tarentum, Sicily, the Lipari Islands and finally Marseille. From there they went northwards in search of amber. Nothing daunted the Mycenaean seafarers who often resorted to acts of piracy, contending with foreign merchants for new zones of influence.

The Downfall of the Achaeans

The late Bronze Age civilization of the Mycenaeans was destined to be destroyed by new invasions out of the north. The Achaeans were overpowered by another Hellenic tribe: the Dorians. The bronze weapons of the builders of Mycenae were of little avail against the iron blades of their new enemies. The Dorians also replaced Achaean burial customs by cremation.

In the twelfth century B.C., the Mycenaean world was merely the shadow of its former self. The wealthy cities of the Peloponnesus had become impoverished as a result of the population migrations which were overturning the whole of the Near East in connection with the arrival of invaders christened the "Sea-Peoples". Sea routes had become insecure and trade was waning. The Mediterranean had become the scene of anarchical piracy which deprived the Achaeans of their traditional sources of income, based on regular and thriving international trade.

The Dorian conquerors thus put the Achaeans to flight, pushing them back towards the sea where they set sail, bound for the islands. Finally reaching the Anatolian coast, the Mycenaeans took refuge in their former colonies, reversing the migration trend inaugurated by the immigrants from Asia Minor who had settled in Crete fifteen centuries earlier. Greece, shaken by wars, mass emigrations and invasions of primitive warriors much less civilized than the former inhabitants, foundered in a gloomy medieval period, a time of stress and turmoil which was simultaneously a period of gestation. After four hundred years of darkness, a new civilization was going to arise as if by magic, giving birth to the two marvellous Homeric masterpieces known as the Iliad and the Odyssey...

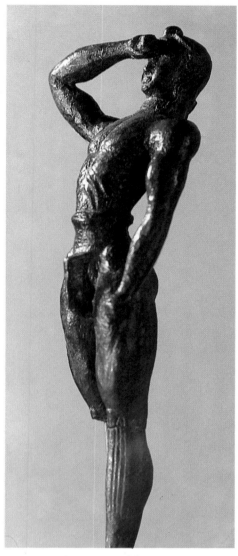

Minoan bronze portraying a worshipper. The pose, with raised hand and uplifted head, is traditionally Cretan. Though this work was found at Mycenae, a similar statue dating from 1500 B.C. has also been unearthed at Tylissus in Crete. (National Museum, Athens)

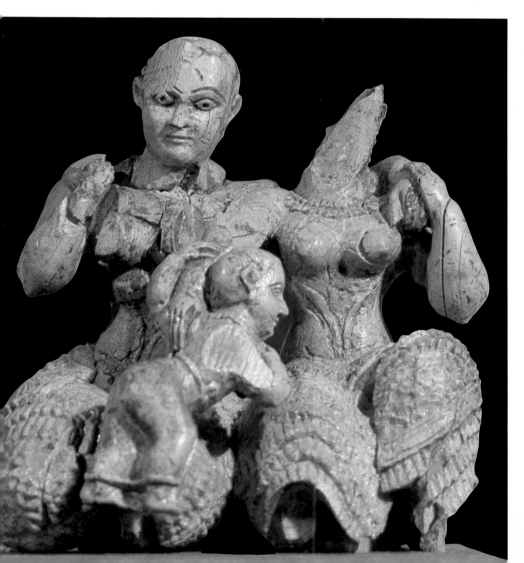

This ivory sculpture dating from the thirteenth century B.C. was found near the palace at Mycenae. It shows two seated women and a child at play. Some scholars believe the two female figures to be Demeter and Persephone. Others regard the group as a portrayal of the young Dionysus with his nurses. (National Museum, Athens)

The Archaic Dawn and the Preclassical Period

When Greece emerged from the dark ages following upon the tremendous migratory movements which had convulsed ancient civilization, turning the Aegean into a "Greek lake", an entirely new world came into the foreground. As early as the eighth or ninth century B.C., the invention of writing marked a threshold of outstanding importance. The birth of the Greek written language was actually a very slow and gradual process. Greek script was derived from the Phoenician alphabet which however, like all Semitic systems, comprised no vowels. Scholars and experts customarily distinguish three different primitive Greek alphabets, originating respectively in the islands, on the Asia Minor coast and on the Greek mainland. During the archaic period, these various types of writing were combined and a uniform system was brought into use. At the same time, the numerous Greek dialects began losing many of their distinguishing features. They were finally united at the dawn of the classical period, thus giving rise to a common language, or "Koine", destined to be shared by the whole of the Hellenistic world from the close of the classical period to the Byzantine era.

This small bronze dating from the seventh century B.C. is the most ancient "kouros" statue discovered at Delphi. The extremely conventionalized pose gives evidence of Egyptian influence. (Delphi Museum)

Right:
Detail of a large funerary crater dating from 740 B.C., found in a cemetery at Athens. The decoration combines geometric patterns and simplified human figures. (National Museum, Athens)

The Phoenicians, who established the first known phonetic alphabet at Ras Shamra (Ugarit) about the fourteenth century B.C., had also built a mighty merchant fleet and taken over from the Achaeans from the standpoint of maritime supremacy. The influence exercised by these masters of the Mediterranean on new-born Greek civilization was therefore no wonder. Nonetheless, the period of torpor which followed the collapse of the Mycenaean world by no means meant the end of Greece. The creation of the Homeric epic poems bears evidence of the swift revival of Greek awareness.

The Homeric Epics

The two tremendous poems known as the Iliad and the Odyssey each comprise twenty-four books of six or seven hundred lines. They were actually con-

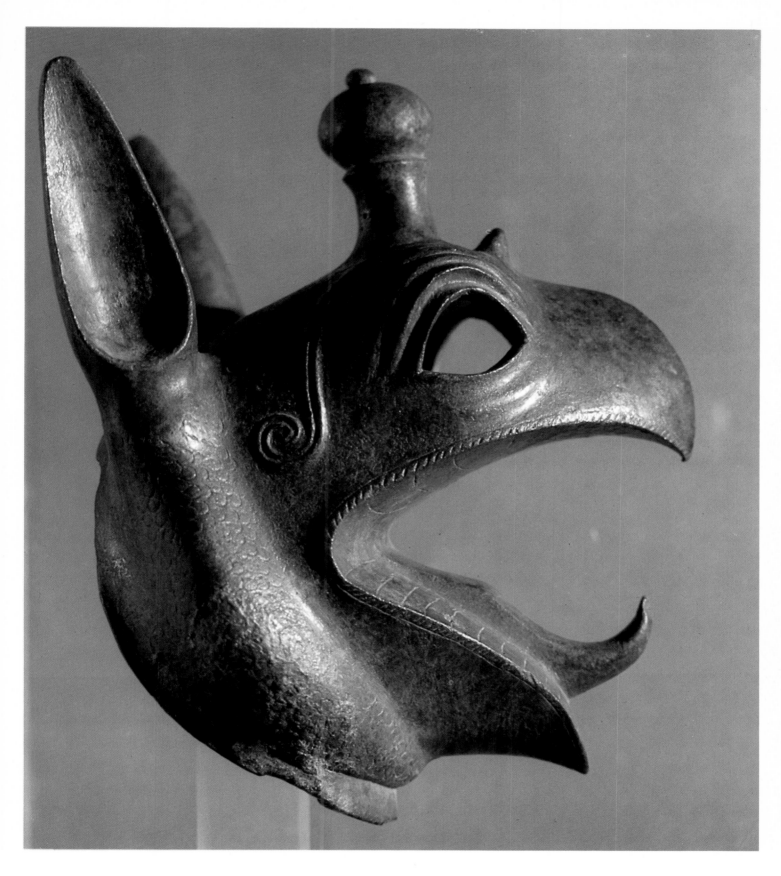

ceived long before being registered in the petrified memory made possible by the invention of writing. Several trends of older narrative tradition mingle in Homer's art. Both of his two epics synthesize heterogeneous local cycles. Each one has its own main hero: Achilles in the Iliad, Ulysses in the Odyssey. The Iliad, which related the great feats of arms accomplished by the Achaeans during the Trojan War, was written for the warrior caste of an aristocratic society. Though the events narrated date back to the thirteenth century B.C., the poem tells us even more about the period during which it was composed. Homer describes the Greek world of his own times, i.e. the eighth century B.C., with its customs, its techniques and its gods. The Trojan War itself, waged five hundred years earlier and surrounded with a halo of mythic glory and obsolete pomp, is treated as a mere pretext.

Head of a bronze gryphon dating from the seventh century B.C. The treatment of the legendary beast is characterized by free and graceful curves. The artefact originally adorned a bronze tripod. (Delphi Museum)

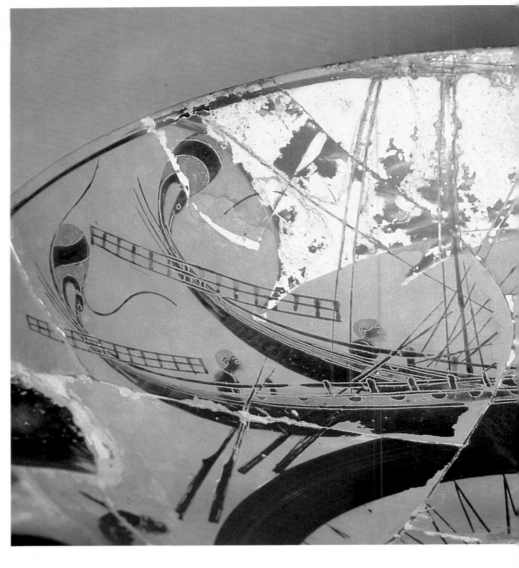

This ceramic cup dating from 525–520 B.C. is an excellent example of Attic red ware. The decoration represents two Greek galleys. We can see the helmsmen and the lookout men, as well as the rostra, or bronze beaks used for ramming. The cup is 28 cm (11.2 in) in diametre. (Louvre, Paris)

Red water-pitcher dating from 520 B.C. found at Caere (Cerveteri). The black figure decoration shows Ulysses and his companions blinding the cyclops Polyphemus. These ceramics are attributed to an Ionian artist working in Etruria about 550–510 B.C. Height: 41 cm (16.4 in). (Villa Giulia, Rome)

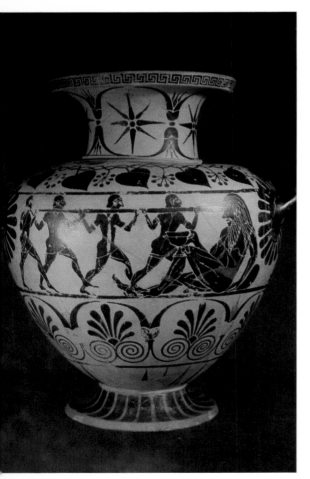

The Odyssey, probably written slightly after the Iliad, is yet more clearly centred round a universe reflecting the daily life and concerns of the Greeks in the eighth century B.C. Translated into matter-of-fact language, the legend narrated is actually the fascinating story of Greek colonization. As stated above, Greek colonization first began under the Achaean kings who spread their dominion throughout the Mediterranean basin, founding a string of colonies and warehouses in remote lands so as to further the development of international trade. According to Homer, Ulysses' journey took place during that period, immediately after the taking of Troy. The fact remains nonetheless that a second period of intensive Greek colonization had begun about the year 800 B.C. And Homer's poem is intended chiefly for his own contemporaries, for the Greek colonists and city-states about to take the plunge into the unknown. The Odyssey tells the story of the dangers, obstacles and objects of dread encountered by Greek navigators who ventured beyond the familiar waters of the Aegean.

Greek Colonization

On the one hand, colonization was a natural result of the Greek genius and fondness for business and adventure which drove these daring seafarers to plough the Mediterranean in search of the natural harbours and mooring grounds best suited to the founding of new cities. On the other hand, the same phenomenon also reflected the social crisis brought about in Greece proper by the scarcity of land. The archaic period witnessed the creation and rise to power of a landed aristocracy including the warriors rich enough to own their own horses, chariots and equipment. As a result, the power of the ground landlords continuously increased. In addition, estates were often broken up among the different sons in each family. Many families were thus reduced to poverty. Those who had no longer enough land to survive chose to leave the country and settle abroad.

In the eighth century B.C., some of these colonists in search of fertile land crossed the Straits, settling in less developed, "barbaric" zones north of the Aegean and the Black Sea. Others went west, bound for Italy and even Spain.

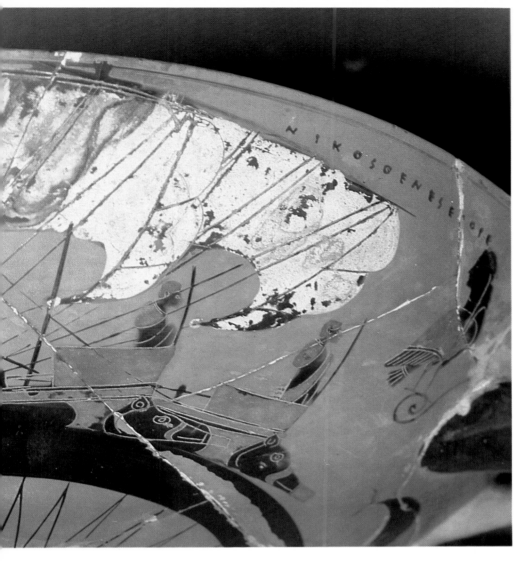

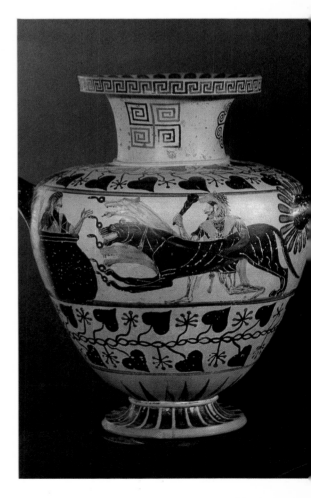

This hydria, or water-pitcher, found at Caere shows Hercules capturing the dog Cerberus. The vessel is 43 cm (17.2 in) high. Though it is classed as red ware, the black figures have been touched up with red and white high lights. (Villa Giulia, Rome)

To the north, Greek acquisitions stretched all the way to Crimea, though trade was actually a more important stimulus than colonization as such. It was a different matter to the west, in Sicily and Southern Italy; the Greeks took undisputed possession of these lands which were destined slightly later to be christened Magna Graecia. Cumae, Catania, Syracuse, Agrigentum, Selinus, Tarentum and Paestum (Posidonia), founded in the seventh and eighth centuries B.C., were all destined to play an important part in the development of the Greek universe of discourse.

Unlike modern colonies, the settlements established by the Greeks all along the circumference of the Mediterranean, from the Pillars of Hercules to the foot of the Caucasus, on the southern shore of the Black Sea, were politically independent entities. The preferential tie which continued to bind them to the mother country was of an essentially emotional character and showed itself chiefly in the field of religion. Many colonists consulted the Delphian oracle before reaching a final decision as to settling abroad. The great panhellenic sanctuaries, at Delphi and elsewhere, largely contributed, along with the common language, to the awakening of Greek "national awareness". The Olympic Games, traditionally believed to have begun in 776 B.C., date moreover from the same period. And the date of the first Olympics provided the starting point for the chronology of the whole of the Hellenic world.

In most cases, these colonies were founded by Greek city-states which commanded important naval forces—Corinth, Megara, the Euboean cities and Miletus. Each one was governed by a founder who assumed personal responsibility for the fate of those who followed him. Greek colonies took root without difficulty all along the northern shore of the Mediterranean. The southern shore was however firmly held by the Carthaginians whose mighty fleet doomed all Greek attempts at gaining a foothold in North Africa to failure. Towards the east, Cyrenaica, across the sea from Crete, was less well defended. Its vast arable plains, which had previously attracted the Minoans, were settled by colonists from Thera. These transplanted islanders were excellent farmers. They turned this now desert region into one of the main granaries of the Hellenic world.

Geometric and Orientalizing Art

As far back as the middle of the ninth century, Greek ceramists developed so-called geometric pottery, characterized by its decoration based on simple, linear designs: triangles, rhombuses, zigzags, meanders ("Greek key patterns"), checker-work, herring-bone patterns, swastikas, spirals, etc. Some of these works are of imposing proportions. In the cemetery near the Dipylon gate at Athens, for example, excavators have brought to light several examples of geometric vases reaching a height of 1.5 m (5 ft). Most were functional, serving purposes connected with funeral ceremonies. As a matter of fact, the custom of cremation which had become general shortly after the Dorian invasion in the twelfth century B.C., went out of use during this period and was replaced, in accordance with ancient Achaean traditions, by inhumation (though some vases, illustrating the Homeric epics, show Patrocles' funeral-pyre!). These large bottomless vases have generally been found in cemeteries, where they were sunken into the ground above the graves in order to receive the drink-offerings made to the dead. As time went by, representational elements were added to their typical geometric patterns. They were at first extremely simplified, but gradually became more and more elaborate. Nonetheless, distinctive Greek key patterns, rosettes and zigzags never wholly vanished even during the classical period. This passion for simple geometric forms, which became evident at the very dawn of Hellenism, is one of the most typical features of the Greek soul. It was destined to make itself felt throughout Greek history, in the theorems of mathematicians like Pythagoras as well as in the works of philosophers who investigated numbers as ideas, in the hope of ascertaining the laws which govern the visible universe.

We have mentioned the Diplyon gate in Athens. The fact is that the city of Athens, though seldom mentioned in Homer's poems, asserted its mastery in the art of pottery at a very early date. The word "ceramics" is indeed derived from the name of a district in Athens where a good many potters lived and modelled clay (keramon). Attica soon became the principal centre of the pottery industry, producing works remarkable for their high quality. Athenian ceramists also initiated the transition from purely geometric decoration to a semi-representational art, ornamenting their vases with human figures illustrating the glorious adventures narrated by Homer in his two masterpieces. One of the scenes most often depicted is the parade of chariots rendering homage to a dead warrior surrounded by weepers wailing and tearing their hair. Sailors and ships call to mind Ulysses' endless journey. The blinding of Polyphemus is yet another favourite theme...

The city of Corinth soon entered into competition with Athenian potters, producing vases, craters and amphorae in a style which betrays undeniable Oriental influences. The legendary animals, floral patterns and ornamental symbols characteristic of Corinthian ceramics are all derived from Oriental sources. A close look enables us to recognize the Persian bestiary with its winged lions and gryphon-birds, Egypto-Phoenician female sphinxes, nilotic

This cup attributed to the painter Xenocles was unearthed in the necropolis at Tarquinia. It dates from 550 B.C. A wide black border surrounds a scene portraying Hercules and Triton. The style is basically Attic, though one can also notice some Corinthian influence. (Tarquinia Museum)

This black-figured Attic vase showing Silenus and a prophylactic eye dates from 525 B.C. (Musée d'Art et d'Histoire, Geneva)

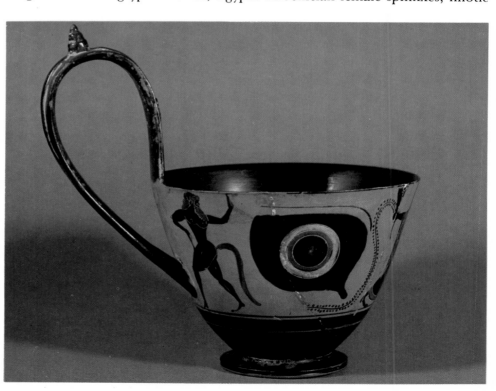

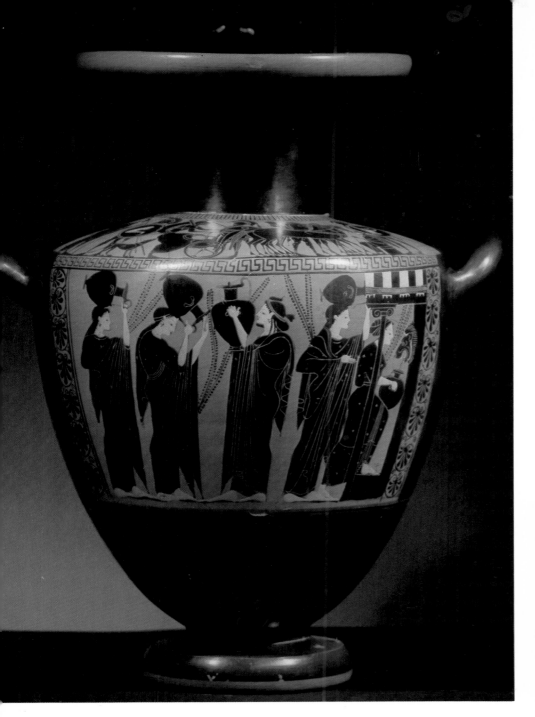

Large Athenian hydria showing women drawing water. This remarkably graceful vase is an example of red ware with white high lights. It probably dates from 530–520 B.C. (Villa Giulia, Rome)

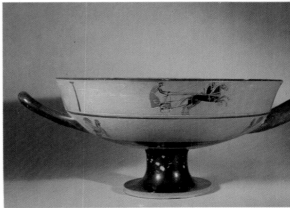

Side-face view of the cup bearing the signature of the painter Xenocles. The decoration shows a racing chariot drawn by two horses. Height: 17 cm (6.8 in). (Tarquinia Museum)

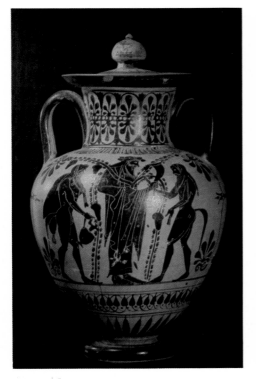

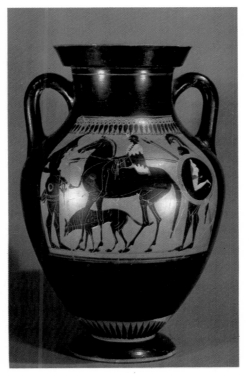

Far left:
Black-figured amphora showing Dionysus flanked by two satyrs. This Attic vase found in Etruria dates from 530–520 B.C. (Tarquinia Museum)

Attic-style amphora showing a horseman, two foot soldiers and a dog. This fine example of preclassical red ware is 39.5 cm (15.8 in) high and dates from about 520 B.C. (Musée d'Art et d'Histoire, Geneva)

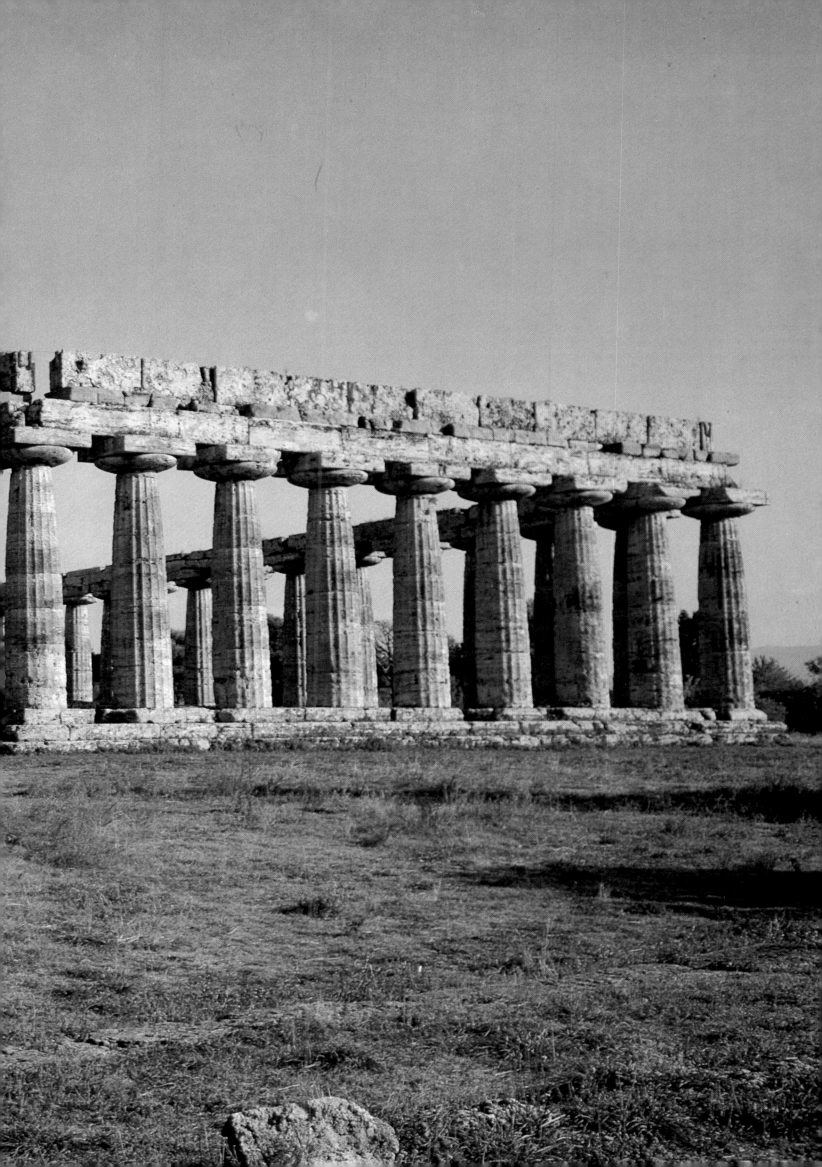

Overleaf (40-41):
In the ancient city of Posidonia (Paestum), founded by Sybarites in Magna Graecia, three Doric temples, rediscovered only two hundred years ago, have miraculously survived to our times. The most ancient one, known as the "Basilica", was actually a shrine sacred to Hera. It was built about 540–530 B.C. The peripteral colonnade, remarkable for its archaic gracefulness, is in a perfect state of preservation. It displays nine columns at each end and eighteen at the sides. The odd number of supports in antis is a peculiarity of this temple; it can be explained by the disposition of the cella which was divided into two naves by a central colonnade.

Right:
Colonnade in the "Basilica" at Paestum. One should notice the exaggerated entasis typical of early Doric columns.

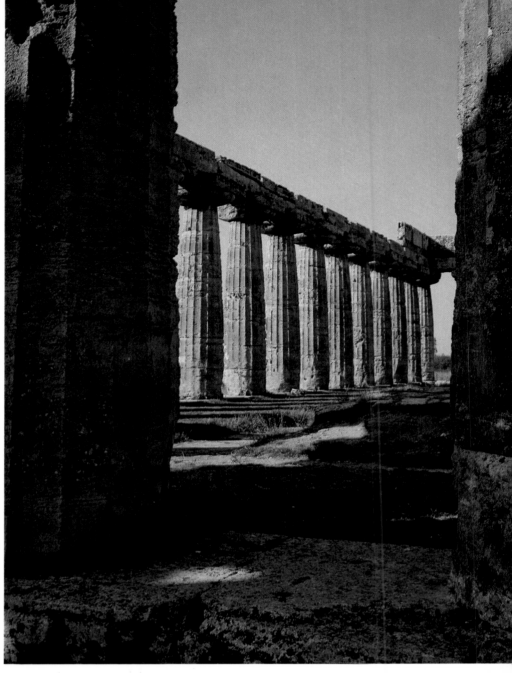

Bottom:
The temple of Athena at Paestum was built about 500–490 B.C. It is a peripteral hexastyle in antis with thirteen columns at the sides. Decorative sculpture is of Ionic style.

Detail of a capital in the "Basilica" at Paestum. The base of the echinus is carved with flowers and palmettes.

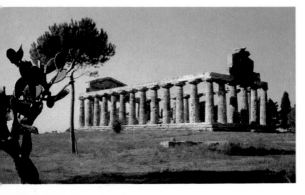

plants, etc. The fact is that relations with Phoenicia had by that time been re-established through the Anatolian coastal cities, and both trade and artistic interchange were recovering.

Greek colonial expansion did in fact go hand in hand with the spread of artistic trends propagated by thriving international trade. In the seventh century B.C., the most important Greek cities exported the manufactured products of their industry throughout the whole of the Mediterranean basin. Ceramics in particular were highly prized not only on the shore of the Black Sea but even more so in Southern Italy, among the Etruscans. Etruscan demand for Greek pottery continued unabated to the apogee of the classical period. The countless finds made by archaeologists in Etruscan tombs at Tarquinia and Cerveteri (Caere) bear witness to the closeness of these artistic and commercial bonds.

The Coining of Money

The considerable extent and importance of these trading relations also entailed the need for a more convenient system of exchange, since primitive bartering was well nigh impossible on the international scale. At first, in Homer's times, iron brooches or bronze plates were used as money. However their use never extended beyond the local scale, and the problem was soon solved by the minting of coins. Most scholars agree that the weight of pieces of metal was certified for the first time by means of hallmarks in the seventh century B.C. The invention of money is attributed to the Lydians. Metallic coins were indeed one of the principal acquisitions which progressively enabled

mankind to intensify exchange of commodities and manufactured products. From thenceforward, craftsmen began making goods especially intended for the export business. Not only ceramists but also metal-workers, jewellers, painters and various other artists made a substantial contribution to increasing the bulk of international trade and drawing the bonds between the different peoples of the ancient world closer.

In addition, coins themselves were not only a measure of value. They soon became a new means of artistic expression. The craftsmen who created the hallmarks decorating both the obverse and reverse sides of Greek coins were not slow in achieving a remarkable degree of sophistication. Minting, which was a privilege of independent city-states, was at the same time proof of self-sufficiency. The result was a heterogeneous but marvellous crop of

Bottom:
The great Doric temple discovered on the island of Aegina in 1811 was built about 500–490 B.C. It is a peripteral hexastyle in antis with twelve columns at the sides. On the right, we see a detail of the inner colonnade.

The Treasury of the Athenians at Delphi was built in 490 B.C. in commemoration of the battle of Marathon.

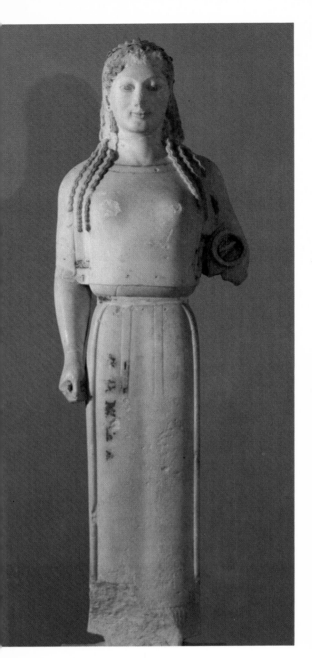

original emblems symbolizing each and every city entitled to coin its own money. The metal most often used for this purpose during the archaic and preclassical periods was silver. The use of gold became common during the classical and Hellenistic periods, but we should also mention the natural ally of gold and silver known as electrum, which was favoured by Greek coiners from the very outset.

The Birth of Statuary

Though no example of the art of modelling from the dark ages has survived to our times, we are justified in supposing that the primitive sanctuaries built at Greek holy places housed wooden "idols" characterized by extreme simplicity of line. The earliest known vestiges of Greek statuary date from the seventh century B.C. They are small bronze statuettes distinguished by rough and spare treatment. The prevailing style is characterized by an unmistakeable Egyptian influence. The orientalizing style in the art of pottery (with its vivid colours, entangled patterns and legendary animal designs) was indeed not the only artistic by-product of the frequent journeys undertaken by Greek merchants to Phoenicia and the Nile Delta. They also brought back to their homeland examples of the statuary peculiar to Pharaonic Egypt. Though Egyptian art was undeniably on the wane, the cultural renaissance which took place during

The so-called "Peplos kore", discovered on the Acropolis at Athens, is a genuine masterpiece of archaic sculpture. It dates from 530 B.C. Slight traces of polychrome decoration can still be seen. (Acropolis, Athens)

Facing page:
This kore unearthed on the Acropolis dates from about 510 B.C. With its kind smile and delicate draperies, it bears witness to the supreme grace and spontaneity of archaic art. (Acropolis, Athens)

Detail of a horse's head carved about 490 B.C. This sculpture of Parian marble was found on the Acropolis, buried in a pit along with other works of art damaged by the Persians. (Acropolis, Athens)

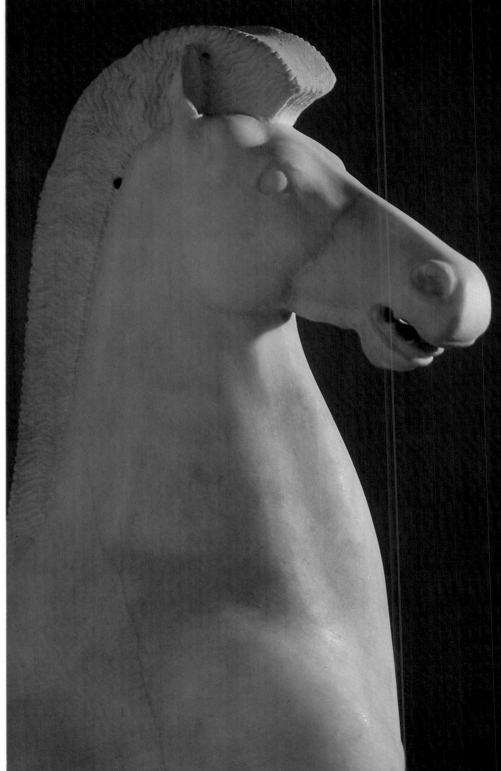

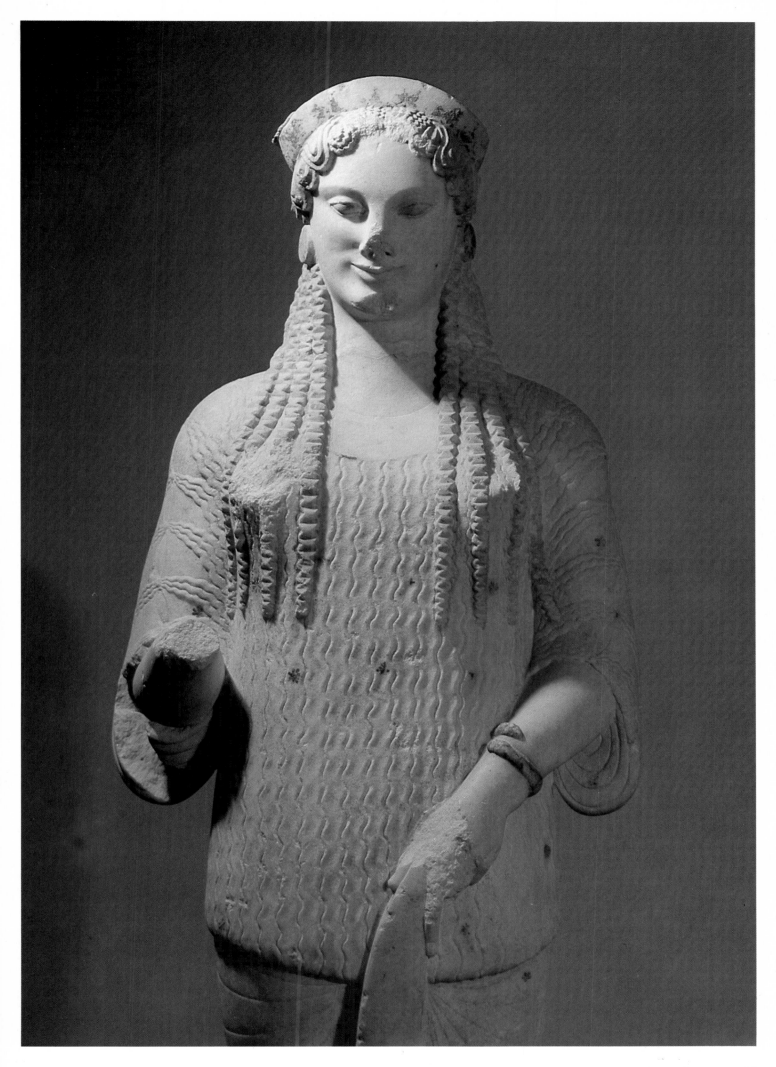

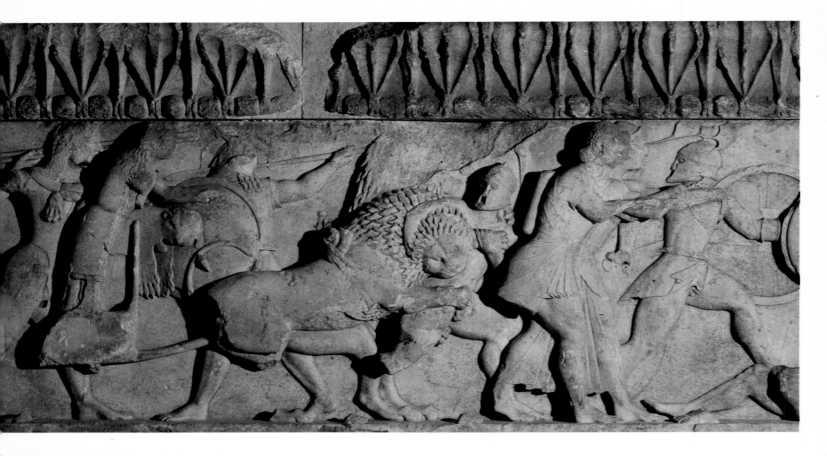

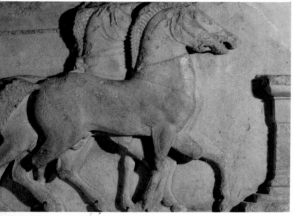

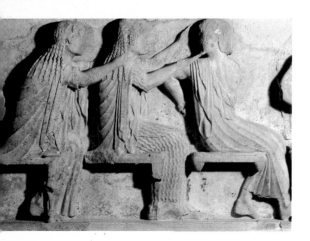

Three details of the frieze ornamenting the Treasury of Siphnos at Delphi, built about 525 B.C. From top to bottom, we see the battle of the gods and giants, with Cybele riding a chariot drawn by a lion; a pair of horses; and the gods watching the Trojan War.

the Saite period (663–525 B.C.), coinciding with the new boom of Greek trade, reinvigorated to a certain extent art forms dating back to the heyday of the Old Kingdom. As strange as it may seem, the earliest Hellenic bronzes obey the rules of age-old Pharaonic statuary: the hairstyle of these figures is typically Egyptian, to say nothing of the pose, with the left leg advanced, the arms stretched down the sides, the fists closed, etc.

The earliest Greek statues were not portraits of specific individuals. The aim of this new art was rather to symbolize godhead by means of idealized and simplified human features often bordering on what we would today call abstract art. It is only surprising to note that, in the seventh century B.C., sculpture, which was destined to play such an important part in classical Greek art and architecture, was actually a minor art. Low reliefs and carving in the round fully developed no earlier than the sixth century.

The Earliest Temples

These statues meant to portray the Greek deities were not left out in the open air. Their first abode was the naos, or cella, built on the model of human dwellings. At the dawn of the archaic period, such structures were hardly distinguishable from small, unpretentious houses. The decoration alone made them stand out.

In the course of time, Greek temples gradually took on the specific appearance now traditionally associated with them. A pronaos, or vestibule, was built at the entrance to the naos and bounded by the pillars of a free-standing portico at the front end of the rectangular structure, often surmounted by a pediment with a triangular tympanum bearing the earliest carved decorations. Later on, a row of columns was added running along the rear end of the building. At the final stage, columns were strung round the whole of the edifice, thus originating the best known Greek formula, illustrated by the so-called peripteral temples.

Like their Egyptian counterparts, Greek temples were basically intended to house the statue of a god and receive offerings. They were not places of assembly. No public mass worship took place within the temples. For this reason, inner space was trifling as compared with the total volume of the edifice. These proportions remained unchanged even at the height of the classical period. The naos of the second temple of Hera at Paestum (Posidonia) does not exceed 3,600 cubic metres (4,680 cubic yards), though the over-all mass of the temple is slightly over 21,000 cubic metres (27,300 cubic yards).

The earliest Greek temples were simple and unpretentious. Walls were of sun-dried bricks, roofs were of wood construction supporting clay tiles, and

columns and uprights were of wood. The Heraeum (temple of Hera) at Olympia, the most ancient Doric temple yet discovered, dating back to the last decades of the seventh century B.C., is a composite, transitional structure. As the original wood columns decayed, they were successively replaced by stone supports. The transition from wood to stone was a process stretching over several hundred years. The stone columns we now see at Olympia date from various periods and differ from one another in shape and proportion.

The wonderful "Basilica", or first temple of Hera at Paestum, dates back to the second third of the sixth century B.C. The entire peristyle can still be seen in a good state of preservation. The temple gives evidence of the experiments made by Greek architects during the archaic period. It is about the only Greek temple which exhibits an odd number of columns in axis. Though the two sides of the peristyle display eighteen columns each, the ends offer only nine. The sturdy Doric column, with its exaggerated entasis and capital in the shape of a flattened loaf, is characteristic of the early stages of Greek architecture. Nonetheless, despite a certain primitiveness, the imposing proportions of the Basilica at Paestum well prove that even the first Greek architects had no less a liking for large-scale undertakings than their more famous followers. The first temple of Hera is 54 m (178 ft) long and 24.5 m (81 ft) wide.

One should not forget that the distinction made between the Doric and Ionic orders, which has so long exercised the minds of European art historians, goes far beyond the established and obvious differences regarding the shape of shafts, capitals, entablatures and ornaments. The Greek Doric column does indeed differ in shape from its Ionic counterpart. It has no base. The massive shaft is customarily treated with twenty flutes, while the very simple capital is characterized by a projecting curved moulding called the echinus, surmounted by a square slab, or abacus. The distinctive feature of the Ionic column is, on the contrary, its spreading scroll-shaped capital. The base is adorned with

Left:
This almond-eyed kore dates from about 500 B.C. Of all the statues of young virgins dedicated to Athena, this is the one which exhibits the most beautiful features. (Acropolis, Athens)

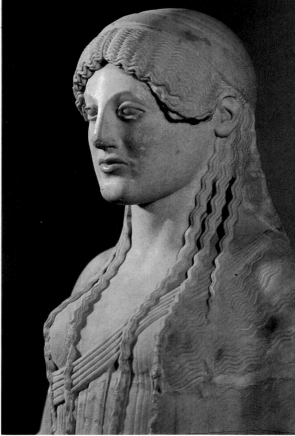

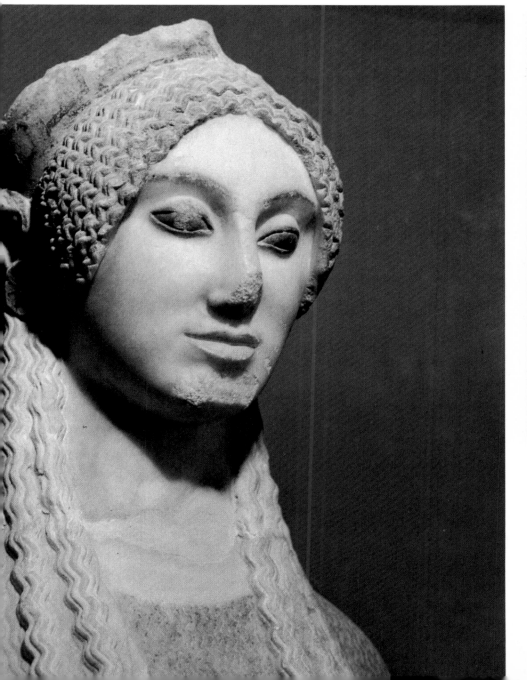

Sometimes called "sulky", this kore dating from about 490 B.C. was discovered in 1882 east of the Parthenon. It is a perfect example of preclassical art. The expression of the face is typical of the "severe style". (Acropolis, Athens)

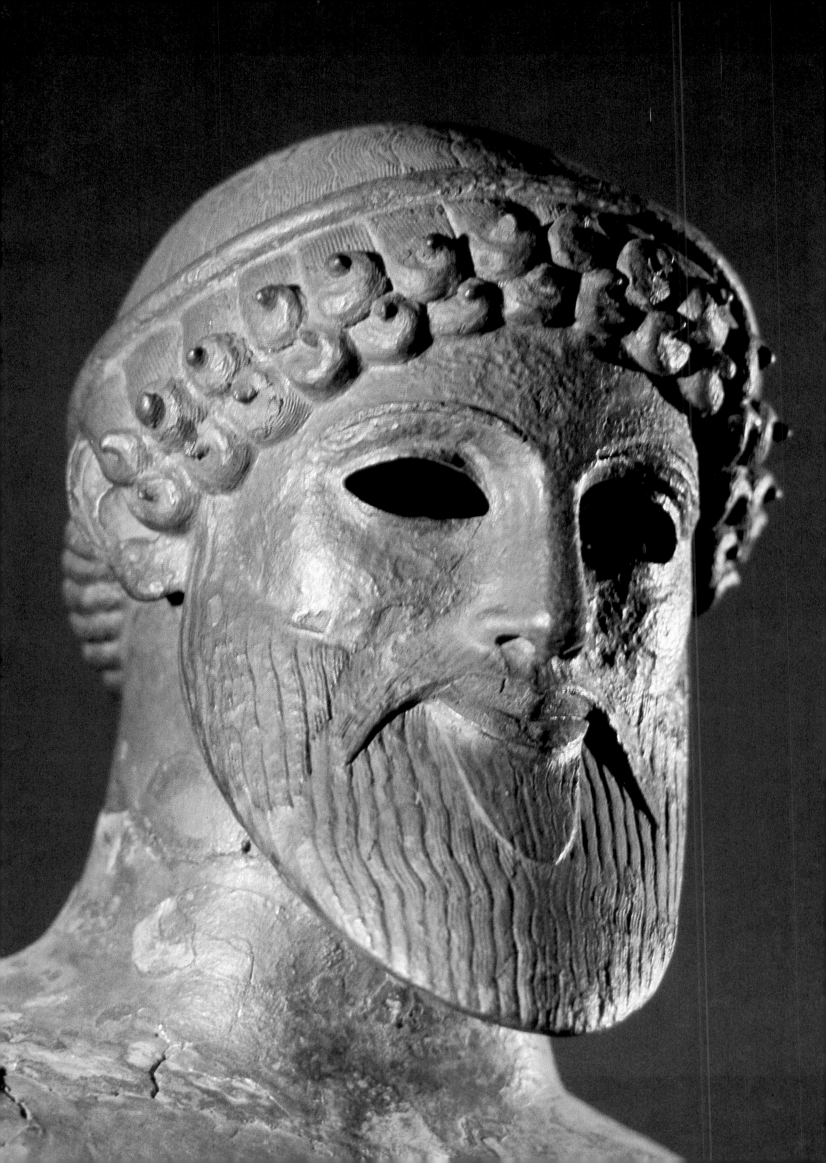

mouldings and the shaft, most often of slender proportion, is carved with twenty-four flutings. In actual fact, the two orders differ chiefly in proportion. The Ionic order is light and airy, whereas Doric columns give an impression of squat and compact strength. The entablature of Doric columns exhibits a frieze ornamented with channeled triglyphs separated by empty square spaces, or metopes. The Ionic order offers an unbroken frieze often adorned with sculpture. The richest Ionic style gives us examples of carved sequences running round an entire building.

Paradoxically, the Ionic style, which originated in Ionia, was almost immediately adopted in Attica and Euboea, homeland of the colonists who left Greece to settle in Asia Minor in the twelfth century B.C. Nonetheless, the most ancient temples discovered both in Attica and in the whole of Magna Graecia obey the rules of the Doric order. These two aesthetic trends were finally united in the fifth century B.C. Some edifices, such as the temple at Bassae for example, actually combine the Doric and Ionic orders.

Facing page:
Detail of the bronze statue of Poseidon found at Livadhostro, near Plataea. The style combines Ionian and Attic features. The copper leaf coating the lips is meant to imitate polychrome decoration. The eyes were originally inlaid. This marvellous work of art dating from 490 B.C. is 118 cm (47 in) high. (National Museum, Athens)

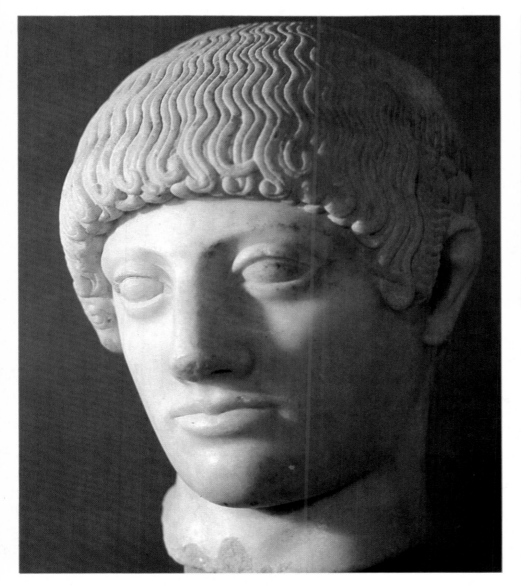

One of the few surviving examples of archaic Greek painting. This clay plaque meant for interior decoration dates from about 510 B.C. It shows an Athenian warrior wearing a crested helmet and armed with spear and shield. (Acropolis, Athens)

Head of the so-called "Fair-haired boy", dating from 485 B.C. The perfect features of this 25 cm (10 in) high fragment are stamped with a dreamily serious expression. (Acropolis, Athens)

The panhellenic sanctuaries at Olympia, Delos and Delphi played a by no means inconsiderable part in the development of Greek religious architecture. By contributing to the unity of Greek national awareness, they were also instrumental in bringing into existence a homogeneous art style. True Greek style as we know it today was indeed the result of a long, slow process in which works of very different origins gradually merged and mingled.

Severe-Style Sculpture

Most of the early Greek carvings which have survived to our times are of marble. We should however not forget that the "idols" raised in the temples were often bronze statues made by cire perdue casting. The bronze Poseidon found at Livadhostro, near Plataea, in Boeotia, is one of the best examples of the severe style which prevailed in Greek sculpture at the turning-point

between the archaic dawn and the classical period. This marvellous masterpiece probably dates from about 500–490 B.C.

A discovery of outstanding importance was made in the course of the large-scale excavations undertaken on the Acropolis at Athens from 1885 to 1891. In a pit near the Erechtheum, archaeologists unearthed a set of fourteen marble statues representing "kores" (young women) dating back to about 530–490 B.C. These statues of pretty maids, dressed in typical Greek cloaks and tunics, are in a very good state of preservation. Vestiges of polychrome decoration can still be seen, though the gilded bronze tiaras they were probably crowned with when they were dedicated to the virgin goddess Athena have not survived. The statues were buried two thousand five hundred years ago, when the Acropolis was laid waste by the Persians.

The severe style can be rightly regarded as the most perfect equilibrium ever achieved by Greek art. The stern poses, rigorous frontality and somewhat stark lack of movement are tempered and softened by the charming features, sweet archaic smiles and magnificent draperies... The purely oval faces with their delicate regular features and well-groomed hair bear witness to the remarkable mastery achieved by sculptors like Antenor, who lived in the last half of the sixth century and is best known for the bronze statues of Harmodius and Aristogiton. The severe style paved the way for the classical period in Greek art.

From Red Ware...

Attic ceramics achieved the height of perfection in the sixth century and the first decades of the fifth century B.C. These originally functional works gave Athenian craftsmen the opportunity of creating an extraordinarily felicitous style and art form. Pottery, which had formerly been a mere handicraft, was thenceforth promoted to the rank of a highly sophisticated art overflowing with expressivity and free from affectation. The Greek vases of this period, turned on the wheel, are famous for symmetry of form, enhanced by the very high quality clay used by the artists. Curves are balanced by perfectly poised counter-curves. Elegant ears and handles set off the gracefulness of these vases remarkable for their unending variety. The diversified purposes served by ceramics gave rise to pieces of all sizes with profiles progressively crystallized round a narrower range of characteristic shapes: two-handled amphorae, large bowls or craters (ornamented with colonnettes or scrolls, calyx- or bell-shaped), water pitchers or hydriae, cups and canthari, perfume jars, aryballae, narrow-necked lecythi, etc.

Though almost no preclassical Greek painting has survived to our times, ceramics enable us to imagine what this lost art was probably like. The bulges of Greek vases and the bottoms of cups were indeed decorated by Attic artists with wonderfully vivid and true-to-life pictorial designs. Concave and convex surfaces alike were brought to life. Even the relatively restrained dimensions furnished by ceramics did not hinder the inspiration of Greek artists who made fun of material obstacles.

The art of pottery, spread throughout the ancient world by Greek

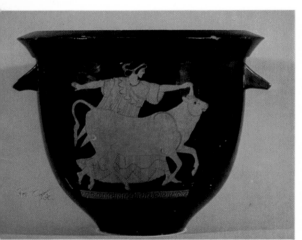

Large Athenian bell-shaped crater. This work dating from about 490 B.C. is an example of black ware. The red figure decoration shows Zeus carrying off Europa. (Tarquinia Museum)

Top:
Attic-style red-figured lecythus, or small perfume vase, dating from 490 B.C. Height: 19.5 cm (7.8 in).

Right:
Attic-style bowl, or skyphos, with Athena's owl. This work dates from about 430 B.C.

Facing page:
Two red-figured cups dating from 510–500 B.C. These works are attributed to artists belonging to the school of the "Nicosthenes painter". Both are 31 cm (12.4 in) in diametre. They show respectively a dionysiac scene (top) and a soldier going off to war (bottom). (Musée d'Art et d'Histoire, Geneva)

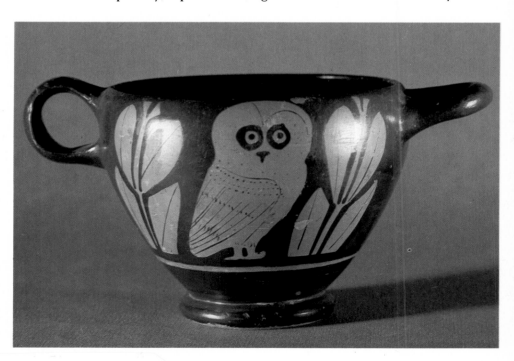

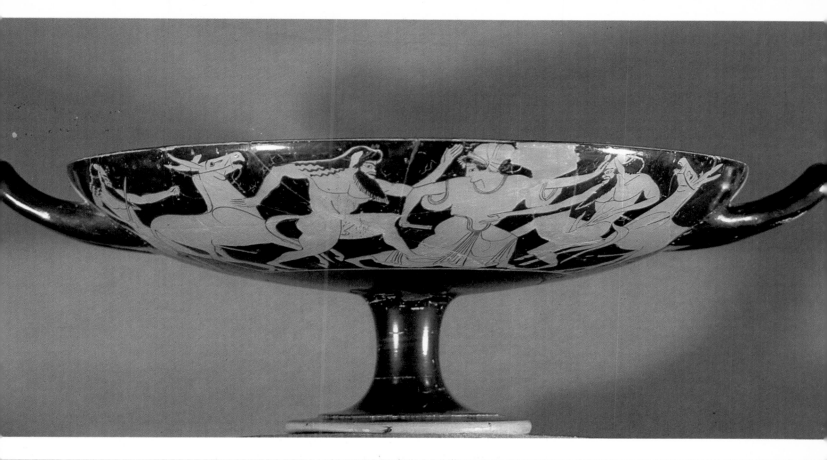
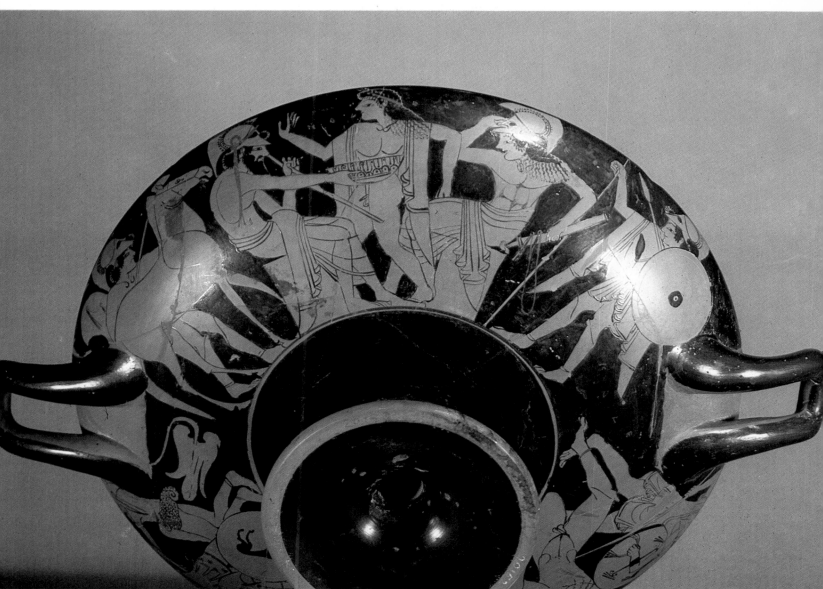

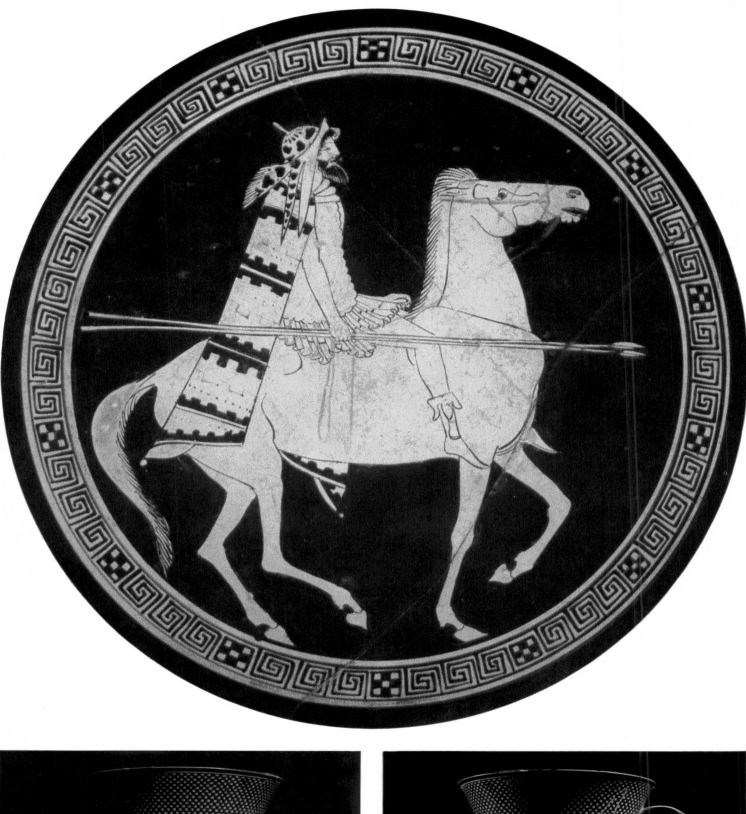

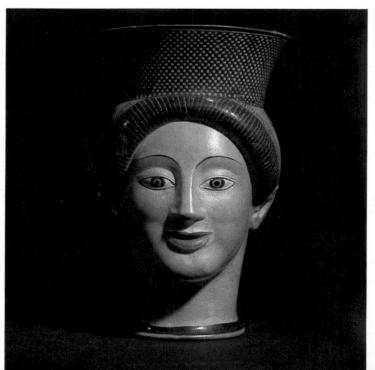

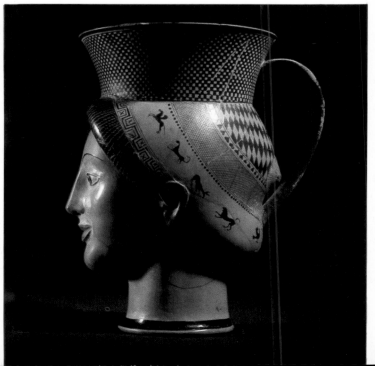

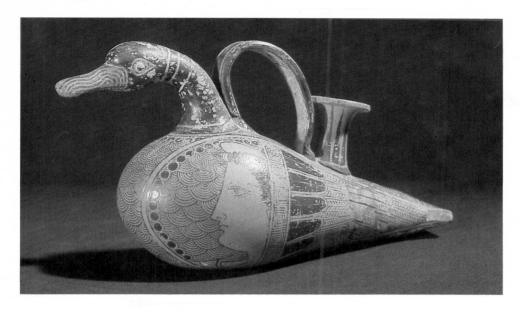

merchants, bears witness to the thriving prosperity of the city of Athens during this period. Some works of particularly high quality bear the signature of the artists who made them. We thus know the names of many potters and painters who were probably extremely famous in ancient times.

The decorating of Greek ceramics involved very complicated and sophisticated techniques which required extraordinary artistic and professional mastery. Most decorations are of an empirical, representational character and bear witness to a remarkable sense of observation. Modern scholars and art historians have scientifically reconstructed the techniques used by Attic potters during the preclassical period. We thus know for example how the black "glaze", in which the figures decorating red ware were painted, was obtained. Artists drew the figures with a colloidal solution of extremely fine clay. When the clay was fired at a temperature of 800° C., the vase took on red tints, due to the formation of colcothar. The so-called reduction process followed. The potter hermetically sealed the kiln and the temperature rose to 950° C. The aim of this operation was to bring about the production of lead monoxide. At that stage, the entire surface of the vase became black. The potter then reopened the chimney of his kiln, the temperature went back down to 875° C. and the fresh oxygen entering the kiln made red colours reappear on all the unglazed surfaces. The non-porous "painted" figures remained black... As we see, the process was extremely difficult, especially considering the fact that the Greeks had not yet invented the thermometre.

... to Black Ware

About 530–520 B.C., Attic ceramists realized that the series of operations we have just described also enabled them to reverse their two main colours. When the ground was black-enameled and the figures showed in red, the result obtained came much closer to true-to-life flesh tints. The red-figured vases produced thanks to this new technique are undeniably among the most perfect creations of Greek potters. They generally express a truly classical will to clearness and legibility which harmoniously complements the over-all proportions of the decorated object so as to produce genuine marvels of poise and beauty.

During the preclassical period, the severe style achieved pinnacles of perfection which were never destined to be surpassed. Monumental compositions were set off by unbelievably delicate and sophisticated detail. Red and white high lights were added to the basic glaze. The use of this white "paint" in treatment of human figures decorating earlier red ware was probably what first made Attic potters hit upon the idea of transposing their two main colours and inventing the so-called red-figure technique. Archaeologists have also brought to light lecythi, perfume jars and white-bottomed cups dating from the fifth century which exhibit black and ochre decoration and touch-ups.

This wonderful art of pottery was short-lived. Greek ceramics, which had achieved perfection during the preclassical period, were already in decay only one century later. As early as 420 B.C., in the middle of the classical period, the art of pottery began to deteriorate, losing much of its former strength. Decoration was progressively exaggerated to such an extent that it became cumbersome, entangled and diffuse. The golden age of Greek ceramics was a thing of the past.

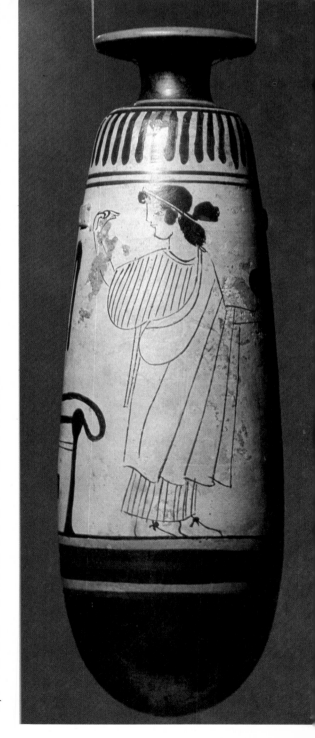

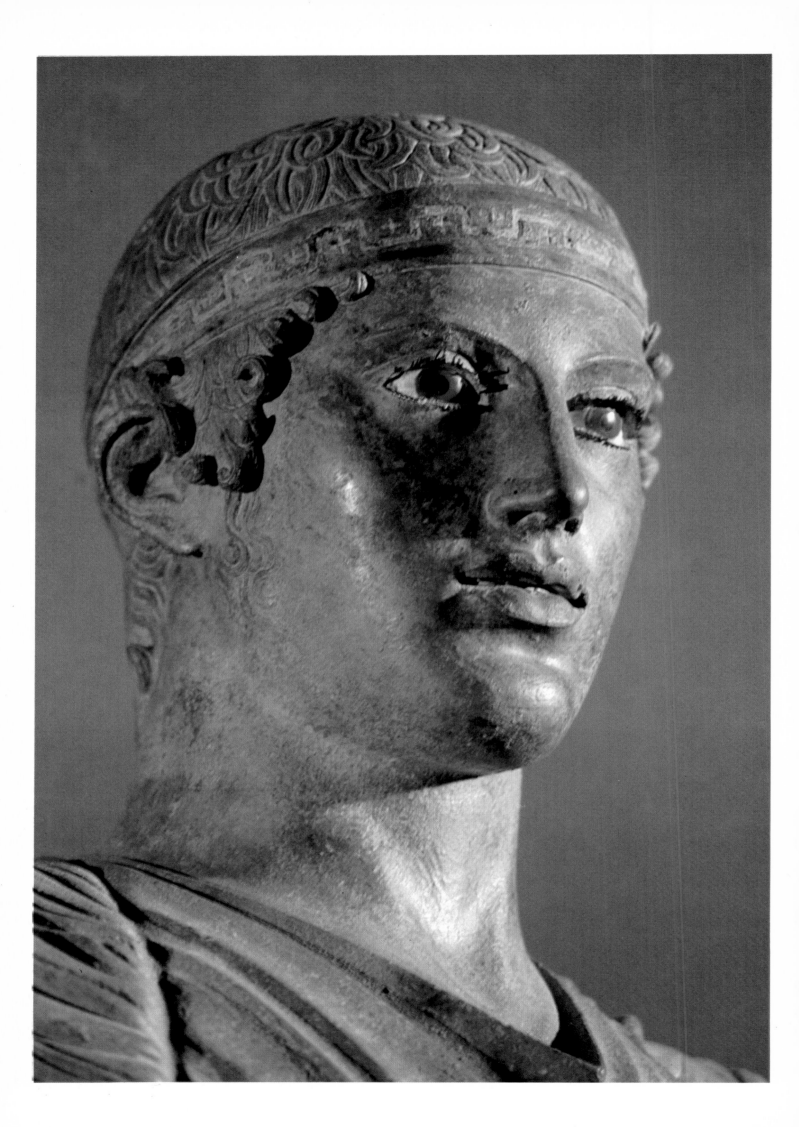

From the Persian Wars to Pericles

The fifth century B.C. undeniably marked the beginning of both the classical period and the democratic system in the city of Athens. At the same time however, the new capital of the Greek world was brought into conflict with the powerful Persian Empire. The Persian Wars led Athens to the brink of ruin. Nonetheless, the naval victories won by the Hellenic fleet enabled the Greeks to stand the test and subsequently expand their own sphere of influence. Pericles brought Athens to the zenith of her glory and classic Greek civilization became an incomparably influential force throughout the ancient world.

The fifth century was indeed one of the most glorious periods mankind has ever experienced. The city of Athens gleamed like a beacon lighting up the whole of the known world. The new Greek democracy was a magnet which drew the best sculptors, the most famous architects and the most wonderful playwrights. During an entire century, Attica, governed by liberal political institutions, built up a genuine maritime empire.

The Democratizing Movement

As far back as the archaic period, Greece, as opposed to modern European countries, was characterized by political dissension and partition. The basic entity was the city, or "polis", a tiny independent and self-governing state which possessed its own army, coined its own money, made its own laws and worshipped its own specific gods. The "polis" comprised a city and the surrounding territory, its inhabitants and their common institutions, government services, religious authorities, military forces and economic resources. In the archipelago, some "poleis" did not exceed a total area of 180 square kilometres (72 sq. mi.), though on the other hand, the Attic political entity surrounding Athens stretched over an area of 2,600 square kilometres (1,040 sq. mi.), and a great inland power like Sparta, with her possessions in Laconia and Messenia, occupied an area of 8,400 square kilometres (3,360 sq. mi.). At first sight, it is not easy to understand how these tiny states, the dimensions of which did not exceed those of many an American county, could be serious enemies for the colossal Asian empires. In addition, the will to supremacy which prompted each and every one of these city-states quite logically led to unending and inextricable conflicts within the boundaries of the Greek world. War between the various "poleis" was more or less endemic. But chronic war also had its corollaries: emulation and particularism.

We have already seen that in Homer's times, the political and economic life of the Greek world was exclusively controlled by an aristocracy whose power was based on the possession of vast estates suited to the breeding of war-horses. As new forces arose and came into the foreground, this minority made up of important ground landlords with absolute power over the whole country was progressively forced to give up some of its prerogatives. The transformation undergone by Greek society and political organization was largely due to the continuing evolution of military techniques; war was a prime mover. Greek armies, formerly made up exclusively of heavily armed horsemen, were expanded so as to include foot soldiers, or "hoplites". The result was the formation of a new class of citizens capable of asserting their rights. They demanded reforms guaranteed by a code of laws.

The bronze charioteer found at Delphi is one of the most famous statues of ancient times. Dedicated by Polyzalos, tyrant of Gela in Sicily, it was originally part of a group commemorating the Pythian Games of 478 and 474 B.C. This work 180 cm (72 in) high was perhaps executed by an artist from Magna Graecia.

Facing page:
Detail of the bronze charioteer found at Delphi. The head-band is a symbol of victory. One should pay special attention to the long-lashed eyes inlaid with glass and coloured stones.

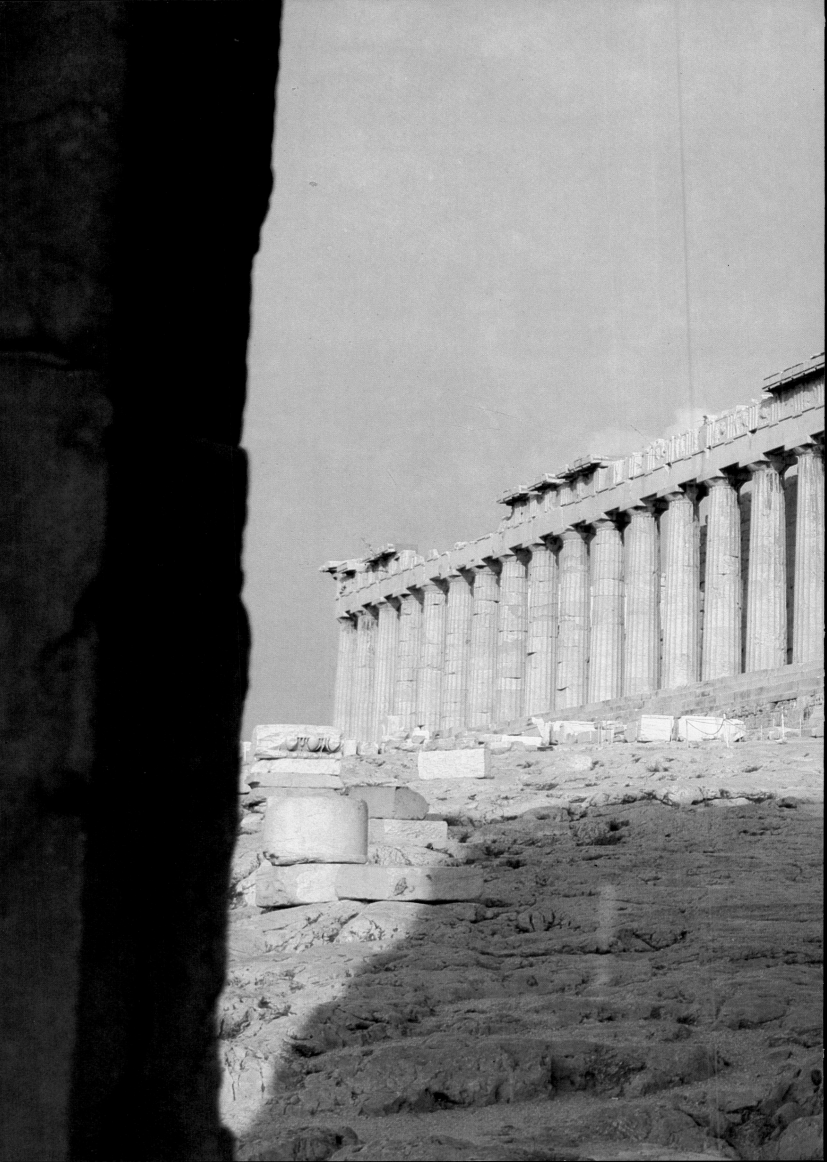

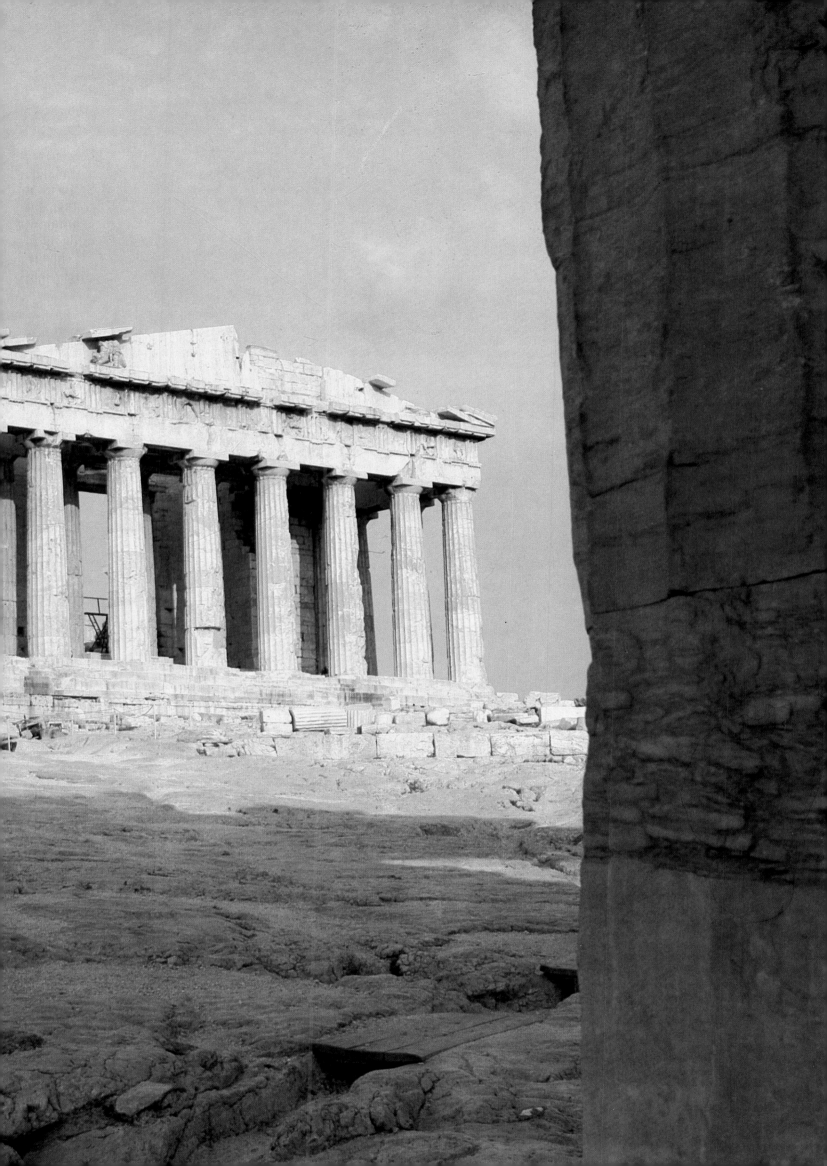

Overleaf (56-57):
The Parthenon, or temple of Athena, on the Acropolis at Athens, viewed from the threshold of the Propylaea. Built from 447 to 432 B.C. by the architects Ictinus and Callicrates, with the help of the sculptor Phidias, the shrine sacred to Athena Parthenos displays eight columns in antis and seventeen at the sides.

The Athenian legislator Draco was entrusted with the task of drafting a system of laws which took the place of private vendettas. Solon completed the work begun by this first reformer. He annulled all mortgages and debts to the relief of the poor peasants who by the end of the seventh century were virtually owned by the nobles. Solon, who lived from about 639 to about 559 B.C., then opened the Athenian assembly, or ecclesia, to all freemen. He divided the citizens into four classes according to income and fixed the taxes accordingly. He gave an assembly of four hundred, or boule, to the upper three property classes, as a check on the popular assembly and on the archons, or principal officers of state. Archons who were found guiltless of maladministration became automatically members of the Areopagus, or prime council of Athens. The Areopagus, which combined judicial and legislative functions, represented the stronghold of aristocracy in the fifth and sixth centuries. As a check on this aristocratic institution, Solon allowed the citizens to have juries to act as courts of last instance.

Members of the upper classes alone were allowed to accede to high state office. A new reform soon became necessary, broadening the prerogatives of the popular assembly and the council and opening office to all Athenians regardless of birth. The art of war once again gave rise to circumstances favourable to thorough reform. Greek phalanx formations were made up of hoplites who had to furnish their own helmets, breast-plates, greaves, shields, spears and swords, but the creating of important naval forces brought into

The "pensive" Athena, wearing a crested helmet and leaning on her spear. This classical stele dating from 460 B.C. portrays the goddess as patroness of the Panathenaic Games. (Acropolis, Athens)

Northern colonnade in the Parthenon at Athens. One should notice the strained echinus of the Doric columns.

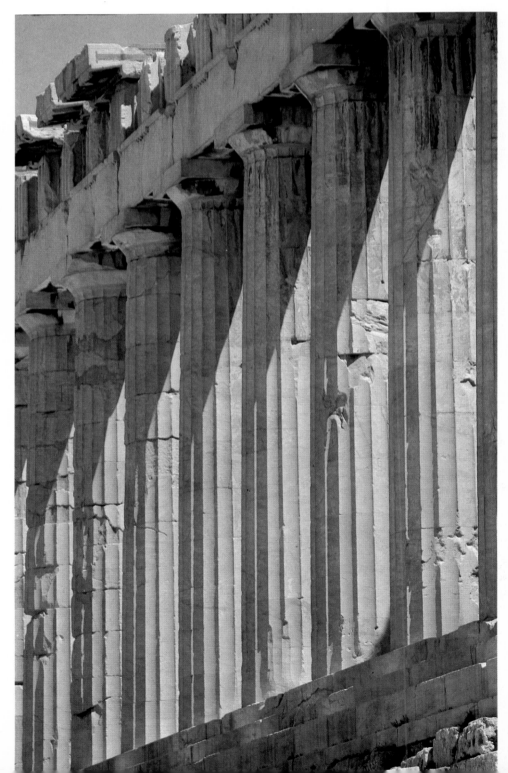

58

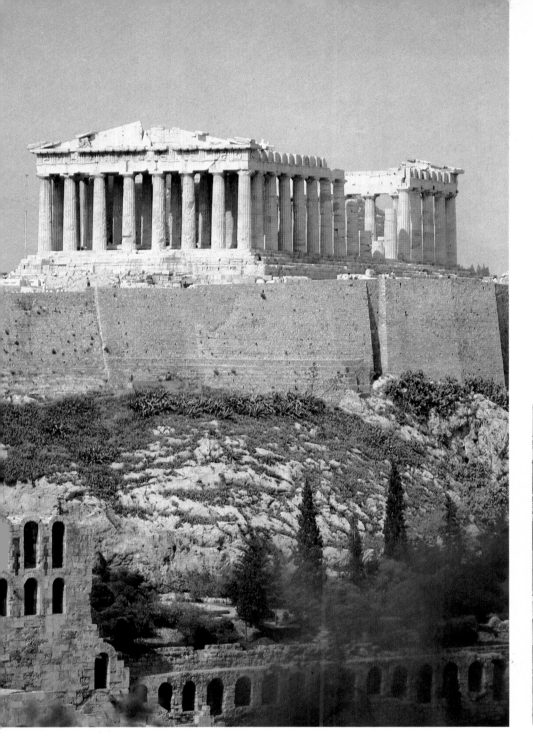

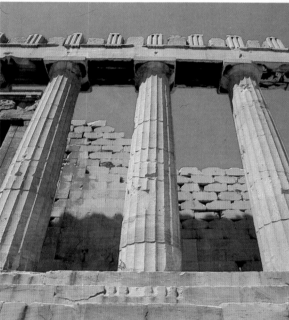

This view of the Parthenon crowning the Acropolis at Athens, with the Odeum of Herodes Atticus in the foreground, enables us to appreciate the subtle proportionings and optical refinements of this mighty temple built on the brink of an abyss.

existence a new class of oarsmen who needed no equipment at all. Thenceforth, even the poorest citizens could put forth their strength in defence of their city, and they did indeed play an outstanding part in the struggle for the independence of the Greek city-states. The building of fleets made up of swift galleys, or triremes, each of which was manned by some 180 oarsmen, was thus an event followed by significant political repercussions. These new circumstances were instrumental in the perfecting of the democratic system initiated by Solon. At the same time, they gave birth to a genuine maritime empire ratified by the Delian League in 478 B.C.

The Tyrants

In the course of this extremely simplified outline, we have passed over the very significant part played by the tyrants—however paradoxical that may seem—in the advent of democracy. The tyrants were political adventurers who seized power and arbitrarily assumed dictatorial authority, and such take-overs were extremely prejudicial to the interests of the aristocratic oligarchy which controlled Greek life up to the end of the seventh century. The tyrants could not have carried out their coups d'état without the support of the working masses excluded from the management of public affairs because they owned no land. To be sure, the cities founded by colonists in Asia Minor and Magna Graecia had encouraged the rise of tyrants from the very outset. It was not the

Ground angle view of the Parthenon's southern colonnade. In the background, we can see part of the wall of the naos.

59

same in Hellas proper, where just about every tyrant who came to power modified the existing constitution of the various cities in favour of a primitive "socialization" which opened public office to all freemen. The dictators' absolute power often enabled them to take useful steps conducive to the progress of democracy. Tyrants were instrumental in developing naval power, undertaking public works, drawing up the first urban development plans, promoting literature and the arts.

Pisistratus is a particularly good example of such an "enlightened" tyrant. He seized power by a coup d'état in 560 B.C. with the support of the common people whose cause he espoused and, though twice in exile, he had so established himself by his death in 527 B.C. that he left Athens in the hands of his two sons, Hippias and Hipparchus, who ruled until 514. Pisistratus, who promoted the development of a powerful middle class and freed small holders from the yoke of the aristocracy, largely contributed to the birth of democracy.

Athenian democracy was based on a system in which officers of state, judges, jurymen and councillors, were selected by ballot, so as to give all citizens equal opportunities. Nonetheless, a minority alone profited by this system. Women, foreigners (all men, even Greek, not born in the city) and the countless slaves were excluded from public office which could be held by citizens alone. In Pericles' times, Athens had an estimated population of 300,000. Out of this

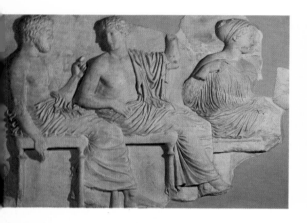

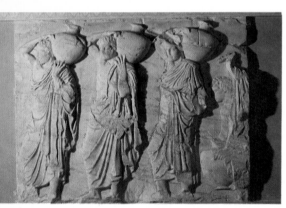

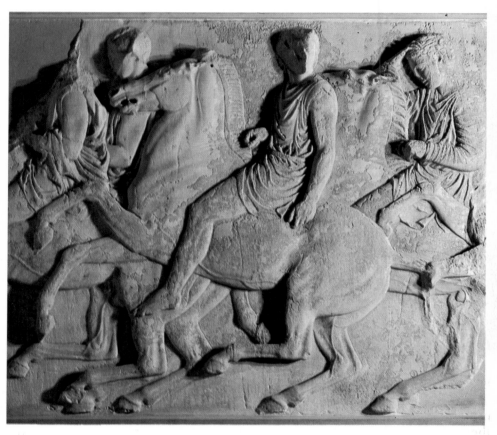

Three details of the Panathenaic frieze adorning the Parthenon. Above, we see Poseidon, Apollo and Artemis, probably carved by Alcamenes, one of Phidias' assistants. The other views show three young men carrying water-pitchers and parading horsemen.

Facing page:
Northwest corner of the Parthenon. One should notice the exquisitely adjusted Doric columns, here closer set. One can also make out the triglyphs and metopes ornamenting the entablature, as well as a lion-headed waterspout in the upper corner.

total, only 30,000 citizens were allowed to take part in political life. And the most important offices remained the stronghold of the upper property classes, since political responsibility, regarded as an honour, was not paid. Only the wealthiest citizens could afford to devote all their time to public affairs. The Athenian democracy thus contained important oligarchic elements. Its founding principle was nonetheless diametrically opposed to the system governing the kingdoms and empires of Asia.

The Persian Threat

The rivalry destined to confront Greeks and Persians in a struggle to the death began taking shape as early as the mid-sixth century B.C., when Cyrus completed his conquest of Asia Minor in 540. About the same time, the Greek cities on the shore of the Aegean had been bent under the yoke of Croesus, king of Lidya, who had succeeded in bringing the entire region into subjection. King Croesus then attacked Cyrus, but he was overestimating his strength. Losing his own kingdom and its legendary riches, he also brough about the fall of Ionia, Caria and Lycia.

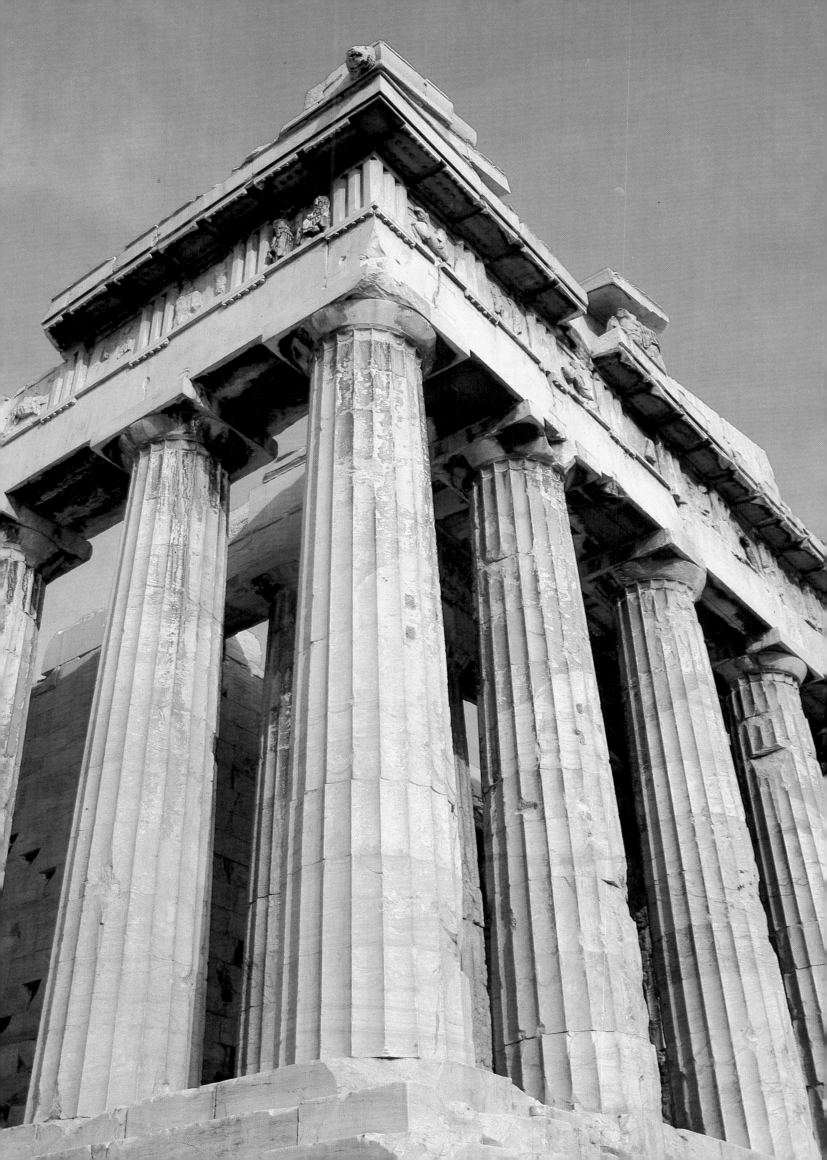

The Ionian city-states revolted against Persian rule in 499 with the symbolic support of Athens. Darius I crushed the rebellion, subduing and destroying a whole series of Greek cities on the Asia Minor coast. The particularly severe punishment inflicted on the city of Miletus marked the end of the revolt and the restoration of Persian supremacy. Darius determined to add Greece to his vast empire. In 492 B.C., a Persian expedition conquered Thrace and Macedon.

In 490, a second expedition set out from Persia, bent on punishing Athens for the help given the rebellious Ionian cities. An army of 20,000 men encamped on the coastal plain near Marathon where it was attacked by the Athenian army of 10,000 men, with the help of 1,000 hoplites from the little city of Plataea. Though expected reinforcements from Sparta came too late, the Persians were decisively defeated by the outnumbered Greeks, thanks to the courage and skill of the Athenian general, Miltiades. The Persian commander re-embarked and did not continue the war.

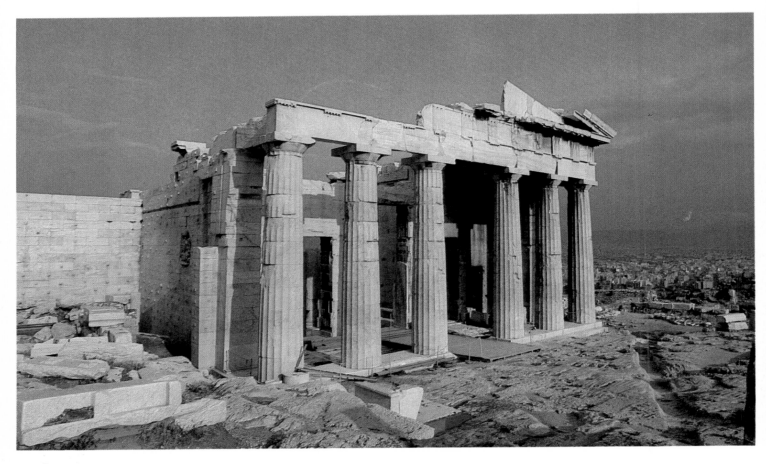

Eastern façade of the Propylaea at sunrise. The Sacred Way leads through this monumental entrance gate to the Acropolis at Athens, built between 437 and 432 B.C.

Top:
Doric columns of Mnesicles' Propylaea standing out against the blue sky.

In spite of their victory, the first Persian expedition against Athens was a warning to the Greeks. Themistocles, archon and strategus, persuaded the Athenians to strengthen their navy. Preparing for further hostilities, he built a new port at Piraeus which thus replaced Phalerum, and decided to fit out 300 triremes. He assigned to this purpose the revenue from the newly prospected silver mines at Laurium. Athens then began minting the famous silver coins bearing the image of an owl, symbol of Athena, which were destined to become the basic currency of the whole of the ancient world. The triremes equipped by Themistocles were galley-type warships decked fore and aft which fought by ramming.

Darius the Great died before he could take vengeance for the Persian defeat at Marathon. His preparations for a second expedition were continued by Xerxes, his son and successor. For three years, he prepared for the new invasion of Greece by cutting a canal through the isthmus of Mount Athos and constructing a bridge of boats across the Hellespont. In the meantime, the Greek city-states, prompted by Themistocles' foresight, were settling internal conflicts and paving the way for an alliance.

Athens and Sparta joined forces in a providential alliance setting two tiny city-states against an enormous empire stretching from the Aegean Sea to the river Indus (over 4,000 kilometres-2,400 miles from west to east), from the Aral Sea to the Persian Gulf and from the Black Sea to Upper Egypt. A democracy of artists in alliance with an aristocracy of soldiers whose total forces hardly exceeded 100,000 citizens thus challenged a world empire with a

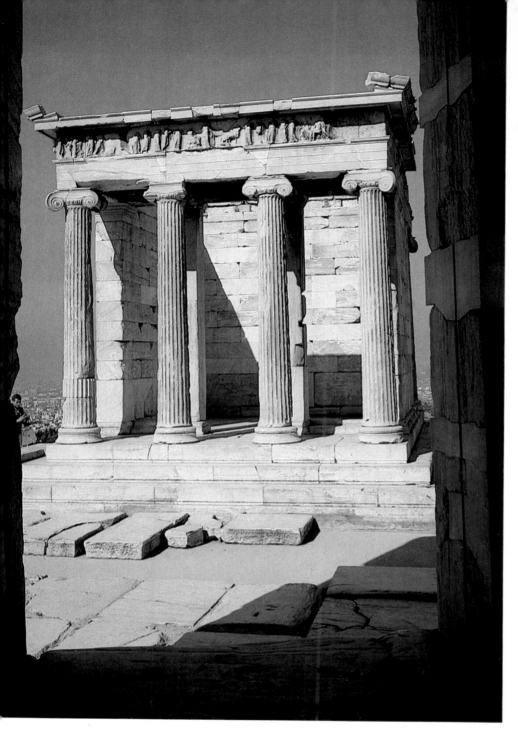

The small Ionic temple of Nike Apteros at Athens was built in 425 B.C. by the architect Callicrates. The frieze illustrates scenes from the Persian Wars.

Red-figured vase, 26 cm (10.4 in) high, showing Oedipus and the Sphinx. The handling of human subjects recalls the style of the "Pasithea painter". This work dates from about 440 B.C. (Musée d'Art et d'Histoire, Geneva)

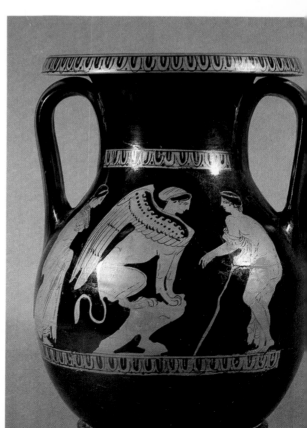

population of several million, uniting Asia Minor and Phoenicia, Egypt, Armenia and Assyria, Babylonia, Media and Parthia, Persis, Bactria and Sogdiana. The impending war was destined to be an uneven contest between an absolute ruler, governing through the agency of satraps in Susa, Persepolis and Ecbatana, on one side, and two cities prompted by an incoercible spirit of independence, on the other.

From Thermopylae to Salamis

The second Persian War began in 480 B.C. According to Herodotus, Xerxes' host included 1,700,000 soldiers on land, as well as 1,200 triremes and 3,000 other vessels. The first battle was a defeat for the Greeks, though the small army commanded by Leonidas, king of Sparta, succeeded in defending the pass of Thermopylae for three days, before being treacherously attacked from behind. Leonidas and his men died fighting in the pass and the Persians continued their advance. A naval battle at Artemisium was indecisive. The Athenians made little effort to defend their city, which was taken by the Persians, plundered and burned to the ground. The Greek fleet of 378 ships then sailed to Salamis where a decisive battle was waged. The Persian fleet was defeated, to the consternation of Xerxes. The Persian land army under Mardonius was defeated at Plataea a few months later, and a Greek naval victory at Mycale (Samos) on the same day ended all danger from further Persian invasions. The Ionians rebelled once again, throwing off the Persian yoke.

Facing page, left and bottom:
The marvellous bronze Poseidon found in the sea in 1928 north of Euboea is attributed to the sculptor Calamis. It is over two metres (7 ft) high and portrays the god brandishing his trident. The eyes were originally inlaid. The statue dates from about 460 B.C.

The war ended by total victory for the Greeks. Their land had however been bled white. Athens was in ruins. The city's destroyed temples had to be raised again. The town walls were soon rebuilt by Themistocles, the architect of the Greek victory. In 478, an alliance known as the Delian League was concluded between Athens and a number of Ionian states. Athens thus became the capital of a mighty maritime empire wealthy enough to erect new magnificent temples on the Acropolis under the guidance of an extraordinary statesman: Pericles.

Pericles' Programme

The rebuilding of the Acropolis by Pericles began thirty years after the Greek victory at Mycale and the founding of the Delian League. In the meantime,

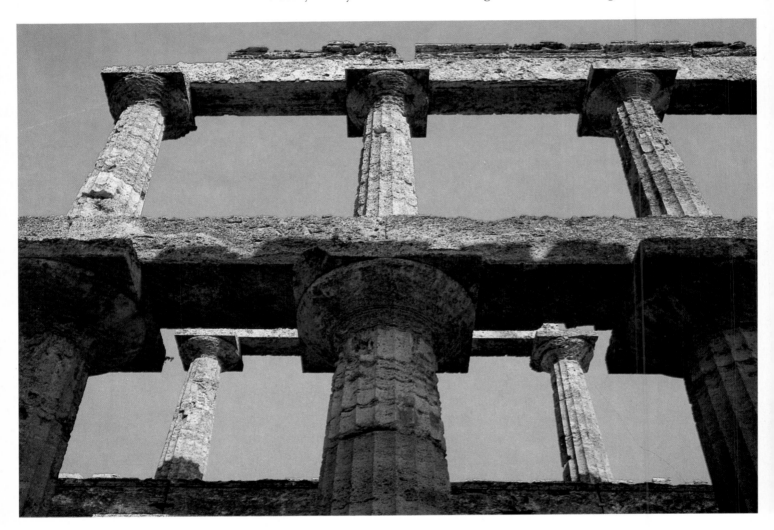

Inner colonnade in the second temple of Hera at Paestum, built about 440 B.C. This classical edifice, sometimes called the "temple of Poseidon", is 60 m (198 ft) long and 24 m (79 ft) wide. The structures supporting the roof timbers are still in position.

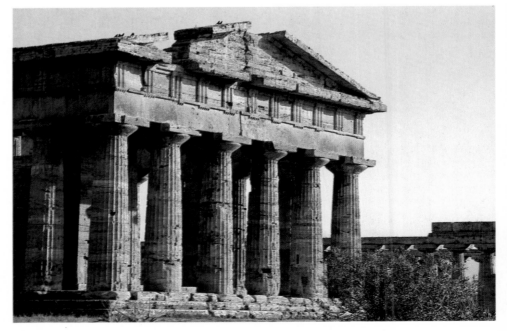

Hexastyle façade of the temple of Poseidon at Paestum. The mighty shafts of the peristyle are crowned by a rather heavy entablature.

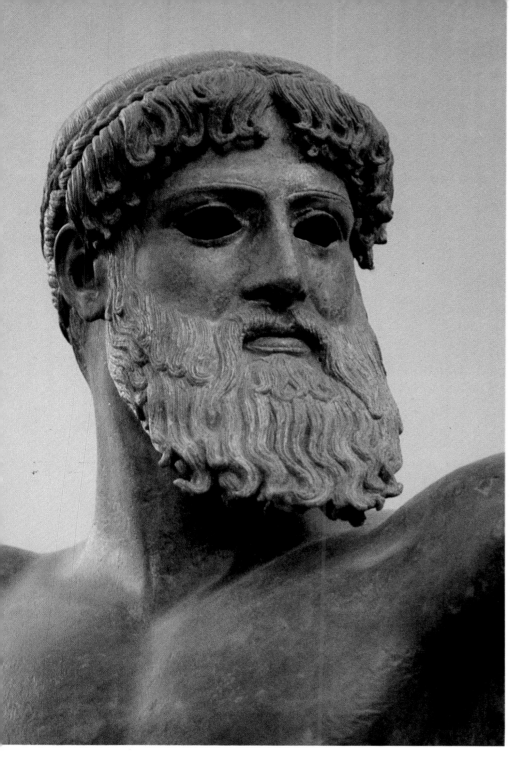

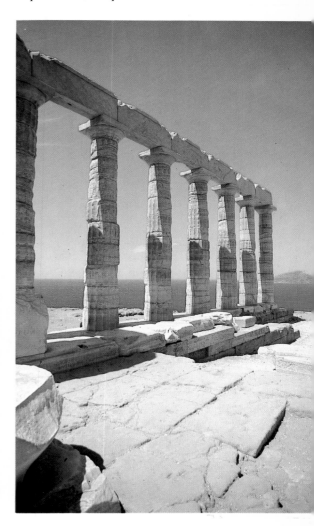

Colonnade in the temple of Poseidon on Cape Sunion, completed in 449 B.C.

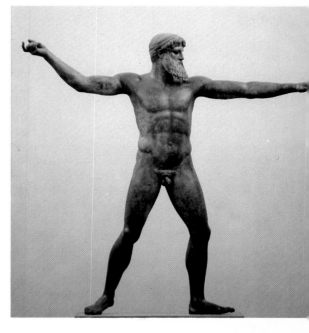

Themistocles used materials from the ruined temples in order to partially rebuild the northern wall of the Acropolis. He also ordered the hasty rebuilding of the naos of the ancient temple of Athena in order to house the collection of sacred ornaments. In 465 B.C., Cimon, son of Miltiades, assumed political leadership in Athens and rebuilt the southern wall of the Acropolis. In 450, Phidias dedicated his warlike Athena (Athena Promachos), a colossal bronze statue some 10 m (33 ft) high, standing in the open air at the entrance to the plateau in front of the ruins of the old temple of Athena which, unlike the Parthenon, built on the southern edge of the Acropolis, rose up in the very centre of the esplanade.

Pericles came to power in 446 B.C. thanks to an alliance with the common people. One of his first aims was to put the Athenian craftsmen to work and embellish the city which had become the capital of a mighty maritime confederation. There was no lack of work to be done. The whole city had been sacked by the Persians. The most urgent task was however the rebuilding of the temples crowning the summit of the Acropolis.

In Greek, the word acropolis means the "high point of the city", i.e. the elevated, fortified district, or citadel. The Acropolis at Athens in particular was a marvellous natural fortress. It was a hill about 100 m (330 ft) high, with a flat oval top running from west to east, about 300 m (1,150 ft) long and 130 m (500 ft) wide. The boundaries were formed by spectacular steep cliffs which were recut in places and reinforced with walls. The rocky plateau itself was artificial-

ly levelled by the Athenians. The Acropolis at Athens bears traces of human settlement dating back to the Neolithic Age. The earliest Hellenic settlers turned it into a fortress, surrounding the hilltop with Mycenaean-type Cyclopean defensive walls. During the preclassical period, military purposes were pushed into the background and the Acropolis was adorned with some of the world's greatest architectural and sculptural monuments.

One of Pericles' first undertakings was to wholly recreate the tiara of temples crowning the Acropolis. He commissioned Phidias to draw up the over-all plan. The first monument erected was an imposing sanctuary dedicated to the city's patroness, Athena, a virgin goddess believed to have sprung from the forehead of Zeus after he swallowed her mother, Metis. Athena was called Parthenos, the "virgin", and her new temple was therefore christened the Parthenon, or virgin's chamber. Pericles then rebuilt the monumental Propylaea at the west end of the Acropolis, at the top of the winding path, or Sacred Way, leading to the upper level. Near the Propylaea, to the southwest, like an advanced bastion poised on the brink of the abyss, was the small temple of Athena Nike or Nike Apteros (Wingless Victory). To the north of the Parthenon was the majestic Erechtheum, with its portico supported by a row of caryatids. All of these edifices have survived to our times. During the classical period, many other temples and an ancient palace were crowded on the slopes and esplanade of the Acropolis. One should mention in particular the theatre of Dionysus, the statue of Athena Eirene and the Chalcotece (storehouse of bronze implements and arms) on the southern slope. The statue and altar of Zeus Polieus adorned the northern slope.

The lay-out's originality lies in the open and well-balanced solution adopted. Instead of placing the colossal mass of the Parthenon in the middle of the esplanade, on the site formerly occupied by the old temple of Athena, Phidias chose to erect the temple on the very edge of the southern slope, overlooking the abyss. The structure can thus be seen from the plain below, as can the less massive Erechtheum on the northern side of the Acropolis. This formula was the result of both an aesthetic purpose and existing cultural con-

Right:
Main façade of the "Temple of Concord" at Agrigentum. This Doric edifice was built about 430 B.C. Along with the temple at Segesta, it is one of the last peripteral Doric structures erected in Magna Graecia. The stylobate is 17 m (56 ft) wide and 40 m (132 ft) long.

Inner gallery behind the colonnade of the "Temple of Concord" at Agrigentum.

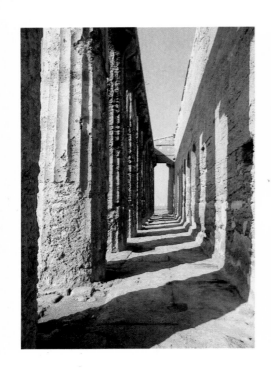

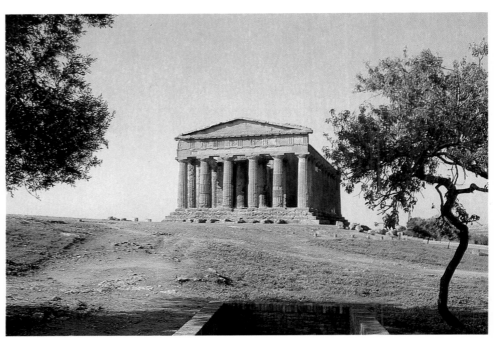

straints, since the naos of the ancient temple of Athena, rebuilt by Themistocles, could not be pulled down before the new Parthenon was consecrated. The Panathenaic procession, held every fourth year in homage to Athena, took place in the vast empty space between the Parthenon and the Erechtheum.

The Parthenon

Ictinus and Callicrates were the architects of the Parthenon. The temple was commenced about 447 B.C. and was practically finished in 432 B.C. The body of the building is about 70 m (230 ft) long and 30 m (99 ft) wide. At its highest point, the pediment probably reached a height of 17 m (56 ft). The Parthenon is a peripteral Doric temple with eight columns at each end instead of the usual six (though we should not forget either that the archaic "Basilica" at Paestum

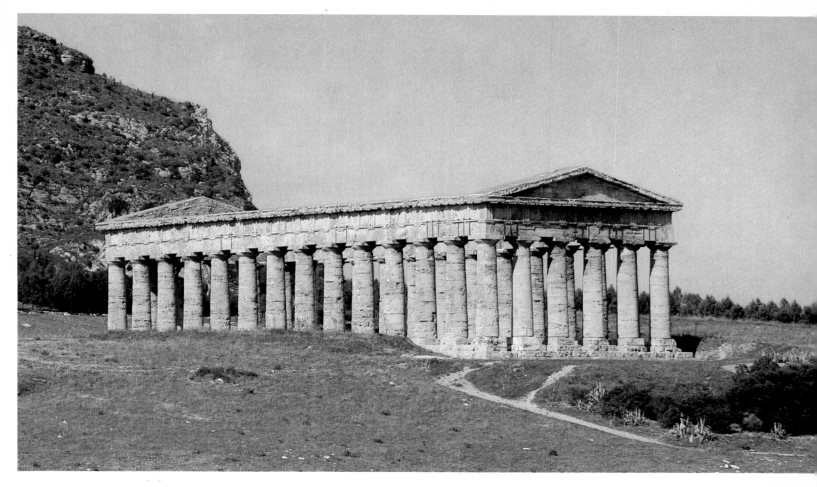

has nine!), and seventeen at the sides. These enlarged proportions promoted over-all symmetry. At front and rear, coming behind the outer colonnade, were two porticoes, known as the pronaos and the opisthodomos. Each comprised six columns of slender proportion, out of alignment with the forty-six sturdy Doric shafts which made up the outer peristyle. At the corners, the columns are slightly wider and closer set, in accordance with subtle optical refinements rediscovered by a British archaeologist, F. C. Penrose, in the mid-nineteenth century. The temple stands upon a stylobate three steps high which shows the same convex curves as the entablatures surmounting the columns. The body of the building gives an over-all impression of perfectly harmonious proportion.

The cella of the Parthenon, 50 m (165 ft) long and 22 m (73 ft) wide, was much larger than in most classical Greek temples. Behind it, the Parthenon

The Hephaesteum—temple of Hephaestus, god of fire, goldsmiths and potters—was built at Athens by order of Pericles about 449–444 B.C. It is customarily called the "Theseum", on account of the decorative sculpture. It is a classical Doric temple situated on the edge of the Agora. Behind the hexastyle façade, the entrance to the loggia is flanked by two imbedded columns.

Attic stele dating from the late fifth century B.C. The deceased is seated. A servant is offering him an unguent box, or pyxis. Though an ancient law forbad the decoration of gravestones, Athenian sculptors under Pericles often added figurative ornaments to the traditional inscriptions. (National Museum, Athens)

proper, or virgin's chamber, was entered by a large western doorway. Four Ionic columns supported the ceiling of the west chamber which apparently served as treasury. Within the cella, or east chamber, opposite from the Propylaea, a Doric colonnade two tiers high supported the roof timbers and divided the space into a lofty central nave bounded by an aisle on three sides. Athena's statue by Phidias, about 11 m (36 ft) high, stood at the west end of this nave which was destroyed by the explosion of a Turkish powder magazine in 1687 in the Venetian attack on Athens.

The upper part of the cella walls, along with the marble friezes above the porticoes formed a continuous band of sculpture round the building. About two thirds of this nobly carved Panathenaic frieze, representing the procession held on the Acropolis every four years, are still in existence. In addition, the metopes in the frieze surmounting the outer colonnade were actually panels of sculpture in high relief representing battles between gods and giants, Athenians and Amazons, Centaurs and Lapithae. All of these carved ornaments were originally stuccoed and painted. Bright red and blue high lights set off the white Pentelic marble which we cannot help admiring though, in actual fact, it was not meant to be seen.

Pericles assigned the revenue from the silver mines at Laurium to the building of this magnificent and costly monument which has made the city of Athens forever glorious. The mines at Laurium were the seamy side of Athenian democracy. Some 20,000 slaves toiled there under savage conditions resembling a genuine concentration camp. At the same time, the Delian League became under Pericles an efficient instrument of Athenian despotic imperialism. The city of Athens was thus enriched and embellished at her allies' expense.

Shortly before the Parthenon was finished, Pericles commissioned the architect Mnesicles to rebuild the Propylaea which had first been erected by

Pisistratus in the sixth century B.C. but had not survived the taking of the city by the Persians in 480. Work began in 437, but the structure was left unfinished in 432, on the eve of the Peloponnesian War. The Propylaea at Athens were basically a roofed passage terminated by a row of columns at each end designed to form a monumental entrance to the Acropolis and its sacred enclosure. They presented Mnesicles with serious technical problems on account of the sloping ground. The west end of the structure is indeed meant to be seen only from a low angle, at the top of a steep slope climbed by a winding path, while the east end is designed to be beheld on a level.

The over-all style has much in common with the Parthenon. The Propylaea exhibit six graceful Doric columns supporting a pediment at each end. The vestibule was originally divided in two. Five bronze doors at the west end made it possible to seal up the Acropolis.

The small temple of Athena Nike, wrongly called Nike Apteros (Wingless Victory), was built on an advanced bastion on the edge of the cliff to the southwest of the Parthenon. This extraordinarily light and airy Ionic structure was erected in 425 B.C. by the architect Callicrates. Rows of four columns surmounted by a frieze representing episodes from the Persian Wars lead on either side to a tiny cella 4.2 m (14 ft) long and 3.8 m (12 ½ ft) wide.

The Erechtheum is another fine example of Ionic religious architecture. Its construction took place between about 421 and 406 B.C. The Erechtheum was a multi-purpose temple, containing sanctuaries to Athena Polias, Poseidon and Erechtheus, son of Hephaestus and Gaea. The plan is somewhat unusual and irregular, owing to the location upon a sloping site and the requirements of the various shrines. The southern portico, known as the Porch of the Caryatids, is the temple's most striking feature, though porticoes also project on the east and north sides of the building.

Bottom:
Side-view of the Theseum at Athens, with exquisite light effects.

Votive stele showing a naked athlete putting on the crown of victory. This classical high relief dates from 450 B.C. (National Museum, Athens)

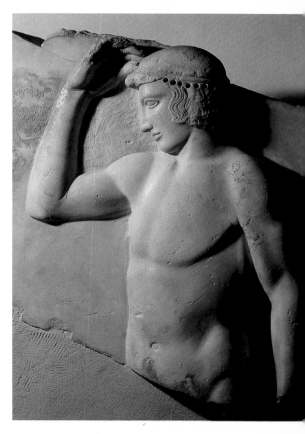

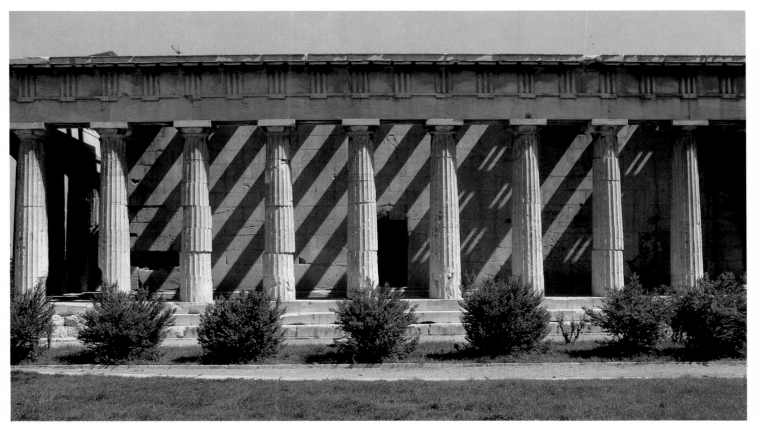

A Tragic Age

In spite of the splendour and glory which crowned the artistic achievements of the Greek classical period, the destiny of the cities and men who created them was tragic. Greek history was sullied during this period by civil wars, jealousy and hatred towards the wisest, most brilliant and most famous men. The introduction of ostracism, an ancient Athenian method of exiling a person, in 488, after the fall of the family of Pisistratus, was originally aimed against tyrants and powerful landowners. But it soon led to many cases of rank injustice. Democracy was mistaken for "mediocracy". All those who outshadowed their fellow-citizens were unmercifully punished. Themistocles himself, who had led Greece to victory against Xerxes, was accused of treason and compelled to take refuge, in 472, at the court of the king of Persia. In 461, Cimon, who had defeated the Persian sea and land forces up the Eurymedon, was ostracized. In 443, the Athenian statesman and historian Thucydides, was sent into exile. The list is very long. Even the famous sculptor Phidias, accused of sacrilege and embezzlement, left Athens and did some of his best work in the temple at Olympia. In 406, during the Peloponnesian War, the Athenians sentenced their ablest naval commanders to death in spite of the victory they had just won over the Spartans at Arginusae. The limit was reached in 399 B.C., when Socrates was brought to trial for corrupting the youth and condemned to drink the poison hemlock.

"Polemos" : War

The classical period was actually an age of conflict, war and public disturbances. Real and true Greece had little or nothing in common with the picture painted by bucolic poets who show us nymphs and gods mingling with wise, beautiful and peace-loving human beings. On the contrary, the classical period witnessed an all-out, desperate struggle for hegemony in Greece. The Peloponnesian War, which ravaged the country from 431 to 404 B.C., set the whole of Greece ablaze. Athenian, Spartan and Corinthian armies scoured the Greek mainland for twenty-seven years, leaving chaos in their trail, plundering

The omphalos, or cosmic egg, marked the navel of the earth at Delphi, near the Treasury of the Athenians.

Three columns restored by archaeologists at the "tholos" at Delphi. This circular temple, built by the architect Theodorus about 370 B.C., was part of a shrine sacred to Athena.

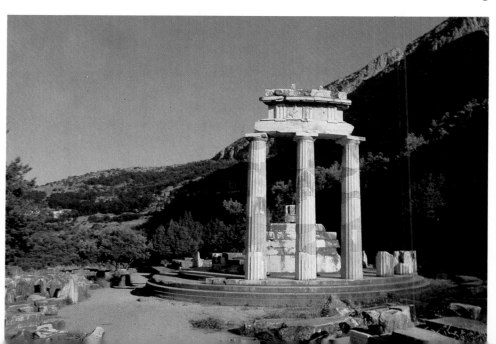

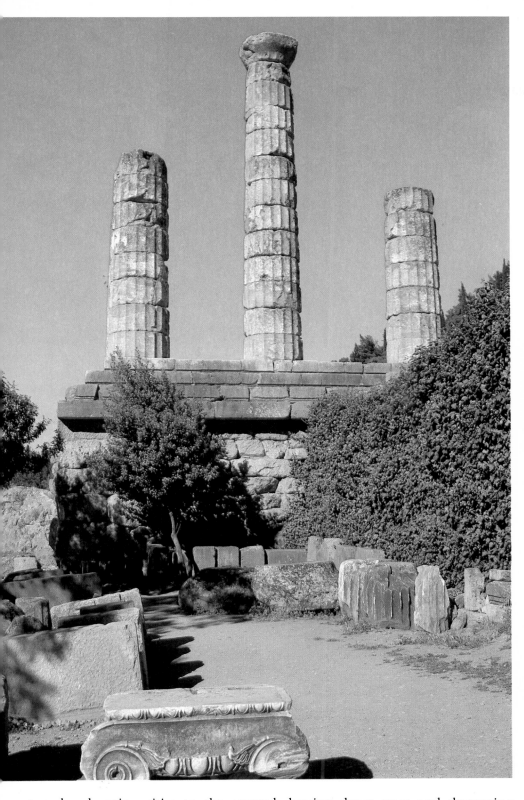

The temple of Apollo, crowning a tremendous stylobate on a hill at Delphi, was completed in 320 B.C. It was a Doric peripteral temple 60 m (198 ft) long and 24 m (79 ft) wide.

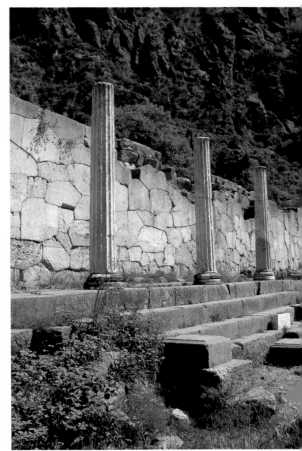

temples, burning cities to the ground, hewing down trees and destroying harvests in the fields.

For twenty-seven long years, the whole of the Greek world was bent under the yoke of war and fratricide. The study of classical fortifications and defence works helps us to better understand this tragedy and its main actors. Greek fortresses show us effigies of steel-clad soldiers wearing helmets, armed with swords and spears and protected by bucklers and greaves. They are more realistic symbols of this period than the beautiful statues of naked ephebes adorning the stadiums and palaestrae.

All kinds of defence works existed in classic period Greece, torn apart by unending battles and endemic civil war. Archaeologists have discovered lookout towers, storm-proof fortresses commanding valleys and mountain passes, to say nothing of the countless walled cities. Athens, for example, built a chain of fortresses on the border of Attica. Nearest Athens was Phyle, perched at an altitude of 700 m (2,300 ft), dominating one of the roads leading to Boeotia: a genuine eagle's nest crowned with symmetrical stone towers. Following the Athenian defence line, we next come upon Rhamnus, built at the

A mighty wall of polygonal masonry sustaining the first temple of Apollo was erected at Delphi in 548 B.C. The Ionic portico lining the wall was added about 478 by the Athenians in order to house trophies of war.

Overleaf (72-73):
Majestic view of Delphi from the top of the theatre built on the slope of Mount Parnassus in the fourth century B.C. The structure was subsequently restored by Eumenes II, king of Pergamum, in 159 and altered during the Roman period. The open-air theatre, adjacent to the temple of Apollo, was an integral part of the religious centre.

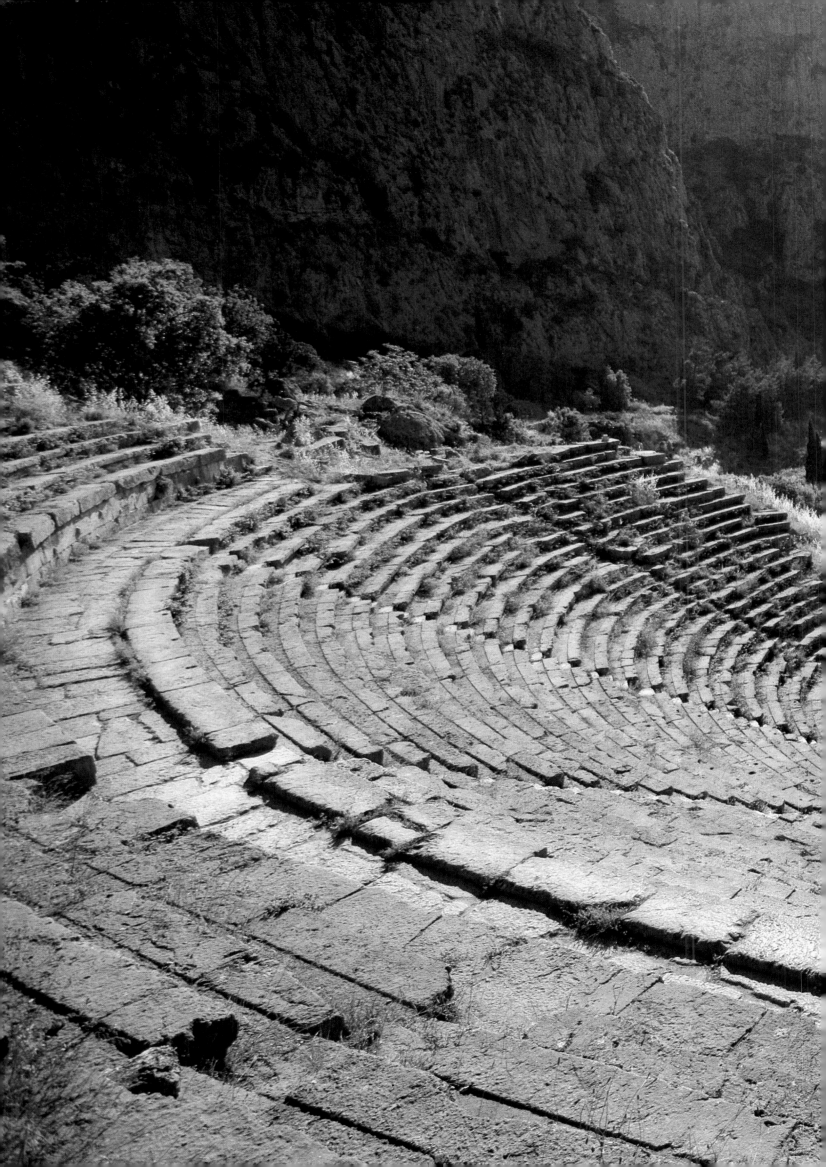

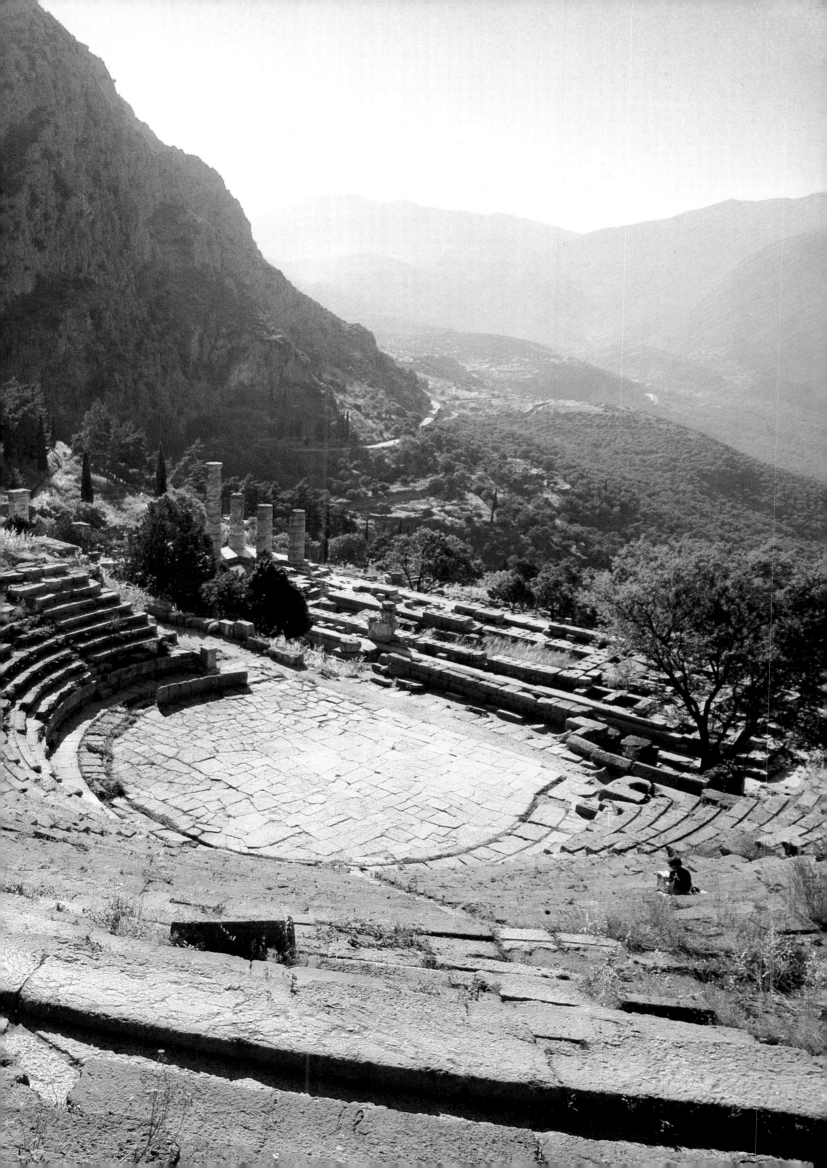

Facing page:
Over-all view and keep of the Athenian fortress at Aegosthenes, on the shore of the Gulf of Corinth. These imposing defence works date from the fourth century B.C.

Right:
Towers mark out the 9 km (5.4 mi) long defensive walls surrounding the ancient city of Messene.

Bottom:
The fortress at Eleuthera in Attica, built in the fourth century B.C., commands the road to Thebes.

View of the formidable circular barbican at Messene defending the gate for ingress into Arcadia in the Peloponnesus. The fortress was built by the Theban general Epaminondas about 375 B.C. as a bulwark against Sparta.

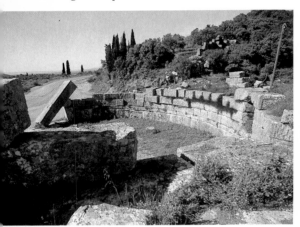

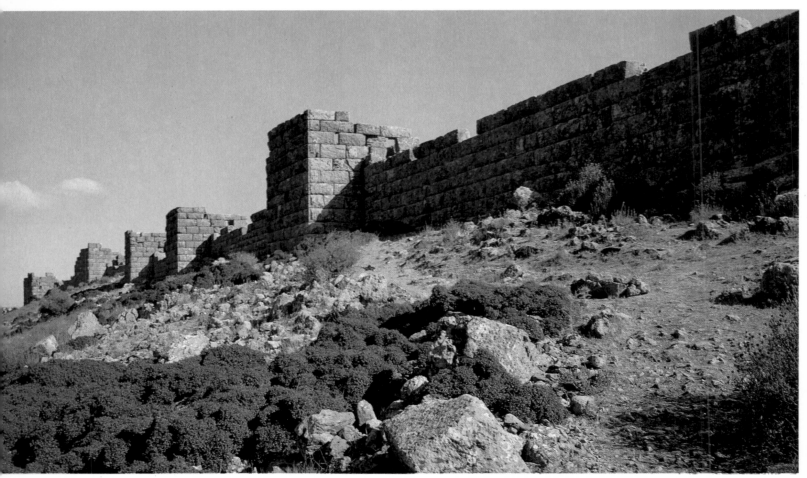

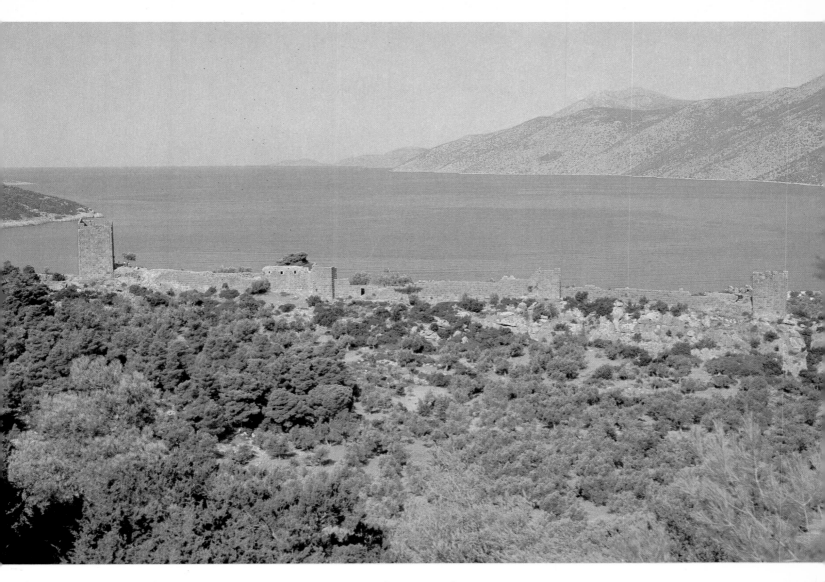

far northern end of the strait separating the island of Euboea from the mainland. To the southwest, Aegosthenes, on the shore of the Gulf of Corinth, prevented danger from an invasion by sea. The central position in this defence system was occupied by the fortress of Eleuthera, commanding the defile of Cithaeron. Its towers and curtains rose up on the edge of a rocky hillock surrounded by steep ravines. All of these fortresses built in the fourth century B.C., with their beautiful isodomic masonry, bear witness to the appreciable and swift progress made by the art of war during this time of stress and turmoil. Dionysus the Elder, tyrant of Syracuse at the dawn of the fourth century, had been the first Greek ruler to increase fortifications and build engines of war. From thenceforward, siege techniques were continuously improved.

The fact is that Athens built the chain of fortresses mentioned above after surrendering to Sparta in 404 B.C. Lysander, the Spartan naval commander to whom was due the capture of the Athenian fleet at the mouth of the Aegospotamos and the final submission of Athens, had destroyed the "Long Walls", raised by Themistocles, connecting the city with its seaport, Piraeus. But Spartan hegemony was destined to be short-lived. In 377 B.C., the second Athenian maritime empire briefly restored the supremacy of Attica.

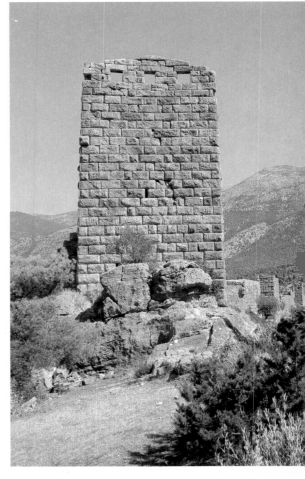

The most remarkable fortified complex in classic period Greece was undeniably Messene. The city was founded in the southern part of the Peloponnesus by the Theban general Epaminondas as a bulwark against Sparta and her expansionist intentions regarding the rich plains of Messenia and Arcadia. Many ruins of the ancient city have been unearthed about Mavromati. Most of the 9 km (5.4 mi) long defence works, winding up and down the southern slope of Mount Ithome, are still in existence.

Built after the defeat of the Spartan army at Leuctra in 371 B.C., the new capital of Messenia, surrounded by awe-inspiring walls, turned its mountainous site to the best account. One should mention in particular the storm-proof acropolis crowning Mount Ithome at an altitude of 798 m (2,633 ft).

The ancient city of Messene is in fact the best surviving example of a fourth century Greek stronghold. In many places, not only the outer walls but also the specific details of the system of defence works are still in position. Modern

visitors can thus see a set of ancient Greek curtains, posterns, round and square towers and battlements crowned with merlons, to say nothing of the formidable circular barbican commanding the Arcadian Gates, with its parapet walks running along the crest of walls 2 m (7 ft) thick and some 6 m (20 ft) high, flanked by protecting towers which rise up to a height to almost 9 m (30 ft).

These fortifications, with their remarkable isodomic mortarless masonry, their monumental blocks of limestone fashioned with such tight-fitting joints that no clamps or dovetails were needed to hold them together, are genuinely magnificent works of architecture. These walls rising straight up to giddy heights, these unbelievable angle towers built with mathematical precision and no sculptured decoration apart from the projecting bosses at the intersecting-points of the ribs, these oval or square loopholes, these colossal lintels and monumental foundations undeniably deserve our attention, from both a technical and an aesthetic standpoint, no less than the most beautiful Greek temples of the classical period. The fact is however that very few scholars and archaeologists are interested in the field of classical military architecture. Hundreds of books and articles in learned journals have been published about each and every classical Greek temple and theatre, the slightest details of the different orders and styles have been thoroughly studied, yet most of the fortresses built in the fourth century B.C. are still in ruins, waiting to be

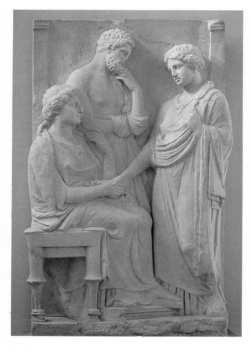

Athenian marble stele dating from the early fourth century B.C. (National Museum, Athens)

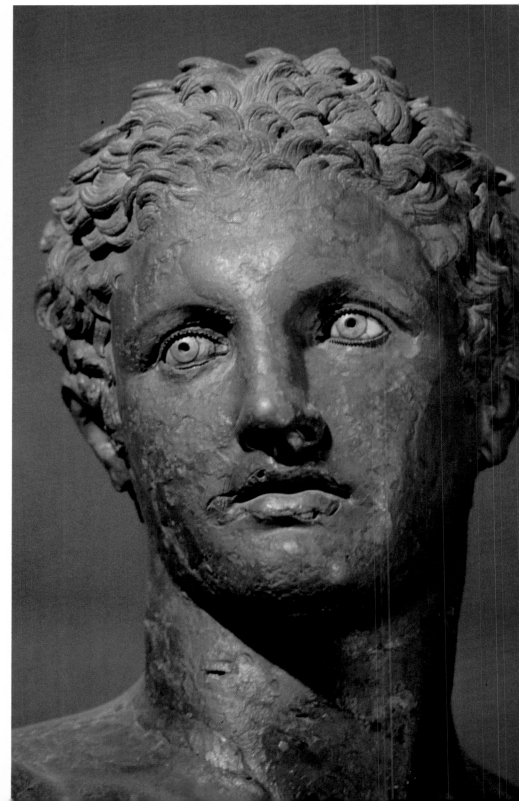

Detail of the "Anticytherian boy", a bronze statue dating from 340 B.C. attributed to the sculptor Euphranor. The enamelwork eyes are truly fascinating. (National Museum, Athens)

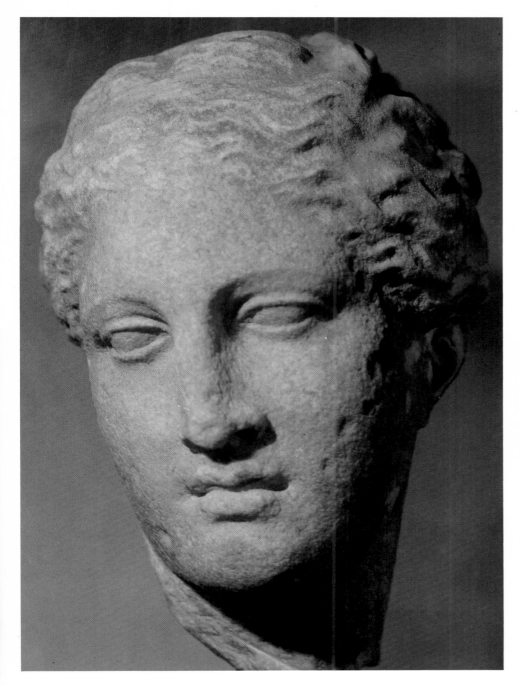

Head of "Hygieia". This marble sculpture dates from 340 B.C. Some attribute it to Scopas, others to Praxiteles, but all agree that it is one of the most beautiful female figures carved during the classical period. (National Museum, Athens)

Reverse and obverse sides of an Athenian tetradrachma coined in the fourth and fifth centuries B.C. with silver from the mines at Laurium. On one side we see Athena's owl and the first three letters of the word "Athenes". On the other, the profile of the goddess wearing a helmet and crowned with a laurel wreath. (Musée d'Art et d'Histoire, Geneva)

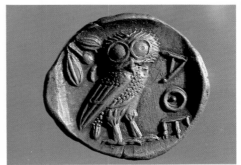

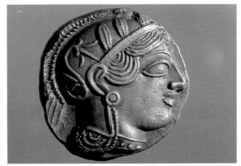

restored. These classical Greek strongholds are however no less beautiful than medieval castles, and their restoration would not be expensive. Though the walls have tumbled down, the materials have not been removed from the sites and many defence works are still in position. All that is lacking is someone willing to put together the pieces of these fascinating puzzles.

These mighty fortresses bear evidence of both the technological progress made by the ancient Greeks during the classical period and the political and social climate of an age shaken by war. In the fourth century B.C., war was indeed the prime mover of Greek civilization. War was the mother of invention. As Toynbee has stated, the adaptibility of a society and its ability to survive can best be judged by the way in which it accepts the "challenge" of history.

Drama and Destiny

The great Greek tragedians brilliantly discerned the grandeur and absurdity connected with the hazards of war and the inexorability of fate. They drew their inspiration from the tragic events of the fourth and fifth centuries: the disastrous attempt of Athens in 415–413 B.C. to take Syracuse (the chief maritime power of the ancient world lost two hundred triremes in this undertaking, while few of the 50,000 men engaged in the expedition returned to Athens), or the taking of Delphi and the plundering of the great panhellenic sanctuary.

The three greatest classic tragedians—Aeschylus, Sophocles and Euripides—lived in the same city (Athens) within one century. Their masterpieces give us

an insight into the ominous atmosphere radiated by Greek society in the fifth century B.C. These great writers drew their inspiration from historical facts in order to move their fellow-citizens, assembled for the celebration of the dionysiac festivals. One of the first authors of Greek tragedy, the Athenian Phrynicus, rival of Aeschylus, wrote in 476 B.C. a play entitled "The Phoenicians" which tells of the recent Greek victory at Salamis, in which many Phoenician sailors fighting for Xerxes were massacred. Phrynicus is best know for another play, "The Taking of Miletus", an account of the dramatic fall of the wealthiest Ionian city, which so strongly moved the audience that the author was fined for producing the drama.

Aeschylus also drew his inspiration from current events in order to more clearly illustrate the awe-inspiring tragedy of human fate. His play "The Persians" also describes the battle at Salamis where the poet himself had fought. The aim of the work was to glorify the city of Athens over Persia. Aeschylus' grim and awful plays, characterized by supreme poetic ability, piety and high-mindedness, are thrilling portrayals of the relation of man and god. Though he was the real inventor of the artistic and intellectual creation known as Greek tragedy, modern readers usually compare Aeschylus unfavourably with his successor, Sophocles.

Sophocles' plays, in which glory complements and mingles with despair, are indeed much nearer the human level than those of Aeschylus. He was the true poet of Greek humanism, showing the motives prompting the human soul as well as the terrible burden of fate laid upon mankind by the gods. The

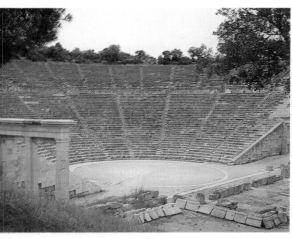

Over-all view of the theatre at Epidaurus, built within the precincts of the temple of Asclepius. The fifty-six stone tiers could seat some 14,000 spectators.

Top:
Detail of a seat reserved for officers of state in the open-air theatre at Epidaurus. One should notice the graceful design of the stone arm-rest.

Facing page, top:
The theatre at Segesta, overlooking a majestic Sicilian landscape, was built in the third century B.C.

Facing page, bottom:
Built in the third century B.C., the open-air theatre at Dodona, near the famous oracle, underwent changes during the Roman period.

Detail of the rigorously geometric arrangement of the theatre at Epidaurus.

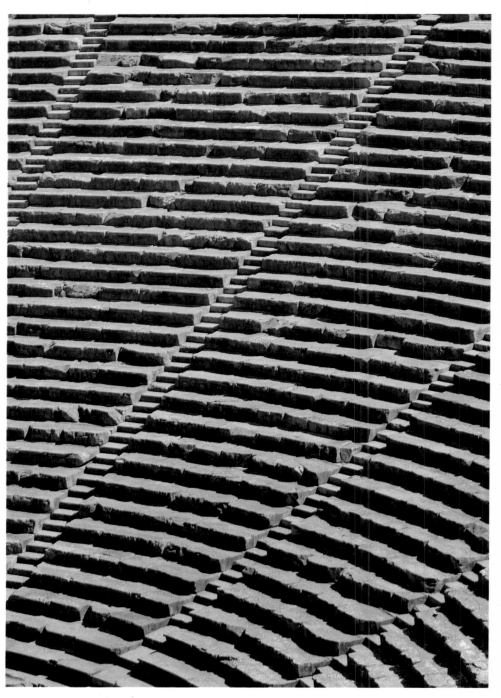

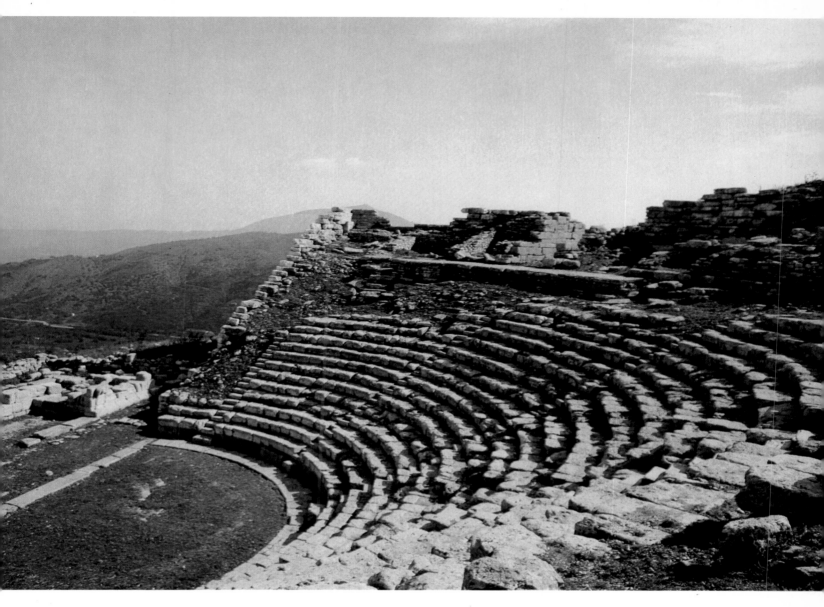

characters of Sophocles' matchless tragedies indeed seem fated to inescapable misfortune. Like all mortals, they are subject to the divine law, or Nemesis: the vengeance of the supernatural powers who punish man's inordinate pride.

Euripides, the last of the great Athenian tragedians and, according to Aristotle, "the most tragic of all poets", wrote some ninety-two plays of which eighteen have been handed down to us. He was less an idealist than his two main rivals. His plays are neither as grand nor as noble as those of Aeschylus and Sophocles, though he often displays a remarkable lyric power, especially in his choruses. The Athenians drew religious and moral lessons from Euripides' art, centred round pity, terror, threats and vengeance.

The fact is that Greek theatre originated from religion. Most Greek open-air theatres were built within the precincts of the various sacred enclosures, or at least near by. At Delphi in particular, the enormous amphitheatre, which could seat some 6,000 spectators, overlooked the temple of Apollo, whose famous oracle played such an important part not only in Sophocles' tragedies but also in the social and religious life of Greece in general. The Pythian Games were held every fourth year in this stadium on Mount Parnassus, in honour of Apollo Pythius. At Epidaurus, ruins of a fine theatre have been discovered near the famous temple of Asclepius. At Dodona, the most ancient Greek oracle, interpreted by priests from the sound of the wind in the leaves of a sacred oak tree, the temple of Zeus also housed a stadium where plays were performed.

Throughout the fifth century B.C., similar open-air theatres in Greece proper, Sicily and Asia Minor rang with the plaintive or avenging tones of tragic poetry, portraying ancient man contending with the horrors of war and the hardships of fate. But the classical drama, which arose at Athens at the dawn of the fifth century, was already on the wane only one hundred years later. The death of tragedy was only one of the symptoms of the irremediable decline of Greek civilization as a whole.

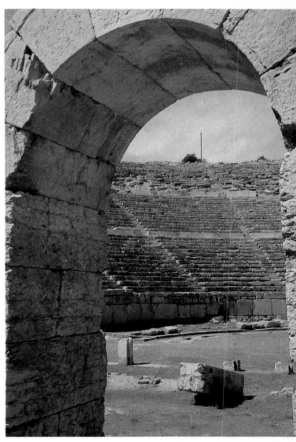

The Discovery of Philip II's Tomb

Scale model of Philip II's tomb, discovered under the great mound at Vergina. From left to right, we see the burial vault and the antechamber with their tuff-stone roof supported by semicircular arches. The frieze crowning the imbedded columns of the façade was decorated with a vast fresco showing a hunting scene. (Archaeological Museum, Salonika)

Façade of a third century Macedonian tomb discovered at Vergina about a hundred years ago. This structure gives us an idea of what the last abode of Alexander the Great's father looked like.

Facing page, top:
View of the treasures found in the antechamber of Philip II's tomb: a gilded silver bow case and quiver (goryte) and gilded bronze greaves (cnemides), one of which is 3.5 cm (1 1/2 in) shorter than the other. Perfume jars lie strewn about the threshold.

After Sparta and Athens, Thebes, the chief city of Boeotia, entered upon a career of conquest and attempted to make its authority felt over the whole of Greece. The death of Epaminondas—the general who built the city of Messene and defeated the Spartans at Leuctra in 372 B.C.—at the battle of Mantinea in 362 destroyed these hopes. At the same time however, perennial disunion was undermining the supremacy of the Athenian League, made up chiefly of islands. Several Greek cities on the Macedonian and Thracian coasts progressively fell away from the cause of Athens, paving the way for the rise of a new military leader, destined to upset and reorganize the whole Greek world: Philip II, king of Macedonia.

Until Philip seized the throne in 359 B.C., Macedon, which was not regarded as a part of Hellas proper, had never asserted itself beyond its own borders. The country owed its glory to Philip, who put an end to internal dissensions

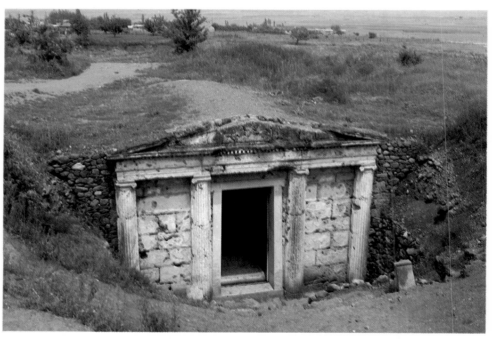

and built the so-called Macedonian Empire. The future king had been a hostage at the court of Epaminondas at Thebes from 367 to 364 B.C. He subsequently put the knowledge gained there to account, reorganizing the Macedonian army on the Greek model, training it in the effective Theban phalanx formation, and arming it with deadly 5 m (16 ft) long spears, or sarissas. Skilful, daring and successful in war, it was he who made possible Alexander's conquests in Persia and elsewhere...

Brilliant strategist, able diplomat and courageous soldier, Philip attacked Amphipolis, an Athenian colony and seaport on the Macedonian coast, in 358 B.C. Athens, taken up with the defection of Rhodes, Chios and Cos, did not respond, though the great Athenian orator Demosthenes, an unrelenting

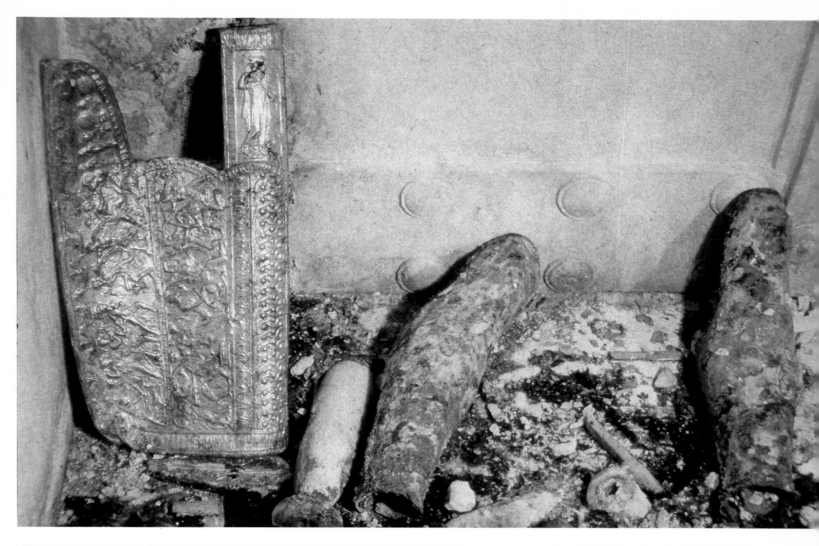

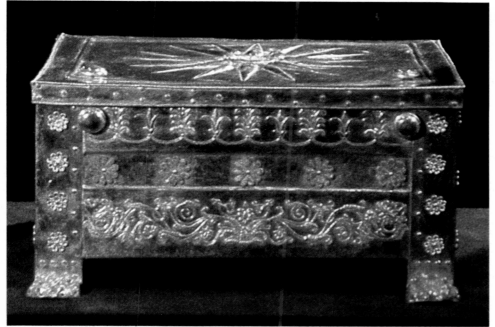

enemy of Macedon, delivered three orations—the "Philippics" (351, 344, 341 B.C.)—violently attacking Philip and putting his fellow-citizens on guard against the Macedonian peril. Philip attempted to invade central Greece by the pass of Thermopylae in 353 B.C., but wisely retreated on finding the pass already held by his enemies. In 340, when the Athenians and the Thebans, lending an ear to Demosthenes, finally united to oppose Philip, the king of Macedonia launched a new attack on the league of Greek city-states. He quick-ly took Boeotia and Thebes and decisively defeated his Athenian and Theban enemies at Chaeronea in 338 B.C. The battle of Chaeronea marked the end of the independence of the Greek city-states or, more precisely speaking, the birth of a new confederation under the military leadership of Philip II.

This miniature ivory portrait of Philip II was found on the floor of the tomb. To all appearances, it originally adorned a bed with chryselephantine inlays. Height: 3 cm (1.2 in). (Salonika Museum)

Left:
This solid gold casket contained Philip II's crown and ashes. One should notice the star pattern on the top. (Salonika Museum)

Peace was proclaimed throughout Greece. A new confederation of city-states was founded, governed by a federal council (the Amphictyonic Council) which met at Corinth. Representatives of the various cities also met at the pan-hellenic games held regularly at Olympia, Delphi and Nemea. Philip's victories over the Greek city-states enabled him to take a place as military commander in the Amphictyonic Council.

Once master of Greece, Philip decided to lead this new confederation against the Persian Empire. In Persia, Artaxerxes III had just died and his son and successor, Arses, was destined to remain on the throne for only one year. He was succeeded in 336 B.C. by Darius III. In the meantime, Philip's general Parmenion had already landed with a Greek army on the Asia Minor coast. All preparations for the planned campaign had been completed when Philip II was assassinated at the wedding of his daughter with the king of Epirus.

A Royal Tomb Untouched

The fantastic discoveries of the perfectly preserved royal tombs in Macedon, in the small village of Vergina, about forty kilometres (25 mi) from modern Salonika, have created a great stir and brought these long by-gone events back into the foreground. In November 1977, excavations undertaken under the direction of Professor Manolis Andronikos led to the unearthing of a whole set of tombs buried under a gigantic mound 110 m (363 ft) in diametre and 12 m (40 ft) high. Though the first tomb discovered had been plundered in ancient times, it nonetheless contained beautiful mural paintings representing in particular the ravishment of Persephone. This work of art, dating back to the fourth century B.C., was the first example of classic period painting discovered in Greece.

The second tomb was however the real eye-opener: a spectacular discovery of outstanding importance, worthy to be compared to the unearthing of Tutankhamen's hypogeum in Egypt in 1922. Not only was it intact and in a perfect state of preservation, but the marvellous gold, silver and bronze treasures it contained proved beyond all question that it could only be the tomb of a king. The discovery gave rise to endless debates between scholars bent on establishing the identity of the ruler buried in these two stone vaulted chambers crammed full of masterpieces of classical jewellery and metalwork. The first thing that occurred to Professor Andronikos was that he had brought to light the tomb of Philip II, king of Macedonia. From 1977 on, every passing year has brought new evidence supporting this brilliant hypothesis.

The enormous burial mound at Vergina had actually fascinated archaeologists for years. The first excavations were undertaken there in 1952. They were unsuccessful. New efforts were made in 1962 and 1963: once again, to no avail. Undeterred by these repeated failures, the Greek archaeologist Manolis Andronikos began digging again at the same site in 1976. In 1977, after having removed some 18,000 cubic metres (23,400 cubic yards) of virgin earth, he had found nothing. Finally, in September 1977, while excavating a new trench, the long-awaited discovery was made. A vaulted tuff-stone monument comprising two separate chambers was brought to light. The tomb's

Bottom:
Over-all view and detail of a silver wine pitcher with a mask of Silenus, found in the royal tomb at Vergina. (Archaeological Museum, Salonika)

Detail of the gilded silver low reliefs adorning Philip II's quiver. We see here a scene depicting the taking of Troy. (Salonika Museum)

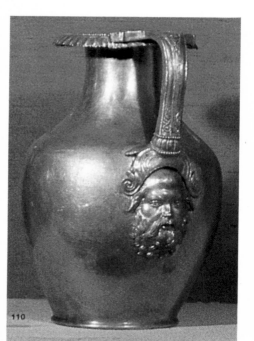

façade was adorned with imbedded columns and crowned by a frieze bearing a mural painting about 5 m (17 ft) long and 1 m (3 ft) high. This vast fresco, in a relatively good state of preservation, represents a hunting scene with horsemen, whips, lions and wild boars amidst a wooded, overgrown landscape. The treatment displays a very free style full of life and teeming with minute, realistic detail which bears witness to undeniable artistic mastery. Manolis Andronikos did not hesitate to attribute this work to the same artist who executed the original fresco of the battle of Issus from which the author of the famous mosaic of Alexander at Pompeii was later to draw his inspiration. In addition, the architecture of the façade still exhibits its original, brightly coloured,

Bronze vases found in the left-hand corner of Philip II's tomb. One should notice in particular the second one from the left, a perforated metal vase used as a lamp. Below we see a close-up of the gilt mask adorning the bulge. (Archaeological Museum, Salonika)

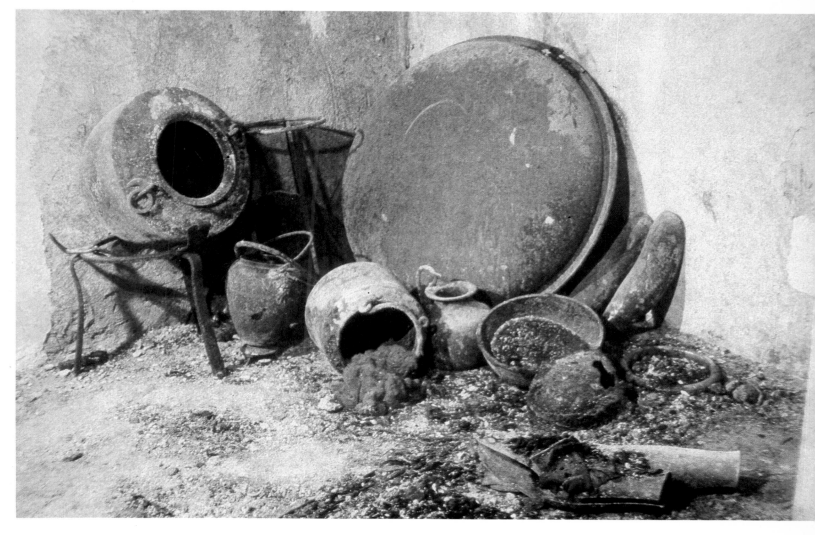

polychrome ornamentation: royal blue triglyphs, vivid red mouldings and string-courses give us an idea of the true appearance of classical Greek monuments, with the colours and gilding customarily applied for emphasizing decorative sculpture.

A Golden Treasure-Trove

Behind a marble folding door, the archaeologist discovered two chambers which had been reverently sealed up twenty-four hundred years earlier. The first room, or antechamber, housed a small cinerary monument on the left-hand side. On opening it, searchers found a golden casket containing a light gold tiara lying on a package of human ashes wrapped in a purple robe. Anthropologists have identified the ashes as the remains of a young woman aged twenty-three to twenty-seven. This was probably the cinerary urn of Cleopatra, Philip II's last wife, who was either compelled to commit suicide or assassinated along with her royal spouse. On the floor there was another solid gold diadem ornamented with carved myrtle leaves and flowers of extremely fine workmanship. Facing the entrance, Andronikos found a gilded silver quiver (or goryte) and gilded bronze greaves, one of which was 3.5 cm (1½ in) shorter than the other. And it is a well known fact that Philip II was lame...

The burial vault proper, separated from the antechamber by another marble door, also displayed a semicircular arch. The far end of the room was occupied by another marble cinerary monument containing, like the first one, a gold

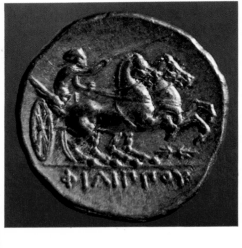

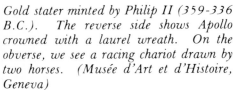

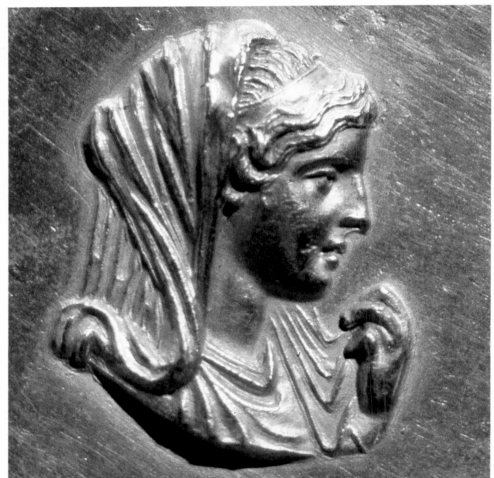

Gold stater minted by Philip II (359-336 B.C.). The reverse side shows Apollo crowned with a laurel wreath. On the obverse, we see a racing chariot drawn by two horses. (Musée d'Art et d'Histoire, Geneva)

Right:
Detail of a large gold medal bearing the effigy of Queen Olympias, wife of Philip and mother of Alexander. This medal was coined in commemoration of the games held in honour of Alexander and Olympias at Veria.

Solid gold myrtle wreath found at Derveni. The style is similar to that of the crowns discovered in the caskets containing the ashes of Philip II and his wife Cleopatra. This marvellous piece of metalwork dates from the second half of the fourth century B.C. (Archaeological Museum, Salonika)

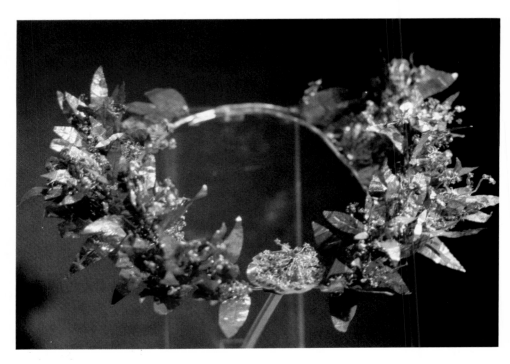

casket. The second casket differed from the first one in that it was sumptuously carved with roses and pampres; the flat cover was decorated with a big star. The casket, weighing over 10 kg (22 lb), contained a solid gold crown made up of marvellously fashioned interlaced oak leaves and acorns, and the ashes of the dead king. According to anthropologists, the ashes are the remains of a man aged forty to fifty. Philip II was forty-six years old when he was assassinated...

The cinerary monument was surrounded by silver and bronze vases, weapons, a gold and iron breast-plate, swords, an iron helmet and vestiges of furniture. One should mention in particular a wooden bed inlaid with ivory and adorned with a gold and ivory frieze in high relief (an example of the art of chryselephantine sculpture, so famous in ancient times). This frieze was made

up of tiny heads which have been thoroughly studied by Manolis Andronikos: one represents a portrait of Philip, another is an effigy of Alexander, while one woman's head probably depicts Queen Olympias, his mother.

The Teachings of a Sensational Discovery

The enormous mound at Vergina which concealed the tombs also contained a set of broken steles dating from the fourth and fifth centuries B.C. These steles had been intentionally smashed to pieces when the royal cemetery (surrounded by graves of ordinary people) was plundered by the Gauls about 274 B.C. After several tombs were rifled, the great mound was raised by order of Antigonus Gonatas, king of Macedonia and master of Greece in the third century B.C.

Antigonus intended the mound as protection for the royal tombs which had escaped the vandals' attention. The most striking thing about the steles unearthed in recent years is that all the inscriptions bear Greek names: all the patronymics are typically Greek. The Macedonian cemetery brought to light at Vergina thus proves beyond all question that the kingdom of Macedonia under Philip II, so harshly blamed and ill treated by Demosthenes in his "Philippics", was really and truly a Hellenic land. The famous Athenian orator called his enemy a "barbarian", term serving to qualify people who did not speak Homer's language.

In addition, the discoveries made at Vergina have made it possible to pinpoint, at the site now occupied by this small Macedonian village, the city of Aegae, first capital of the kingdom, which architects hitherto believed situated near Edessa. The ruins of an imposing palace dating back to the third century B.C. had been excavated at Vergina as early as 1957, renewing and continuing digging undertaken by the French archaeologist Heuzey in the mid-nineteenth century. The existence of this palace at Vergina should have given scholars a clue. Be that as it may, at the present time all specialists accept the evidence brought to light by Professor Andronikos...

Last but not least, the magnificent workmanship of the mural paintings and over fifty metal vases found in the tombs, to say nothing of the furniture adorn-

Left:
The second larnax, or solid gold casket, found in Philip II's tomb contained a magnificent tiara and the ashes of Queen Cleopatra, wrapped in a beautiful piece of gold and purple brocade. (Archaeological Museum, Salonika)

Enlarged detail of an ear-ring representing a chariot drawn by two horses and driven by Victory. This piece of jewellery dating from the fourth century B.C. was found at Pelinnaion in Macedonia. (Archaeological Museum, Salonika)

ing the burial chambers, bear out the existence of a highly developed and original Macedonian civilization which was undeniably an integral part of the world of classical Greece.

And the sensational discovery of Philip II's tomb has not been the only one made at Vergina. Professor Andronikos has continued the work begun in 1976. On 5 August 1978, he brought to light, under the same mound which had concealed Philip's burial vault, a new sepulchre, it too perfectly intact. It too housed sumptuous pieces of bronze, silver and gold furniture. It too was ornamented with a polychrome frieze, representing a set of racing chariots. The handling of the four horses drawing these vehicles abreast is particularly remarkable for its dazzling liveliness and spontaneity. It is still too soon to say which member of the Macedonian dynasty was buried in this opulent tomb.

Alexander's Epic

Philip II had many wives. It is believed that his assassination was instigated by one of them, Olympias, mother of Alexander the Great, who had reasons to fear that Philip would choose another than her son to succeed him on the throne. As soon as the murder was revealed, Alexander, who was only twenty years old at the time, proclaimed himself king of Macedonia. From the very outset, he displayed an iron will, sustained by supreme political and military ability. The other pretenders to the throne were put to death by way of precaution. The young king then assembled his army and went into Greece to quiet the restive cities. After a successful campaign against Corinth, he was named strategus "autocrator" of the Greek confederation and marched north to put down revolting tribes in the central Balkans. Hearing that Thebes was in revolt and had declared Greek independence, he rushed back south and sacked the city, sparing only the temples and the house of Pindar, on account of his great admiration for the poet. He was then ready to carry out his father's plans and his mother's visionary dreams, declare war on Persia, invade Asia and conquer the world.

Philip II had chosen the best possible tutor for his son. The young Alexander had been brought up by the famous Greek philosopher Aristotle. Born at Stagira, an ancient city of Macedonia, about 384 B.C., Aristotle was the favourite and most gifted pupil of Plato at Athens. He was tutor of Alexander from 343 to 336 B.C. When Alexander put down the Greek rebellion and took Athens in 335, Aristotle returned to the capital of Greek philosophy and began to conduct a school known as the Lyceum. Like so many other famous men exiled by the Athenians, Aristotle was forced to leave the city once again in 323 B.C. on account of anti-Macedonian agitation. He died at Chalcis near the Macedonian border a few years later.

Aristotle is the author of some 146 works on all imaginable topics: logic, metaphysics, physics, astronomy, zoology, psychology, politics, ethics, rhetoric and poetics. He was a man of truly encyclopedic knowledge who has dominated European thought and science from ancient times up to the present day. His works bring together all the earlier trends and schools of philosophy which had come into existence in Greece, from the primitive Ionian

The famous mosaic portrayal of Alexander at the battle of Issus paving a house at Pompeii is actually an ancient copy of a fresco attributed to Philoxenes of Eretria. (Naples Museum)

Marble head of Alexander the Great. This sculpture dating from 335 B.C. is generally attributed to Leochares, who made several portraits of the conqueror. (Acropolis, Athens)

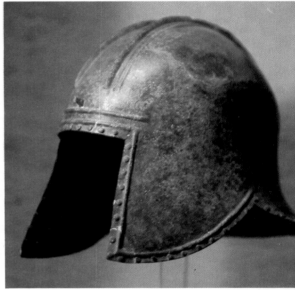

Macedonian helmet worn by the soldiers who fought in phalanx formations. (Archaeological Museum, Salonika)

Left:
Gold staters coined by Alexander the Great. The reverse shows a head of Athena, the obverse a figure of Victory holding a crown. These coins were minted from 336 to 323 B.C. (Musée d'Art et d'Histoire, Geneva)

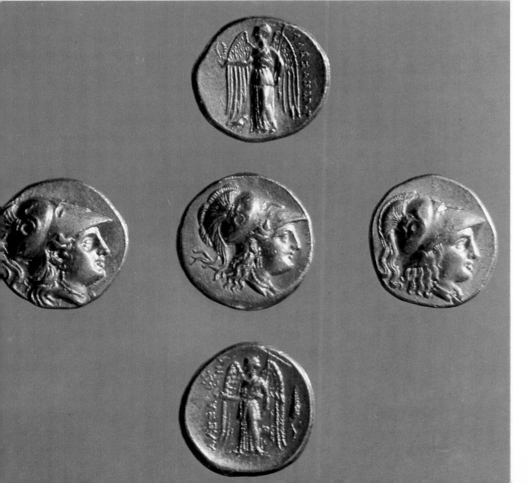

Overleaf (88-89):
The Stoa of Attalus at Athens, built by Attalus II, king of Pergamum from 159 to 138 B.C., has been meticulously restored by the American School of Archaeology. It is interesting to remark that the outer colonnade exhibits Doric capitals, while the inner one obeys the rules of the Ionic order. The fluting of the Doric columns stops halfway down. This is the setting in which Hellenistic philosophy was born.

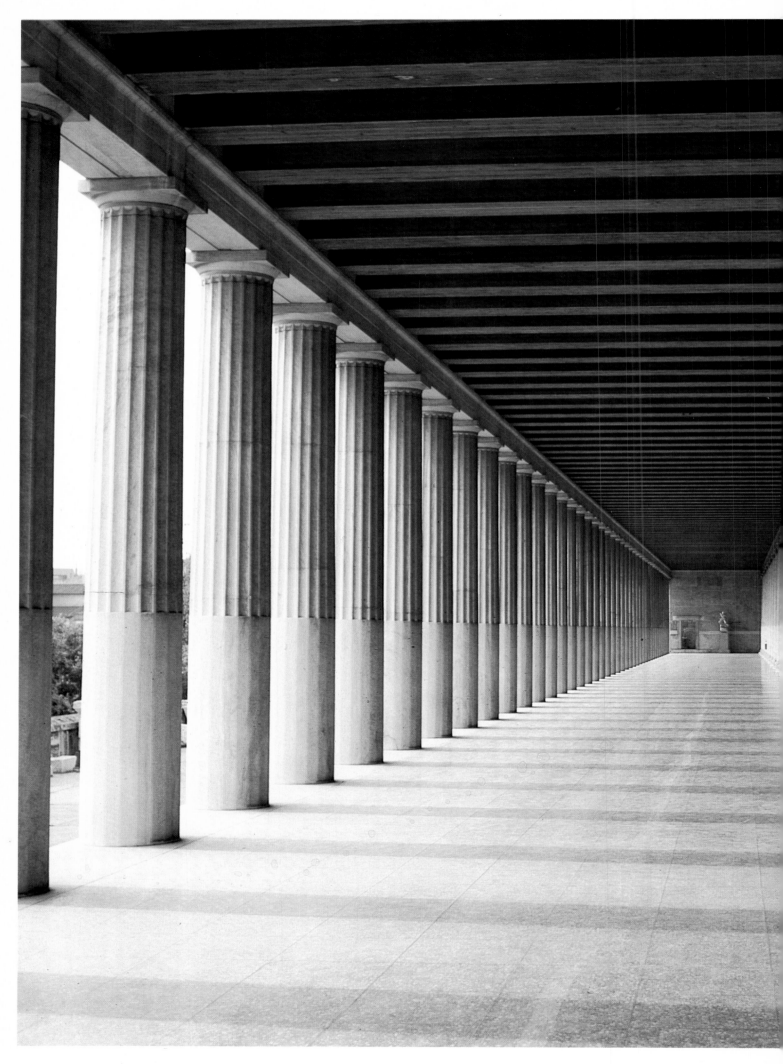

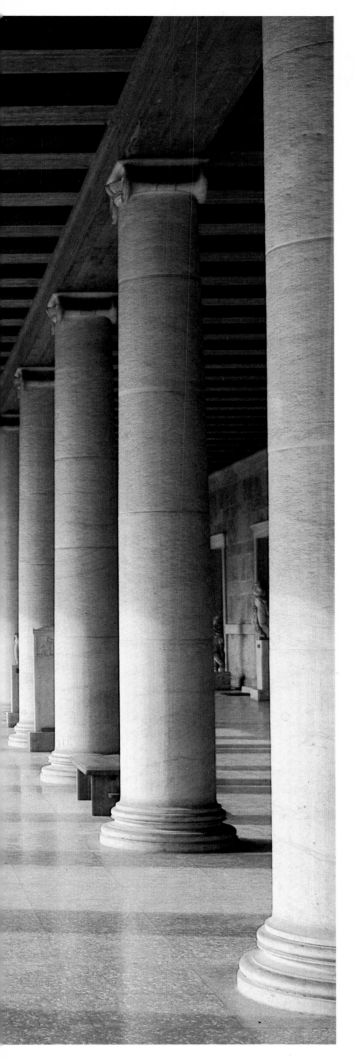

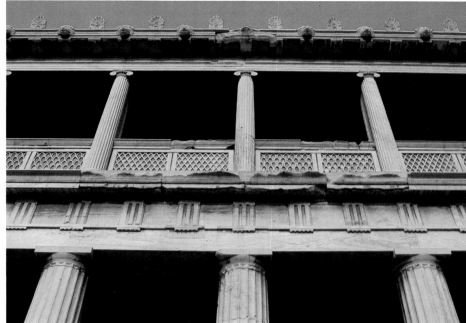

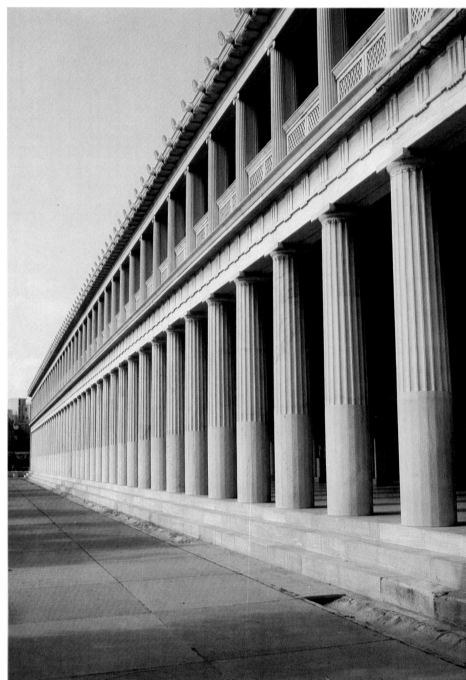

"physiologists", who studied the nature of the world and matter, to the sceptics and sophists. They revive the will to synthesis which characterized the Eleatic philosophers such as Parmenides, Zeno and Melissos, who had come under the influence of Egyptian and Babylonian thought. They recall the cosmological visions of thinkers like Thales of Miletus, Anaximander, Anaximenes or Pythagoras, altered by ethical standards originating in the works of Protagoras, who termed man "the measure of all things". Through Plato and his theory of Ideas, Aristotle was also heir to Socrates. His works summed up all the knowledge acquired by the Greeks from the birth of conscient reflexion to the fourth century B.C. But they also paved the way for the great thinkers of the Hellenistic period, many of whom studied under him at the Lyceum in Athens. Stoics like Theophrastus, Zeno or Cleanthes, with their new doctrine bearing the stamp of Oriental thought, were destined to give rise to a Greco-Oriental syncretism promoted by the policy of conquest which characterized and accounted for Alexander's career in Asia. Revived by Arab scholars in the ninth century, Aristotle finally became the philosopher par excellence of the Christian Middle Ages.

On an isolated hilltop in Epirus, the site of Mesopotamos (Ephyra) exhibits an underground temple upon which a Christian church has been built in modern times. This religious site, occupied since the Mycenaean period, comprises an oracular crypt.

The underground sanctuary, or Necromanteion, at Ephyra, where the living communicated with the dead, is a vaulted crypt built in the third century B.C. According to the ancients, the entrance to Hades, the gate of the underworld, was located here.

The Asian Campaign

Thanks to his studies under Aristotle, the brilliant and hot-headed king of Macedonia possessed a considerable amount of knowledge when he crossed the Hellespont in 334 B.C. with an army of 40,000 Greeks and Macedonians and 5,000 horsemen to declare war on the enormous Persian Empire and begin one of the greatest continuous marches in history. His adventure commenced symbolically at Troy. At the Granicus river—actually a mere stream flowing into the Sea of Marmara—he met 20,000 Persian horsemen and 20,000 foot soldiers in the pay of Darius III Codomannus and put them to flight, then moved on to Sardis, Miletus and Halicarnassus. The whole of Asia Minor collapsed and surrendered at one blow. Ionia, Lydia, Caria and Phrygia espoused Alexander's cause. Sardis, Ephesus and Pergamum threw off the Persian yoke and joined forces with the conqueror. Alexander had come to Asia as a deliverer.

The Macedonian advance encountered little or no resistance. Alexander expected an ambush at the Cilician Gates, but the mountain passes were not held by the Persians. The conquering army thus moved on from Miletus to Halicarnassus to Pamphylia and finally into Phrygia for the winter. In 333 B.C., Alexander started south, heading for Syria. He finally met Darius at Issus, an ancient town in the plain north of Syria. After a hard battle, the Greeks routed the Persian army. The king of Persia, put to flight, deserted his camp, surrendering his wives and his treasures to his enemies. The conqueror

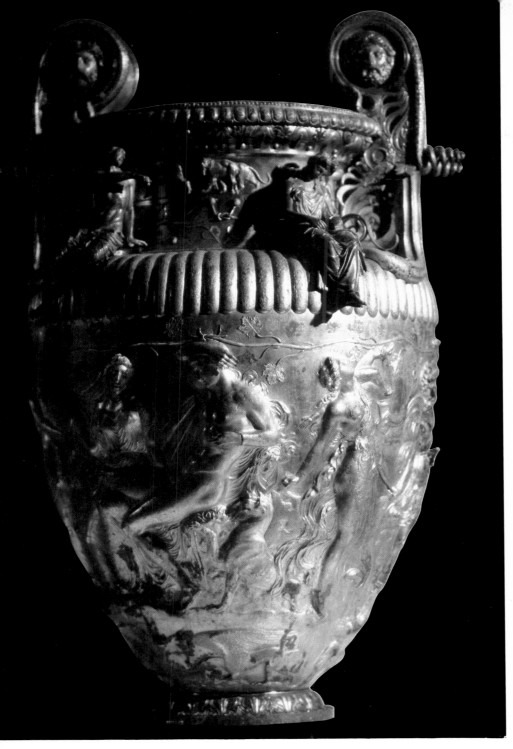

This large gilded bronze crater found at Derveni dates from 330 B.C. It is a good example of the flamboyant, "baroque" style favoured by goldsmiths at the dawn of the Hellenistic era. The scroll-shaped handles are flanked by carvings in the round illustrating dionysiac themes, while embossing shows an orgiastic ceremony with Dionysus and Ariadne. (Archaeological Museum, Salonika)

Detail of the crater found at Derveni: a maenad possessed by Dionysus.

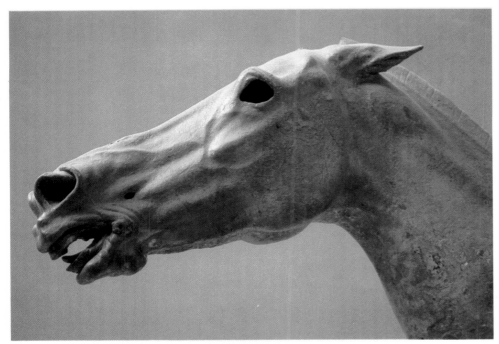

Head of a bronze horse found in the sea off Cape Artemision. This work of art, probably dating from the mid-second century B.C., is remarkable for realistic and vivid treatment. (National Museum, Athens)

91

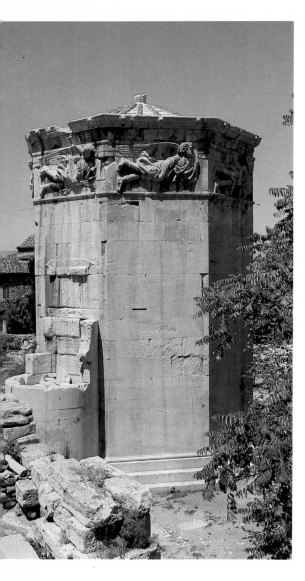

is said to have treated his royal captives generously. The victory at Issus left the way open into Asia. Alexander took Syria and Phoenicia and entered Egypt in 332 B.C., seating himself on the throne of the Pharaohs at Karnak. When in Egypt, he also visited the oasis of Ammon (Zeus) where, according to his biographers, he was hailed as a god. After these long marches through the desert, he took a short rest and founded the port of Alexandria, perhaps his greatest monument, destined to become the capital of the Hellenistic world...

Alexander then turned north again, bent on conquering Persia. Crossing the Euphrates and the Tigris, he found Darius awaiting him at Gaugamela, in the middle of a plain near Arbela, where he could deploy abreast his enormous army including thousands of horsemen and charioteers, to say nothing of the dreaded Scythian squadrons and the millions of foot soldiers drafted from the four corners of his enormous empire. A distance of nine kilometres (5.4 mi) separated the right wing of the Persian army from the left wing. Alexander succeeded in avoiding encircling, broke up the Persian ranks and once again put his enemy to flight. This brilliant victory won in 331 B.C. left the way open to Babylon and Susa, one of the Persian capitals, and the Macedonian army immediately took advantage of the situation. Alexander progressed to Persepolis, the very heart of the dominion of the Achaemenidae. His army sacked the city and burned the magnificent palaces to the ground, taking vengeance for the destruction of the Acropolis at Athens during the second Persian War. Darius, fleeing to Ecbatana and thence eastward, was treacherously murdered by his cousin Bessus who then proclaimed himself king of Persia. Alexander pursued the new king through northern Parthia, into Bactria, and past the Oxus. His armies entered deeper and deeper into Asia, reaching Sogdiana, near modern Samarkand, in 327 B.C., after having crossed the Afghan mountains. Alexander was thenceforth master of the whole of the Persian empire and nothing seemed to be able to check his advance.

Asia surrendered to the twenty-nine-year-old conqueror whose kingdom stretched from the Greek peninsula to the steppes of central Asia and from the Black Sea to Nubia. But all these conquests, forming the vastest empire of the ancient world, had only whetted the appetite of the impulsive general. Alexander remained unsatisfied. He entered India in 324 B.C., when his troops, caught in the rainy season and dissatisfied with their leader, who had been playing the Oriental despot, mutinied and refused to go any farther. Alexander had in the meantime defeated an Indian king at the Hydaspes and was moving southeastward toward the Ganges. He stationed several Macedo-

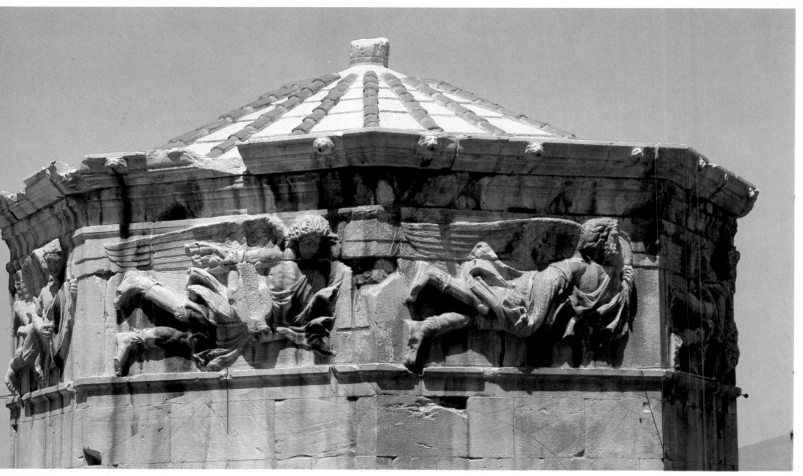

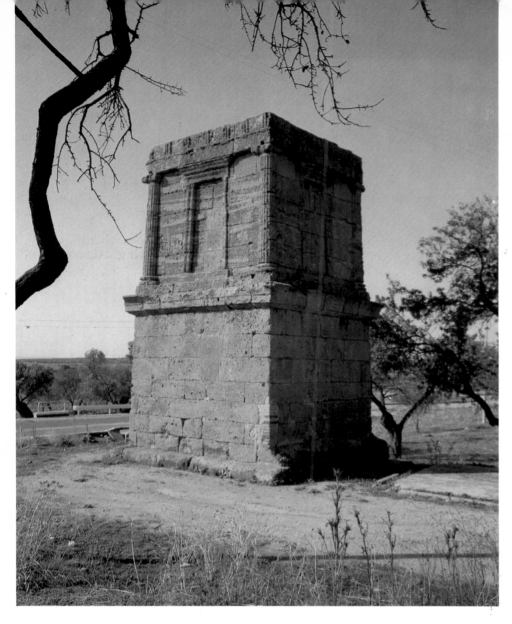

Facing page:
The Tower of the Winds, or Horlogium of Andronicus of Cyrrhus, at Athens, is an octagonal marble structure. It was built by a Syrian architect in the first century B.C. Below, we see a detail of the frieze containing figures in relief representing the winds.

The mausoleum of Thero at Agrigentum is a small, two-storeyed monument built in the first century B.C. Similar structures have been found at Cnidus, Xanthos, Halicarnassus and even in Rome.

The small sacred island of Delos drew its fresh water supply from cisterns. The stone vaults brought into use in the Hellenistic period facilitated the construction of these underground chambers.

nian garrisons in India and started home. Marching down the Indus to the ocean, he sent his fleet commanded by Nearchus up the Persian Gulf and turned westward with the bulk of his army. After a long, weary march through Gedrosia and the Persian wastes, he finally arrived in Susa in 324 B.C. Even then, he let his troops take only a short rest: there were endless rebellions to be quelled and countless traitors to be punished. Alexander spent the next year moving about and reforming his government. After his long stay in Asia, he was about to make a series of decisions destined to shock and overwhelm the Greek and Macedonian soldiers who had followed him from the very outset, covering some 20,000 kilometres (12,000 mi) in ten years on foot or horseback while bitterly fighting.

Alexander the Politician

Alexander's aim was to closely blend European and Asian civilization, to unite the two continents within the framework of a tightly bound Greco-Oriental syncretism. The only way to re-establish lasting peace was to take steps capable of healing the breach between the vanquished and the vanquishers. This dream of a reunited world explains the marriages and rejoicings organized by Alexander at Susa in 324 B.C. He himself married the daughter of King Darius—without repudiating his favourite, Roxana, a Bactrian princess—and decided to marry ninety-two of his generals with the flower of Persian aristocracy. In addition, some 10,000 Greek and Macedonian soldiers got married in Persia, so as to bind tighter the ties of kindred between Europe and Asia. The wedding festivities, also meant as a victory celebration, were similar in many ways to the traditional dionysiac festivals. As a matter of fact, Alexander, who had proclaimed himself the son of a god, was also affecting Oriental dress.

One year later, at Babylon, at the end of a banquet, Alexander took a sudden fever and died. He was only thirty-three years old. The cause of death may have been either pneumonia or an attack of malaria. He left only one yet unborn child, Alexander, son of Roxana. Various pretenders contended for

succession. Alexander's enormous empire was soon broken up by internal dissension...

Nonetheless, the conqueror's great dream was destined to survive. Alexander the Great was the originator of a new civilization, the founder of the Hellenistic world. The spread of Greek culture all over the east and in Egypt was largely his doing, and the result was an unprecedented unification of ancient society. Wherever he went, Alexander founded cities on Greek models. Out of a total of thirty-four cities founded by him, twenty-four were called Alexandria. His successors followed in his footsteps: Seleucus alone founded some fifty-nine new cities and Antiochus IV over twenty. The whole of the Near and Middle East was urbanized. Cities following the methods elaborated by the Greek architect Hippodamus in the fifth century B.C. sprung up from Asia Minor to Sogdiana. Trade and commerce were Hellenized: Greek coins were in circulation the world over. For centuries, the entire world spoke Greek, the

Stele at Olympia with a carved Greek inscription.

Right:
Columns in the Hellenistic palaestra at Olympia, built in the late third century B.C. The structure comprised a central courtyard bounded by a Doric portico. This is where athletes trained for the Olympic Games.

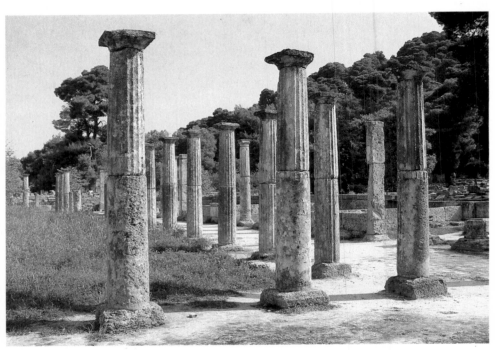

common language, or Koine, and the Hellenistic princes had the masterpieces of the Athenian tragedians performed from the Aegean to Afghanistan. In India, Asoka, the first Buddhist "emperor", wrote his diplomatic archives in Greek. Lysippus' bronze statues were taken by boat to Calcutta and Tonkin. Menander, the Greek conqueror of the Ganges and ruler of the independent kingdom of Bactriana, between the Hindu Kush mountains and the Oxus river, summoned councils of Buddhist philosophers to discuss matters to do with religion, while scholars at Alexandria, capital of the Mediterranean basin, were translating the Bible into Greek. The library at Alexandria, founded by Ptolemy I in the third century B.C., contained some 700,000 rolls or volumes of papyrus representing the epitome of human knowledge. The statuary born on the Acropolis at Athens or at Delphi entered India with the conqueror, and the Buddha image arose as a copy of Greek "kouros" statues. From India, the distinctive features of this art were exported to China and Japan.

For centuries to come, Alexander's epic was destined to profoundly affect the course of history and fire the imagination of the world.

When he died, Alexander the Great was too young to have thought of choosing a successor. His favourite wife, Roxana, was indeed pregnant, but the long regency promised to be a problem. It was necessary to attend to the most urgent things first. While awaiting the coming of age of the heir to the throne, the various satrapies were shared out among the conqueror's closest associates and ablest generals.

This partition of the empire triggered off the long war known as the quarrel of the Diadochi, Alexander's followers. The whole of the Hellenistic world was seething with excitement, envy and anger. The dismemberment of the empire let loose the fury of war. Twenty years after the death of the young conqueror, his kingdom was divided among five main rivals: Ptolemy in Egypt, Seleucus in Babylonia, who extended his power all the way to the Oxus and Indus, Antigonus Cyclops in Syria, Greater Phrygia, Lycia and Pamphylia, Lysimachus in Thrace and Cassander in Greece and Macedon.

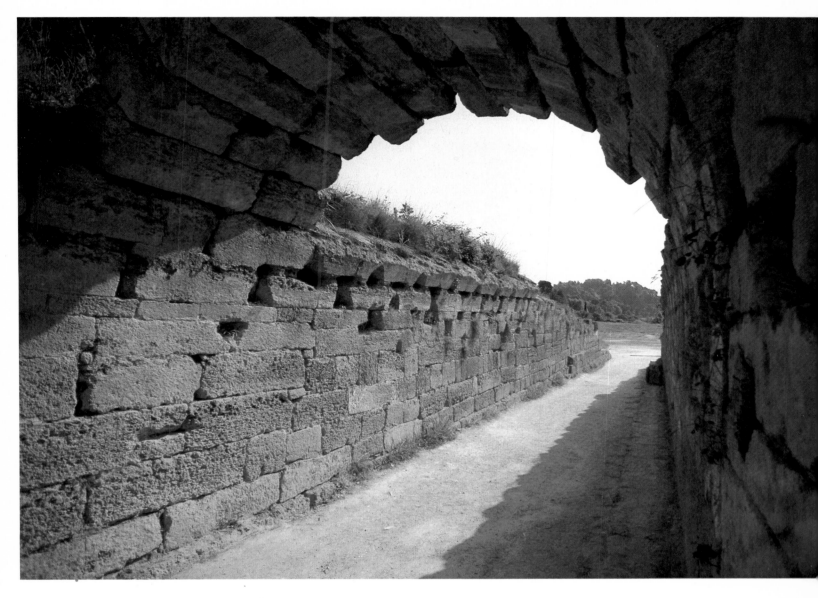

Wars continued between Alexander's generals and successors over the disposal of the empire. The Hellenistic kingdoms came into collision with each other especially in Syria, located on the dividing line between the three main territories, belonging respectively to Seleucus, Antigonus and Ptolemy. The result was a life and death struggle.

On the other hand, the Hellenistic kingdoms which dominated the ancient world for three centuries developed a marvellous and fastuous civilization, chiefly characterized by the birth and blossoming of Greco-Oriental art forms. Hellenistic artists and architects created not only isolated monuments but also fabulous urban complexes which can still be seen at Pergamum in Asia, at Alexandria in Egypt, as well as at Athens in Greece proper.

As early as the fourth century B.C., sculptors like Praxiteles and Lysippus, the favourite portrait sculptor of Alexander the Great, freed the art of statuary from all stiff religious conventions. Lysippus introduced a naturalistic style of modelling, especially in handling of human subjects. Praxiteles' workmanship was characterized by both strength and grace of conception and delicacy and perfection of modelling. The great "baroque" Altar of Zeus at Pergamum, built for Eumenes II, is one of the best surviving examples of Hellenistic sculpture. At the same time, dwellings and palaces were becoming richer and more elaborate. The luxury and magnificence of the porticoes and mosaic pavings of Hellenistic abodes heralded the birth of a life style destined to be perpetuated by the Roman Empire.

Roman legions entered Greece, Anatolia, Syria and Egypt in the first and second centuries B.C. Thenceforth, Rome took over from the Hellenistic world, becoming the protector and continuator of the Greek intellectual achievements and laying the foundations of the future Western world. No one can deny the fact that the legacy of the philosophers and mathematicians, poets and playwrights, sculptors and architects of the world of Ancient Greece is what gave birth, through the instrumentality of Rome, to the political and cultural entity known as Europe, master of the modern world.

Athletes competing in the Olympic Games went under this arch built in the first century B.C. to enter the most famous stadium of the whole of ancient Greece. They were greeted by some 20,000 spectators.

95

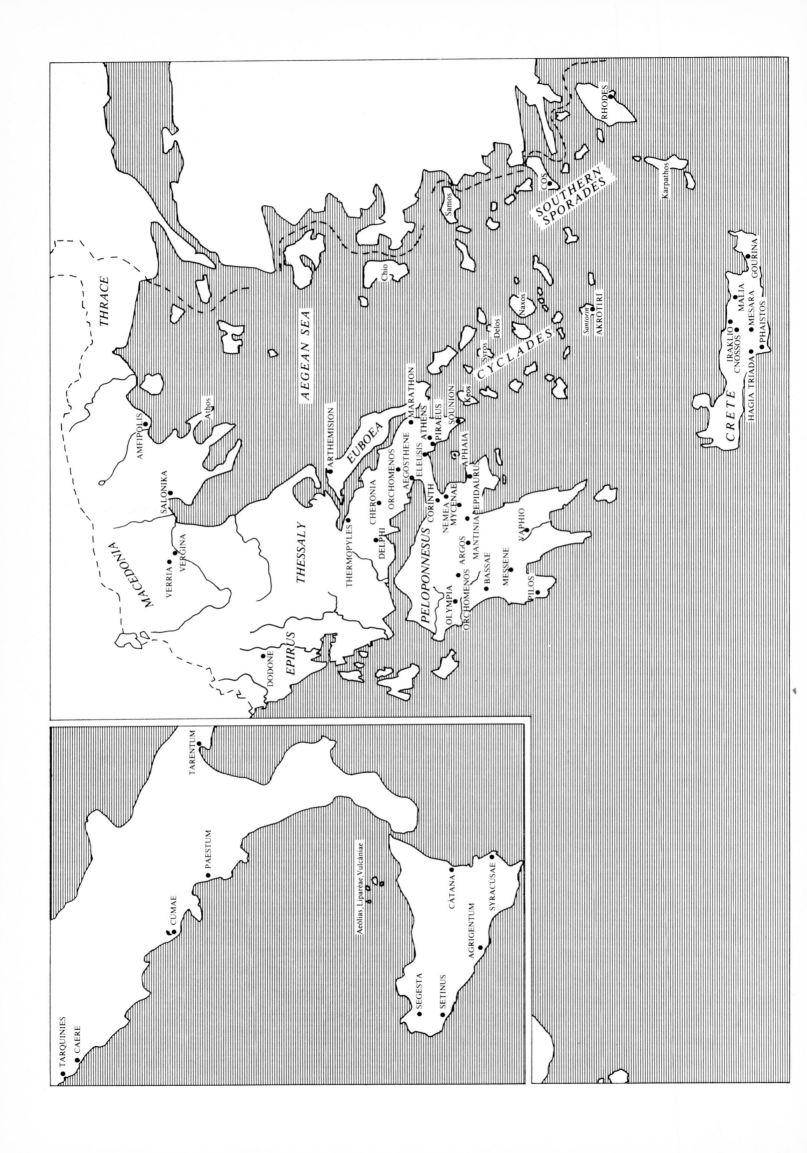

THRACE

AEGEAN SEA

AMFIPOLIS

SALONIKA

Athos

MACEDONIA

VERRIA
VERGINA

THESSALY

ARTHEMISION

EUBOEA

THERMOPYLES

DELPHI
CHERONIA
ORCHOMENOS
AEGOSTHENE

EPIRUS

DODONE

Chio

Samos

COS

SOUTHERN
SPORADES

Karpathos

Naxos

Santorin
AKROTIRI

Delos
Syros
Keos

CYCLADES

MARATHON
ATHENS
ELEUSIS
PIRAEUS
APHAIA
EPIDAURUS
CORINTH
NEMEA
MYCENAE
OLYMPIA ARGOS
ORCHOMENOS MANTINIA
BASSAE
MESSENE
PILOS

SOUNION

VAPHIO

PELOPONNESUS

RHODES

CRETE

IRAKLIO
CNOSSOS
MALIA
GOURINA
HAGIA TRIADA MESARA
PHAISTOS

TARENTUM

PAESTUM

CUMAE

TARQUINIES
CAERE

Aeolias, Lipareae, Vulcaniae

CATANA

AGRIGENTUM
SYRACUSAE

SEGESTA
SETINUS

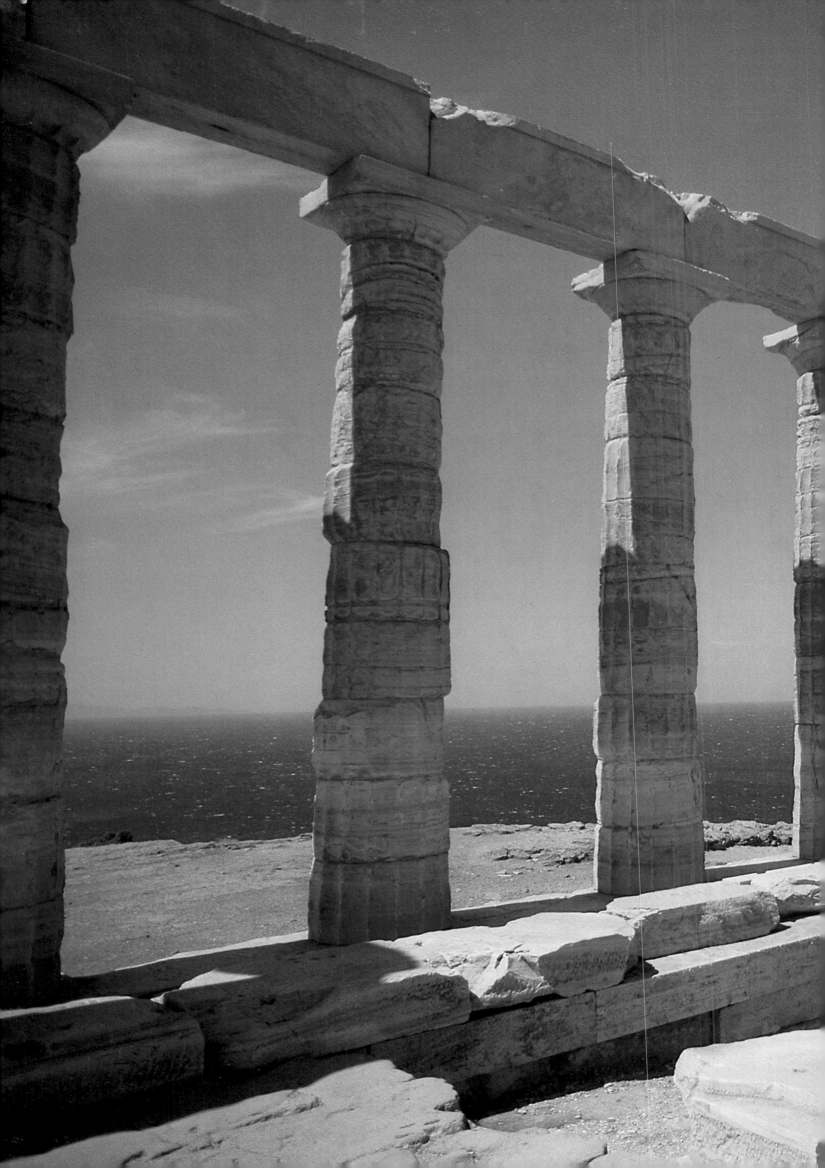